P9-BBV-114

DESIGN BASICS

Copyright © 2002 by Rockport Publishers, Inc.

All rights reserved. No part of this book may be
reproduced in any form without written permission
of the copyright owners. All images in this book
have been reproduced with the knowledge and prior
consent of the artists concerned and no responsibility
is accepted by producer, publisher, or printer for any
infringement of copyright or otherwise, arising from
the contents of this publication. Every effort has
been made to ensure that credits accurately comply
with information supplied.

First published in the United States of America by
Rockport Publishers, Inc.
33 Commercial Street
Gloucester, Massachusetts 01930-5089
Telephone: (978) 282-9590
Facsimile: (978) 283-2742
www.rockpub.com

ISBN 1-56496-903-7 (hardcover)
ISBN 1-56496-854-5 (paperback)

10 9 8 7 6 5 4 3 2

Cover Design: Casey Design

The work in this book originally appeared in *Graphic
Idea Resource: Color*; *Graphic Idea Resource: Type*;
and *Graphic Idea Resource: Layout*; by Joyce Rutter
Kaye. Grateful acknowledgement is given to the
author for permission to reprint her work in this
special edition.

Printed in China.

DESIGN **BASICS**

Ideas and Inspiration for
Working with Layout, Type,
and Color in Graphic Design

Joyce Rutter Kaye

GLOUCESTER MASSACHUSETTS

ROCKPORT PUBLISHERS

introduction

design
BASICS

graphic design is an ever-changing medium. We have gone from mechanical page layout to electronic mechanicals and digital output and printing in what seems like an afternoon. The technological changes that have affected the field of graphic design challenge not only the way in which graphic designers must work, but also the basic foundations upon which good graphic design is built.

Design Basics presents examples of some of the best graphic designs using the most fundamental areas of graphic art—strong layout, compelling color, and good use of typography. A strong understanding of these three elements is the basis of good design. Each of the projects selected for this collection reflects a masterful use of one or more of these design elements.

With widespread access to computers and the mass marketing of good design, understanding the basics of what makes good graphic design is more essential than ever. We hope this book will provide new and seasoned designers with the inspiration and know-how to get back to basics.

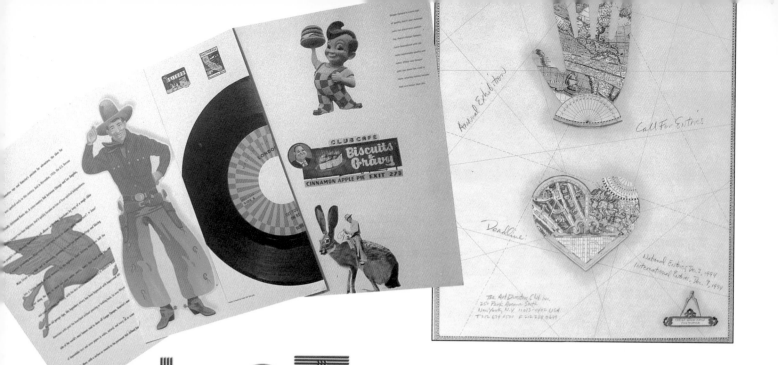

LayouT

. Graphic design is a bit like cooking. When you begin the creative process, you follow a basic structure, using the essential ingredients of type, color, paper, and format, along with a pinch of intuition and a dash of inspiration. You then stir it all together and hope for the best results.

The best graphic design layouts have a balance of flavors that harmonize to create an effective message. Like a great meal, in their ideal form layouts should engage the senses and create an unforgettable moment. The best layouts reveal that the designer trusts his or her instincts to know what is appropriate for the intended audience. Sometimes that means incorporating an element of surprise—using for example, purely type on a brochure to promote a photographer, or photographs of dancers to highlight the elegant lines of a line of eyeglasses. Wit and humor can also be an effective way to engage a consumer's attention, through a clever use of graphic icons to make a visual pun or through deliberately jarring use of contrasting color or type.

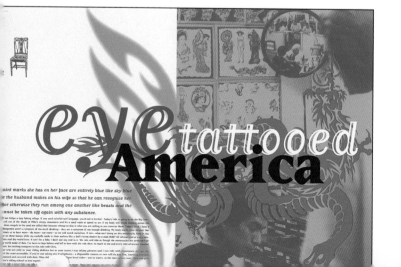

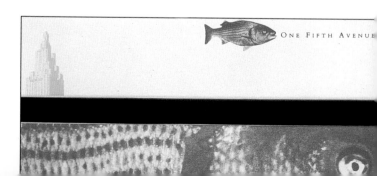

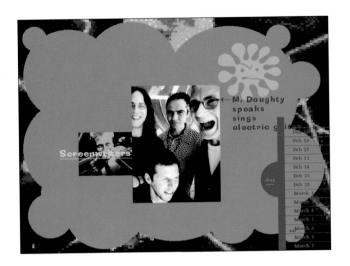

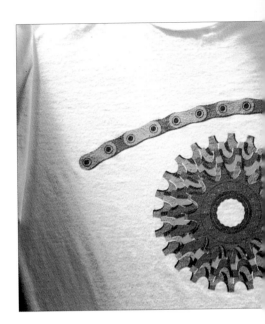

Some designs communicate instantly by their physical form: a flip book to announce a film festival; a die-cut moving announcement that tilts forward, a dinner party invitation that unfolds like a napkin. Other layout designs are remarkable for their simplicity and subtlety: a catalog spread for a furniture company with beautifully lit photos and elegant type, or a menu with soft woodcut illustrations.

The elements of layout design can be taught. However, good layouts become great when the cook in the kitchen knows how to use fine-quality ingredients, experience, intuition and restraint. This book contains 90 examples for you to sample.

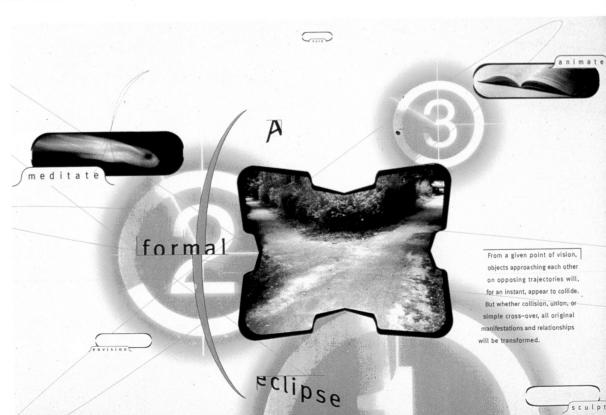

animate

meditate

A

3

formal

From a given point of vision, objects approaching each other on opposing trajectories will, for an instant, appear to collide. But whether collision, union, or simple cross-over, all original manifestations and relationships will be transformed.

envision

eclipse

sculpt

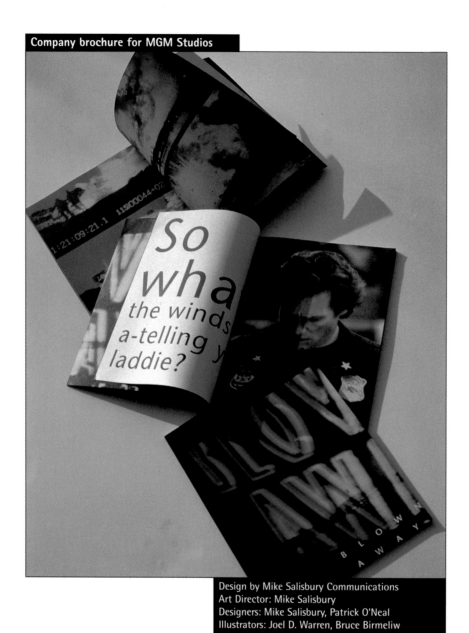

Company brochure for MGM Studios

Design by Mike Salisbury Communications
Art Director: Mike Salisbury
Designers: Mike Salisbury, Patrick O'Neal
Illustrators: Joel D. Warren, Bruce Birmeliw

This promotional book for entertainment company MGM emulates the drama of the company's big-screen productions by showing full-page stills from action films combined with lines of dialogue in provocative, large-scale type.

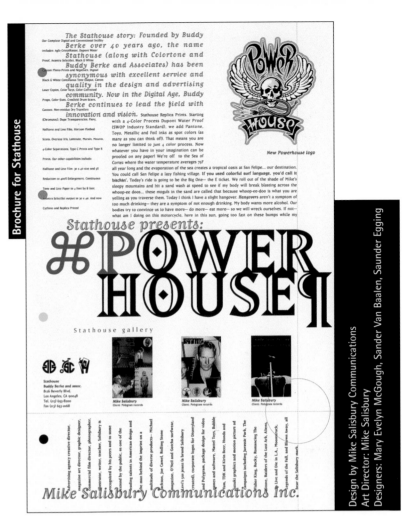

Design by Mike Salisbury Communications
Art Director: Mike Salisbury
Designers: Mary Evelyn McGough, Sander Van Baalen, Saunder Egging

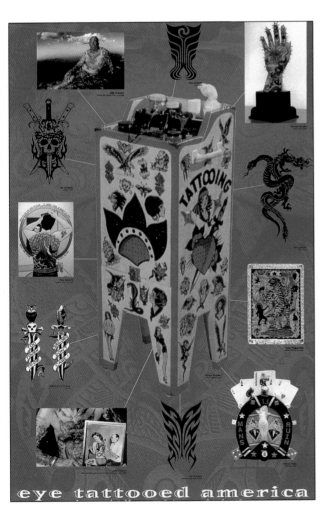

eye tattooed america

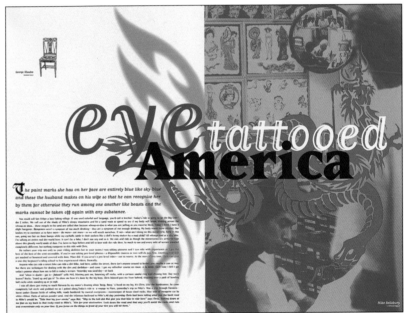

To promote the services of Stathouse, a pre-press service bureau, Mike Salisbury Communications created a brochure that uses striking graphics based on tattoo designs to convey a message about the company's precision color and state-of-the-art digital capabilities.

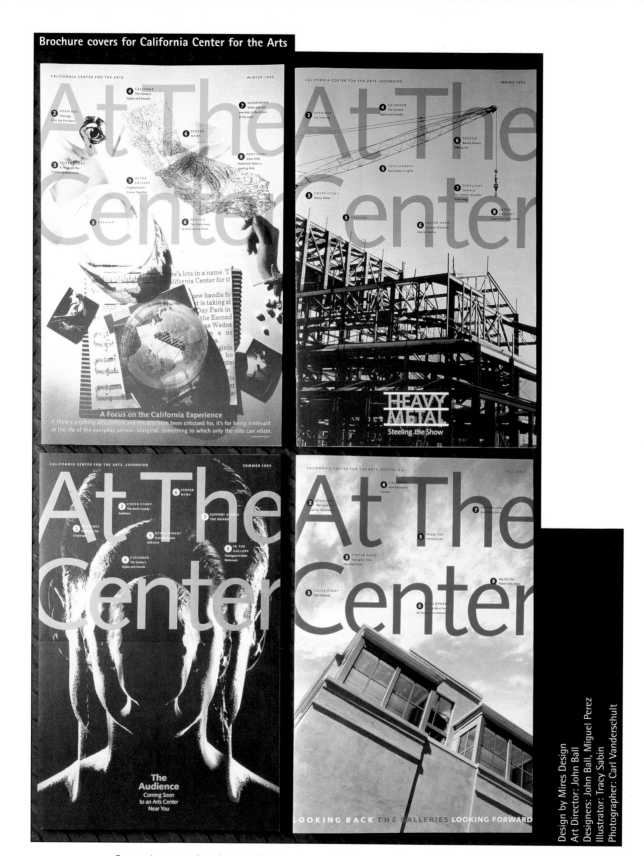

Brochure covers for California Center for the Arts

Design by Mires Design
Art Director: John Ball
Designers: John Ball, Miguel Perez
Illustrator: Tracy Sabin
Photographer: Carl Vanderschult

Cover layouts for *At the Center,* a quarterly magazine published by the
California Center for the Arts, consistently feature strong, singular
black-and-white images from feature articles with a logo treatment in
ITC Officina that changes color from issue to issue. The table of contents
is sprinkled over the logo treatment, communicating at a glance what is
served up inside.

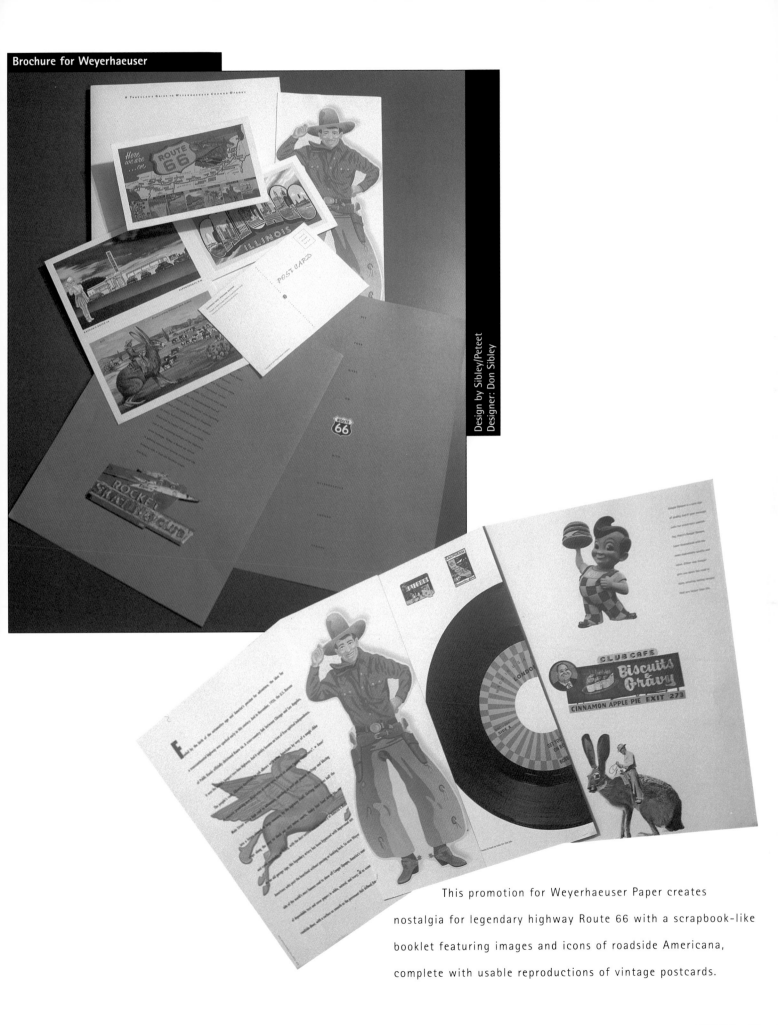

Brochure for Weyerhaeuser

Design by Sibley/Peteet
Designer: Don Sibley

This promotion for Weyerhaeuser Paper creates nostalgia for legendary highway Route 66 with a scrapbook-like booklet featuring images and icons of roadside Americana, complete with usable reproductions of vintage postcards.

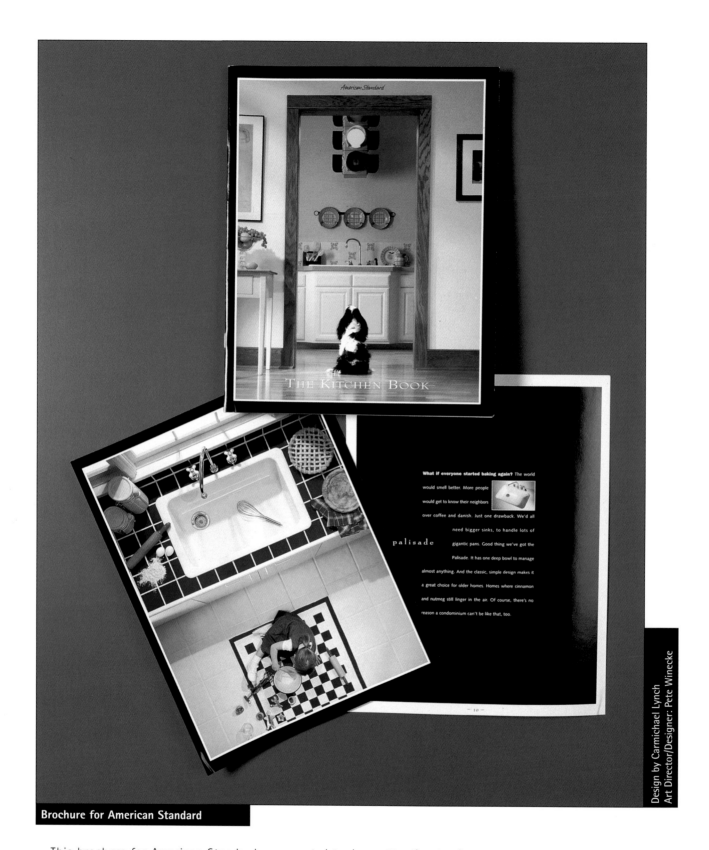

THE KITCHEN BOOK

What if everyone started baking again? The world
would smell better. More people
would get to know their neighbors
over coffee and danish. Just one drawback. We'd all
need bigger sinks, to handle lots of
gigantic pans. Good thing we've got the
Palisade. It has one deep bowl to manage
almost anything. And the classic, simple design makes it
a great choice for older homes. Homes where cinnamon
and nutmeg still linger in the air. Of course, there's no
reason a condominium can't be like that, too.

palisade

— 10 —

Design by Carmichael Lynch
Art Director/Designer: Pete Winecke

Brochure for American Standard

This brochure for American Standard was created to draw attention to the
company's line of kitchen fixtures. Color photographs subtly display how
the faucets complement both the beauty and the lifestyle of the
households where they are found.

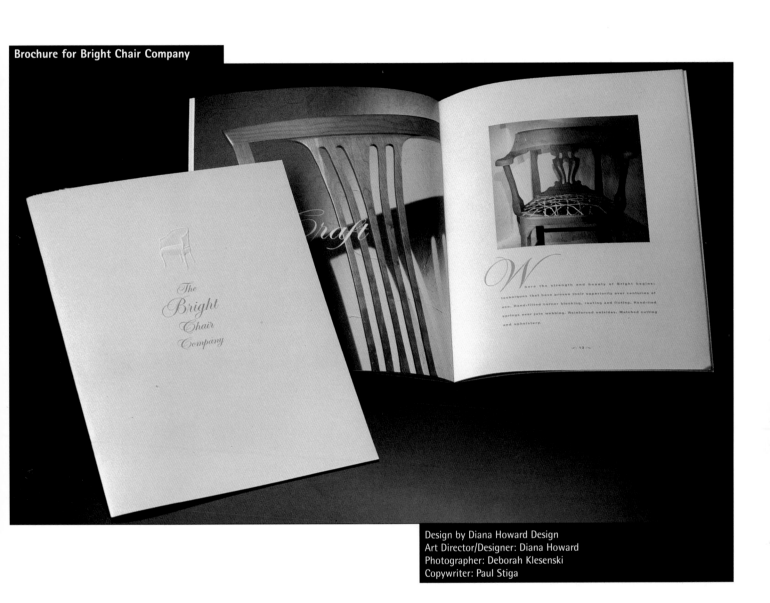

Design by Diana Howard Design
Art Director/Designer: Diana Howard
Photographer: Deborah Klesenski
Copywriter: Paul Stiga

Spreads in this brochure for the Bright Chair Company
convey old-world craftsmanship through softly lit
photographs of furniture details and the use of a
delicate script for headlines and drop-cap letters.
Ornaments framing folios add a genteel touch.

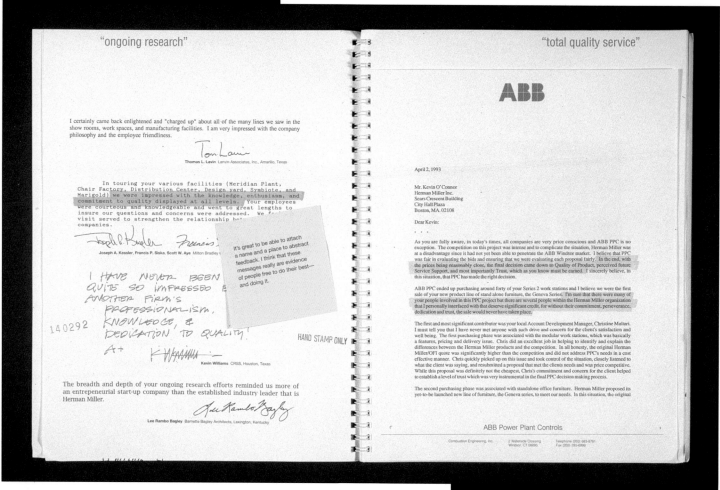

Design by Herman Miller in-house design team
Art Director: Stephen Frykholm
Designers: Stephen Frykholm, Yang Kim, Sara Giovanitti
Copywriter: Clark Malcolm
Production: Marlene Capotosto

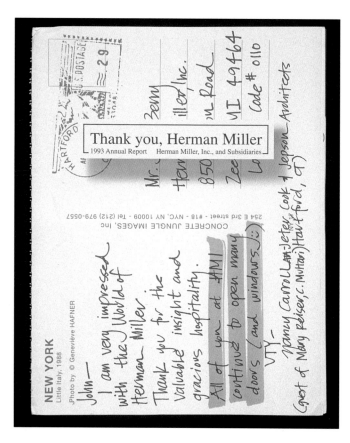

An annual report for Herman Miller takes a sharp departure from a print category that typically features glossy product shots and vanity photos of CEOs. This effort instead emphasizes Herman Miller's personal, quality service by reproducing correspondence to the company exactly as it was received, and then binding it into a spiral folder. This intentionally unslick approach aims to dazzle with honesty and integrity, instead of beautiful imagery.

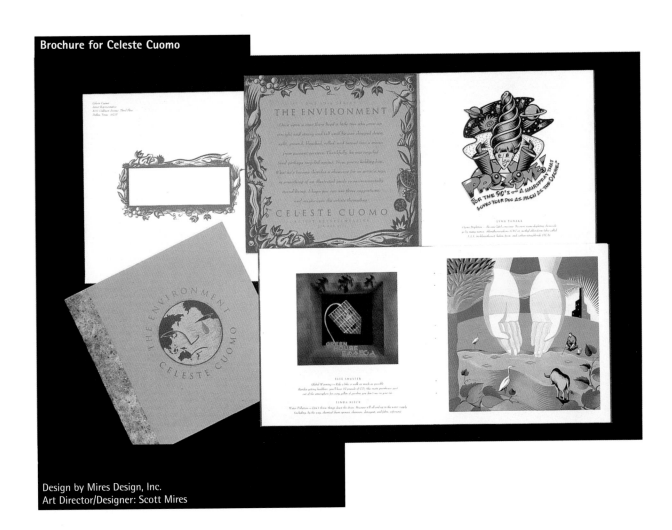

Brochure for Celeste Cuomo

Design by Mires Design, Inc.
Art Director/Designer: Scott Mires

A gentle message about protecting the environment was woven into this direct-mail campaign promoting a group of illustrators represented by Celeste Cuomo. The mailer's cover establishes the mood with woodcut images printed on olive paper; subsequent layouts feature illustrations relating to the environment with copy emphasizing their statements on contemporary problems such as global warming and water pollution.

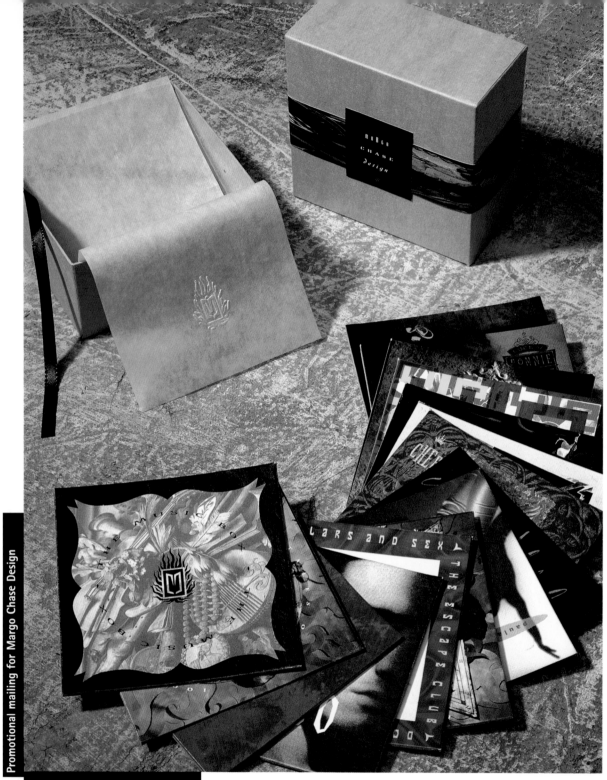

Promotional mailing for Margo Chase Design

Design by Margo Chase Design
Art Director/Designer: Margo Chase
Photographer: Nels Israelson

A music box containing overprints of CD package designs provides an effective promotion for Margo Chase, who has created contemporary baroque identities for artists such as Prince and Madonna.

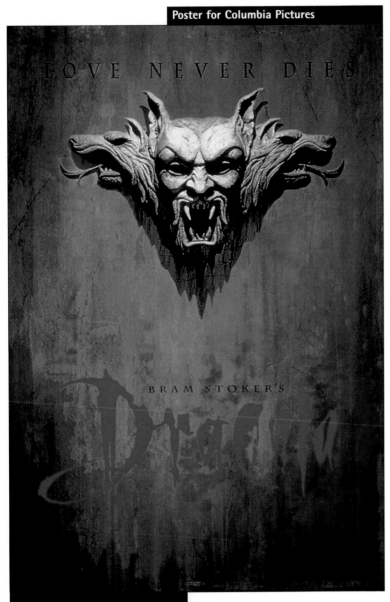

Poster for Columbia Pictures

Design by Margo Chase Design
Creative Director: John Kehe
Art Director: Margo Chase
Lettering Designer: Nancy Ogami
Photographer: Sidney Cooper
Sculptor: Jaqueline Perrault

This image of a triple-headed Gothic gargoyle, paired with Nancy Ogami's hand-rendered, bloody title treatment, creates a chilling mood for the film adaptation of Bram Stoker's *Dracula*, one that could not have been achieved by merely showing photographic head shots of the film's stars.

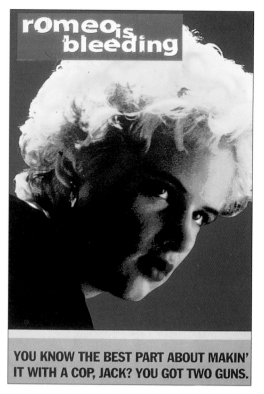

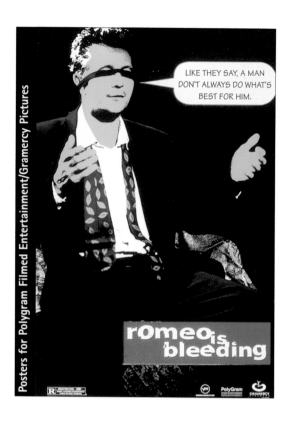

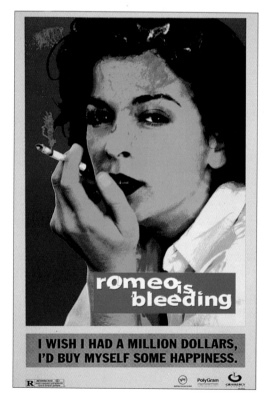

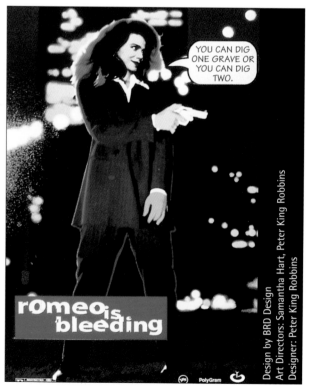

For this film noir production of *Romeo is Bleeding*, a four-poster teaser campaign was used. Each poster promoted one of the four leads in a highly touched-up manner suggestive of 1950s pulp paperback covers. A final poster combined the images with the title and production information.

romeo is bleeding

The Story Of A Cop
Who Wanted It Bad
And Got It Worse

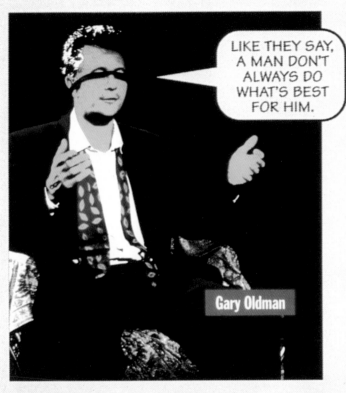

LIKE THEY SAY, A MAN DON'T ALWAYS DO WHAT'S BEST FOR HIM.

Gary Oldman

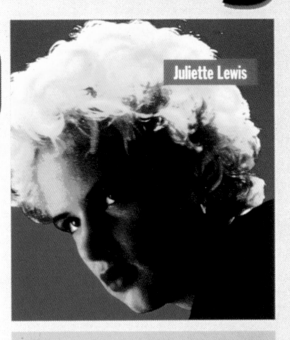

Juliette Lewis

YOU KNOW THE BEST PART ABOUT MAKIN' IT WITH A COP, JACK? YOU GOT TWO GUNS.

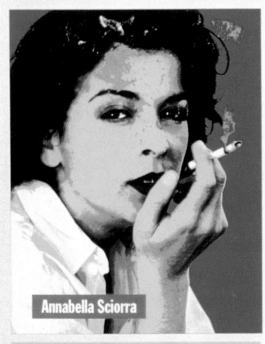

Annabella Sciorra

I WISH I HAD A MILLION DOLLARS. I'D BUY MYSELF SOME HAPPINESS.

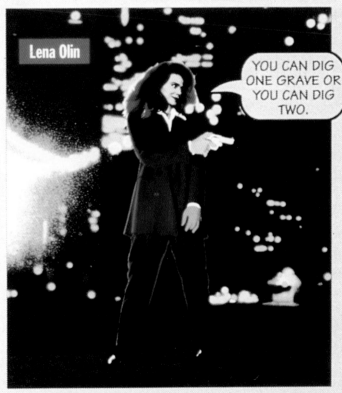

Lena Olin

YOU CAN DIG ONE GRAVE OR YOU CAN DIG TWO.

POLYGRAM FILMED ENTERTAINMENT PRESENTS A WORKING TITLE/HILARY HENKIN PRODUCTION
GARY OLDMAN LENA OLIN ANNABELLA SCIORRA AND JULIETTE LEWIS A PETER MEDAK FILM "ROMEO IS BLEEDING" AND ROY SCHEIDER
CASTING BY BONNIE TIMMERMAN MUSIC BY MARK ISHAM EDITED BY WALTER MURCH PRODUCTION DESIGNER STUART WURTZEL
DIRECTOR OF PHOTOGRAPHY DARIUSZ WOLSKI EXECUTIVE PRODUCERS TIM BEVAN AND ERIC FELLNER WRITTEN BY HILARY HENKIN
PRODUCED BY HILARY HENKIN AND PAUL WEBSTER DIRECTED BY PETER MEDAK
PolyGram R RESTRICTED DOLBY STEREO Verve GRAMERCY

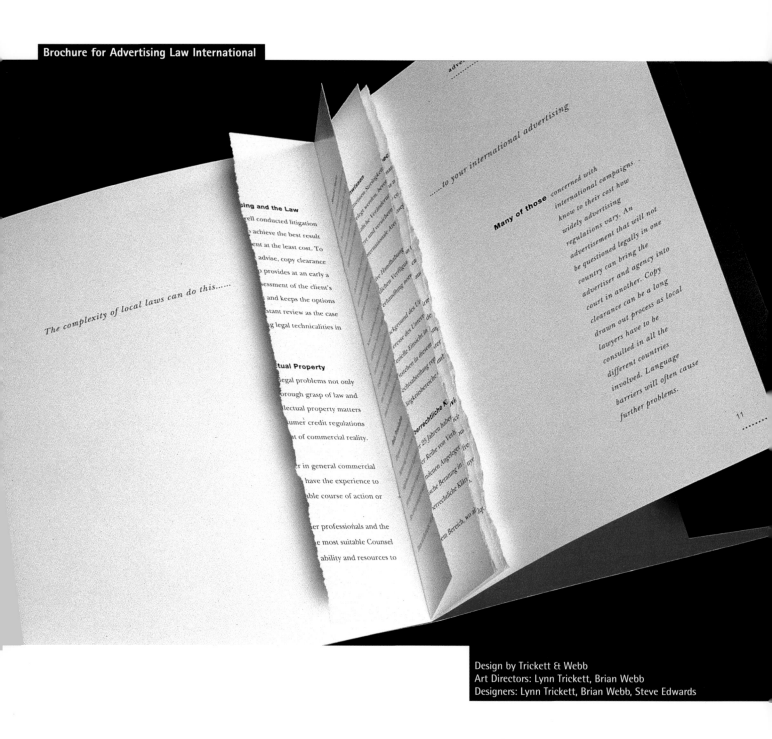

Design by Trickett & Webb
Art Directors: Lynn Trickett, Brian Webb
Designers: Lynn Trickett, Brian Webb, Steve Edwards

Emphasizing the potential legal quagmire faced by advertising agencies marketing overseas, this brochure promoting the services of a group of international lawyers literally demonstrates how the complexity of local laws abroad can rip an advertiser's work to shreds.

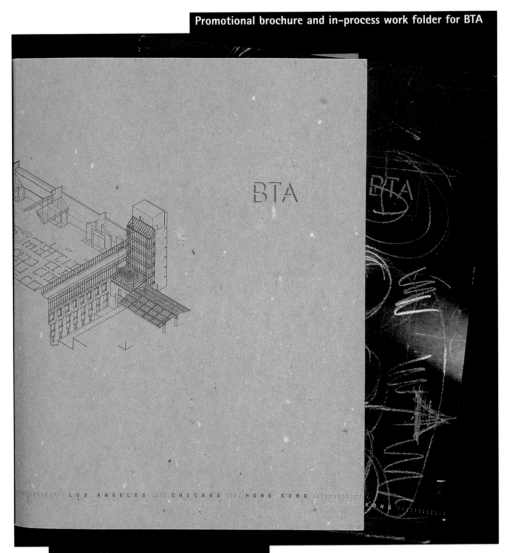

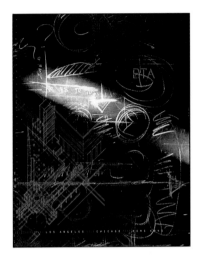

Design by COY
Art Director: John Coy
Designers: John Coy, Albert Choi, Rokha Srey
Production: Rokha Srey

The conservative cover of this brochure for architectural firm BTA belies the explosion of energy found within the folder in the form of idea sketches in chalk. Together with other elements, including reprints from the magazine *Architectural Record*, the book forms a complete picture of the firm, emphasizing the creative process and the employees' perspectives.

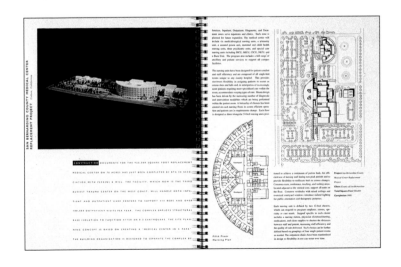

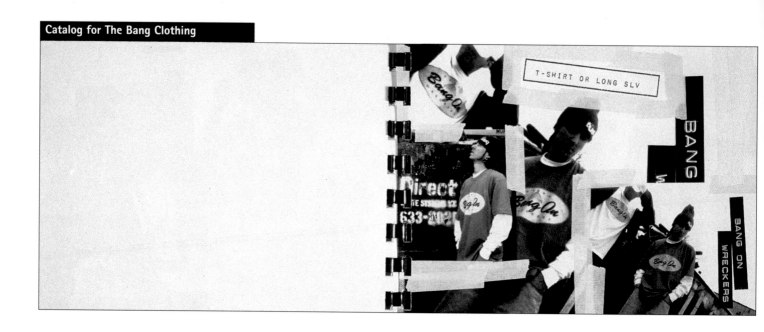

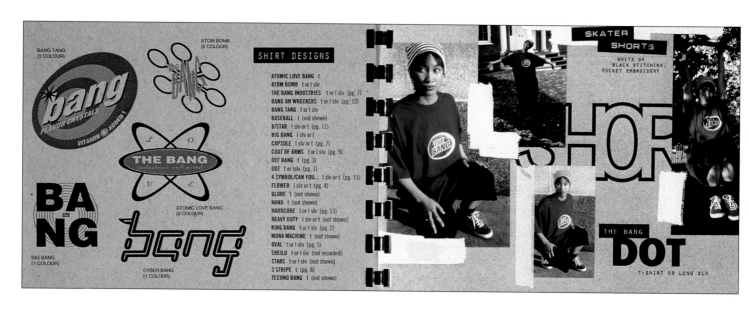

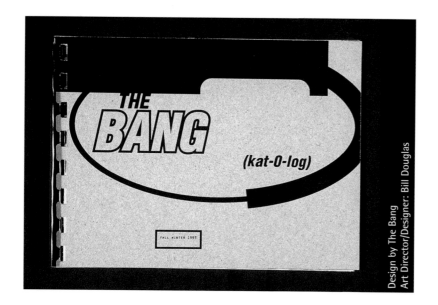

Design by The Bang
Art Director/Designer: Bill Douglas

Designer Bill Douglas' clothing catalog for The Bang maintains street appeal by taking a determinedly unslick approach. Layouts were designed in a scrapbook fashion with photos "taped" down, and some headlines made on a label maker. The piece used low-grade paper stock printed on a color copier.

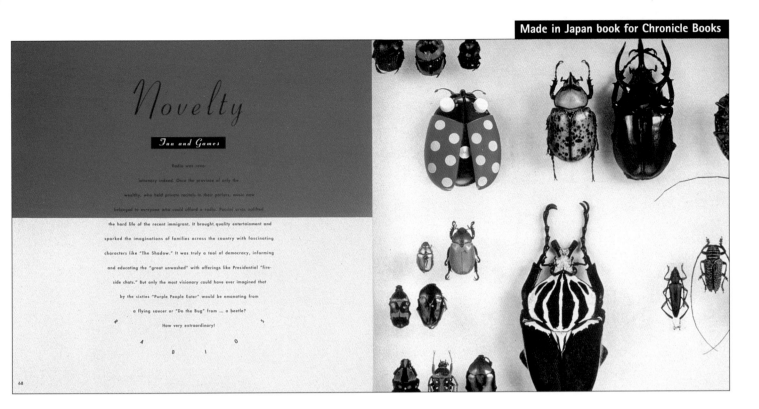

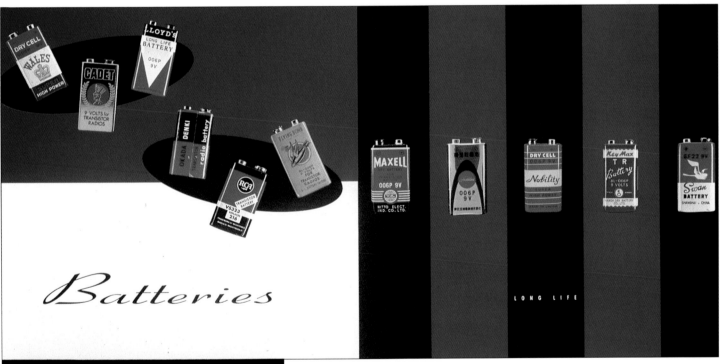

Design by Maureen Erbe Design
Art Director: Maureen Erbe
Designers: Maureen Erbe, Rita A. Sowins
Photographer: Henry Blackham
Copywriter: Aileen Antonier

Layout designs for a book about collectible transistor radios from the 1950s and 1960s use a whimsical format that employs bold use of color, ample white space, and headline type that evokes advertising styles from that era. Type set in a circular shape echoes the shape of a transistor radio speaker.

Sportswear advertisements for Gotcha

Design by Mike Salisbury Communications
Art Director/Designer: Mike Salisbury

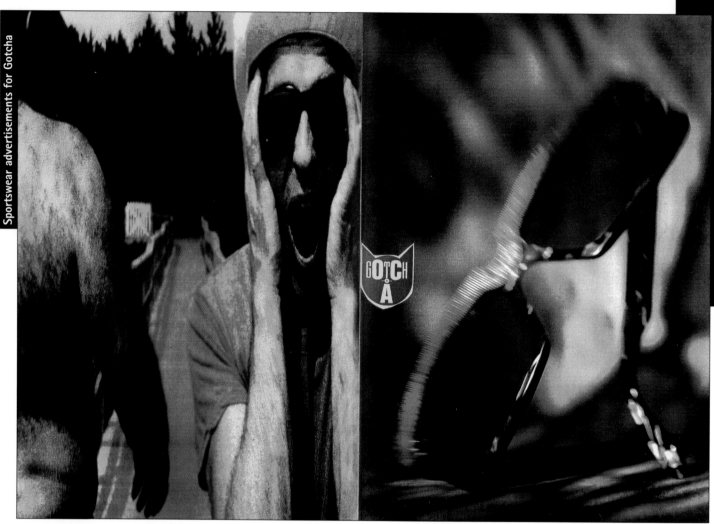

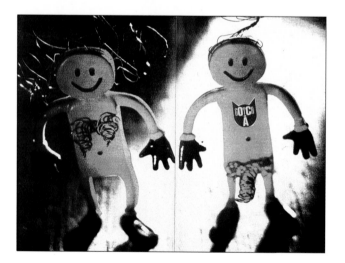

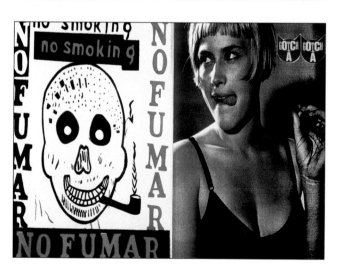

You have to have attitude to appeal to Gen X-ers: One surfwear ad for Gotcha uses edgy photography to spoof an Edvard Munch classic painting; while others rely on vernacular signage and anatomically correct figures that spring to life.

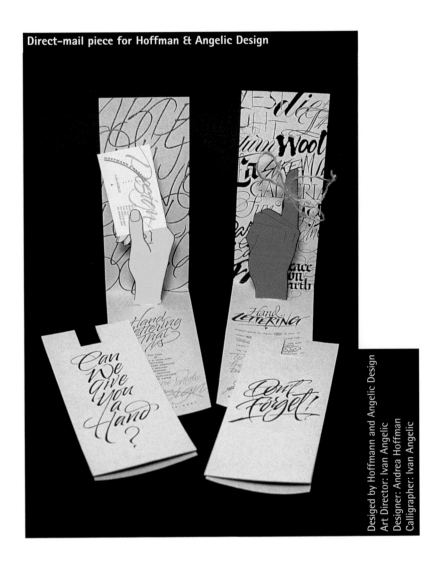

Direct-mail piece for Hoffman & Angelic Design

Desiged by Hoffmann and Angelic Design
Art Director: Ivan Angelic
Designer: Andrea Hoffman
Calligrapher: Ivan Angelic

Pop-up hands were used in this direct-mail campaign to promote a design studio's hand-lettering services, while the message and background letterforms reveal the variety of lettering styles.

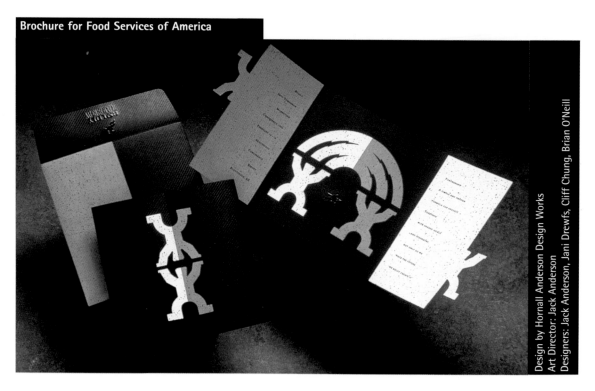

Brochure for Food Services of America

Design by Hornall Anderson Design Works
Art Director: Jack Anderson
Designers: Jack Anderson, Jani Drewfs, Cliff Chung, Brian O'Neill

This brochure for an annual partnership-building conference combines striking color contrast and a bold, almost primitive icon to emphasize the strength and balance in joining forces.

Design by Stewart Monderer Design, Inc.
Art Director: Steward Monderer
Designers: Robert Davison, Jane Winsor
Illustrator: Richard Goldberg

This series of six postcards was conceived to promote a design studio's variety of design approaches, from purely typographic to entirely photographic.

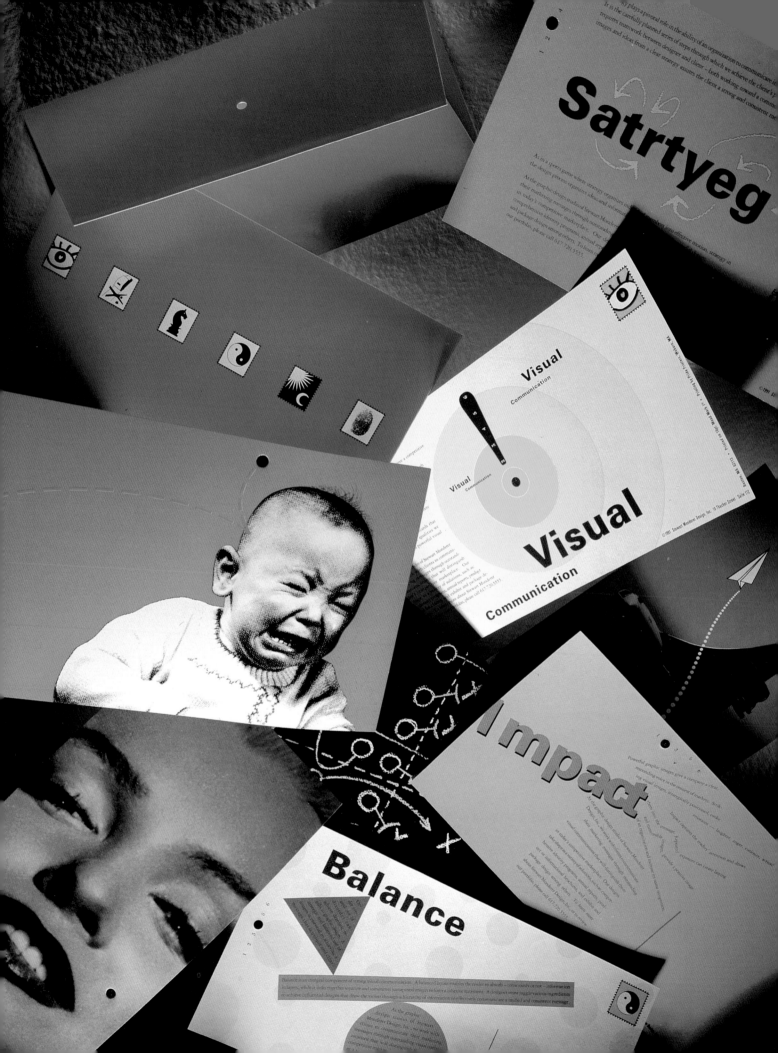

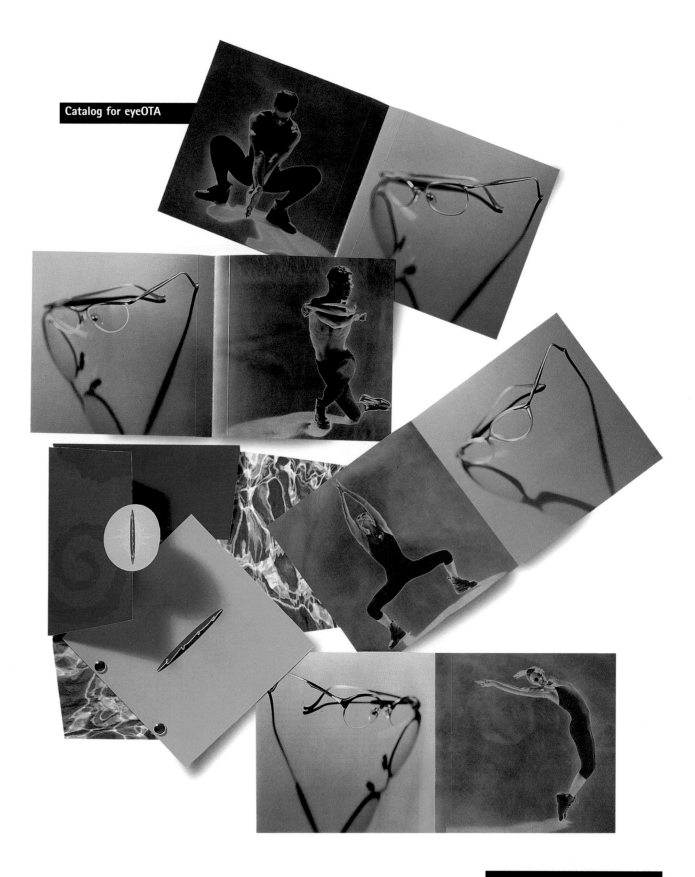

Catalog for eyeOTA

In a catalog for eyeOTA, the products' grace, beauty, and elegant lines were emphasized in layouts featuring dramatically lit photographs of eyeglasses paired with shots of professional dancers.

Design by eyeOTA in-house studio
Art Director: David Kilvert
Designers: Krista Kilvert, David Kilvert
Photographer: Amedeo

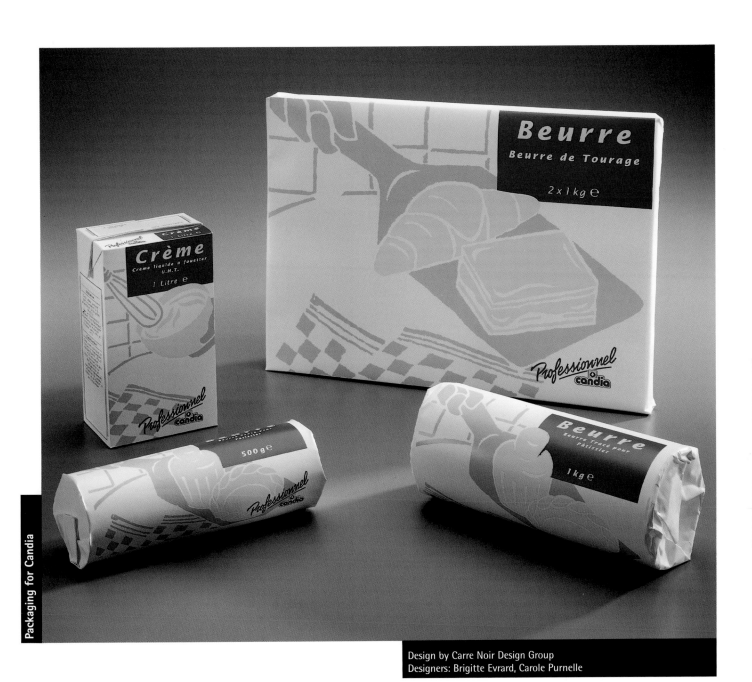

Packaging for Candia

Design by Carre Noir Design Group
Designers: Brigitte Evrard, Carole Purnelle

With an eye-pleasing palette of pastels and silk-screened imagery reminiscent of 1920s and 1930s, this package design for a line of French butters and creams projects an image of quality and purity.

Packaging for Italia

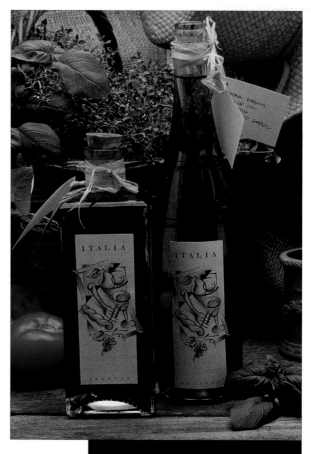

Design by Hornall Anderson Design Works, Inc.
Designers: Jack Anderson, Julia LaPine

Bottles for Italia's line of herbed vinegars and olive oils exude a casual, yet sophisticated image through labels and tags with sprightly illustrations that reveal the source of the essence and the elements of a fine, simple meal.

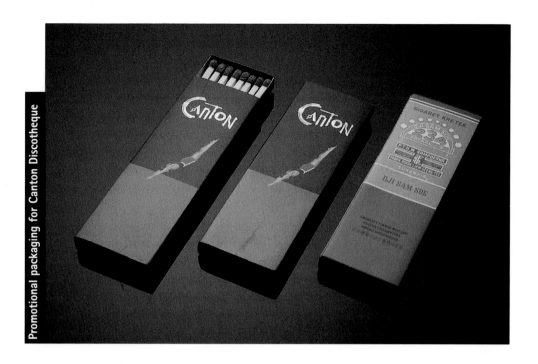

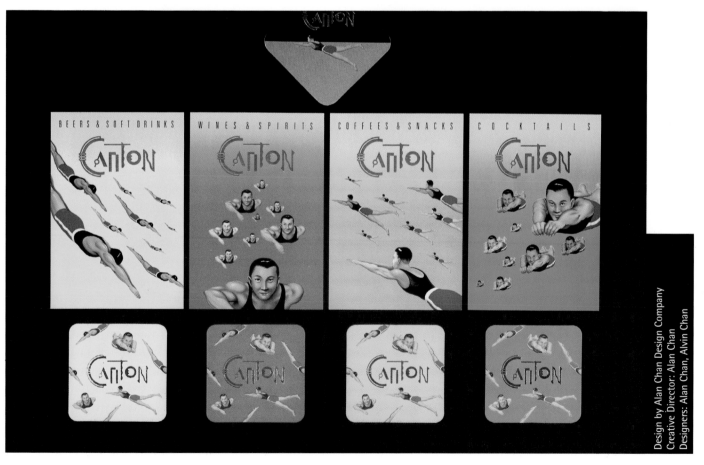

Design by Alan Chan Design Company
Creative Director: Alan Chan
Designers: Alan Chan, Alvin Chan

The packaging for promotional items for the Canton Discotheque projects a hip

sensibility with 1930s-style illustrations on candy-colored backgrounds with a

logo created from a hodgepodge of futuristic letterforms.

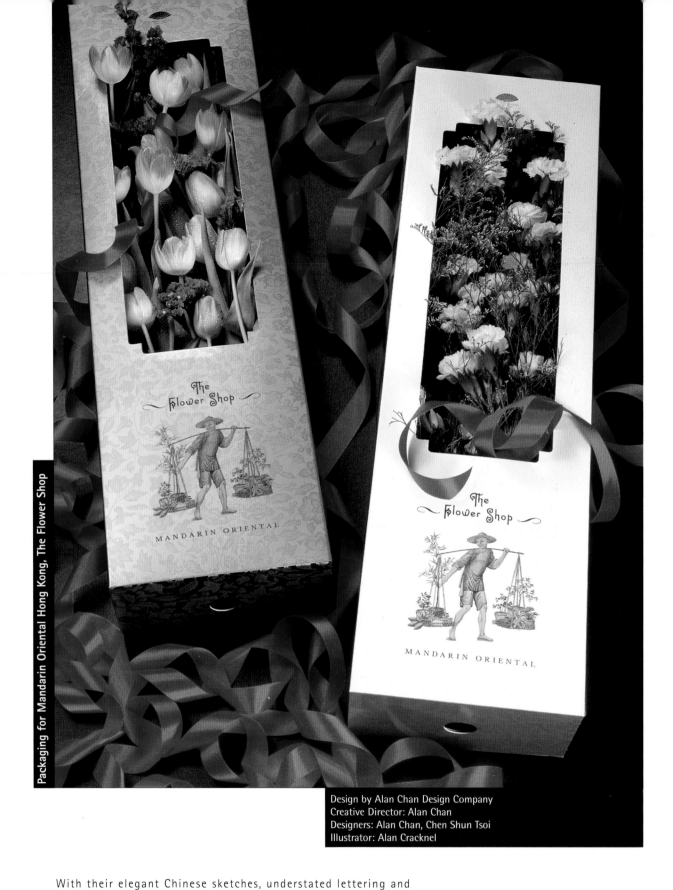

Packaging for Mandarin Oriental Hong Kong, The Flower Shop

The Flower Shop

MANDARIN ORIENTAL

The Flower Shop

MANDARIN ORIENTAL

Design by Alan Chan Design Company
Creative Director: Alan Chan
Designers: Alan Chan, Chen Shun Tsoi
Illustrator: Alan Cracknel

With their elegant Chinese sketches, understated lettering and
backgrounds, and an open window for presentation, these floral boxes
employ a beautiful framing device that almost demands that flowers
remain in the package.

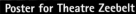

meditate

A

formal

envision

eclipse

animate

sculpt

From a given point of vision, objects approaching each other on opposing trajectories will, for an instant, appear to collide. But whether collision, union, or simple cross-over, all original manifestations and relationships will be transformed.

Design by Studio Dunbar
Art Director: Gert Dunbar
Designer/Photographer: Jeremy F. Mende

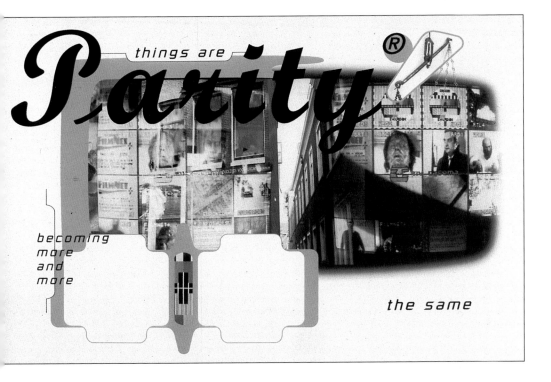

things are

Parity®

becoming
more
and
more

the same

For their theater clients in Holland, Studio Dunbar choose an elliptical approach in their poster and brochure designs. Messages are conveyed through layouts that seamlessly weave type, images, and icons for a textural approach that speaks to the subconscious.

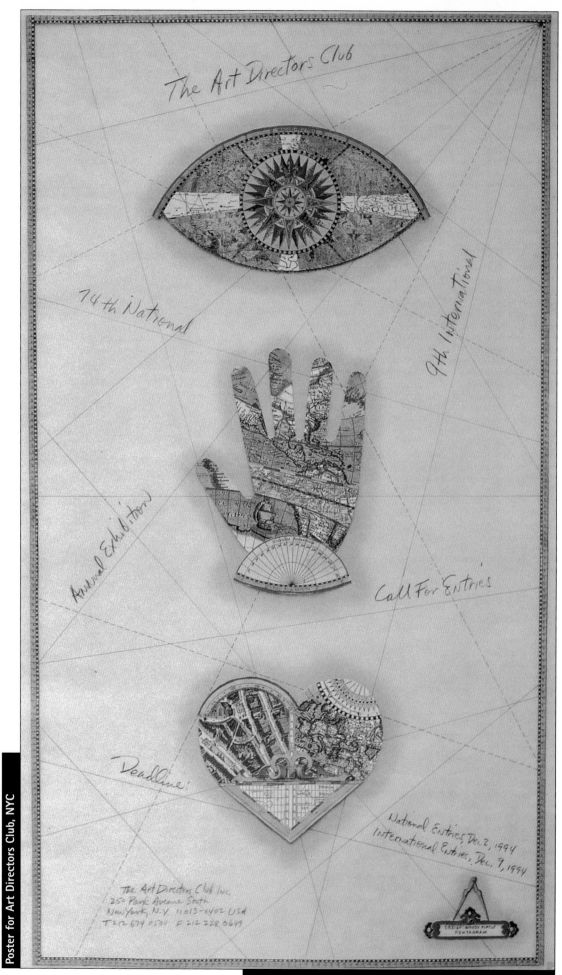

Modern-day hieroglyphics were created to convey three key elements of creativity—the eye, the hand, and the heart—for this call-for-entries poster for the Art Directors Club's annual awards competition.

Design by Pentagram Design
Designer: Woody Pirtle

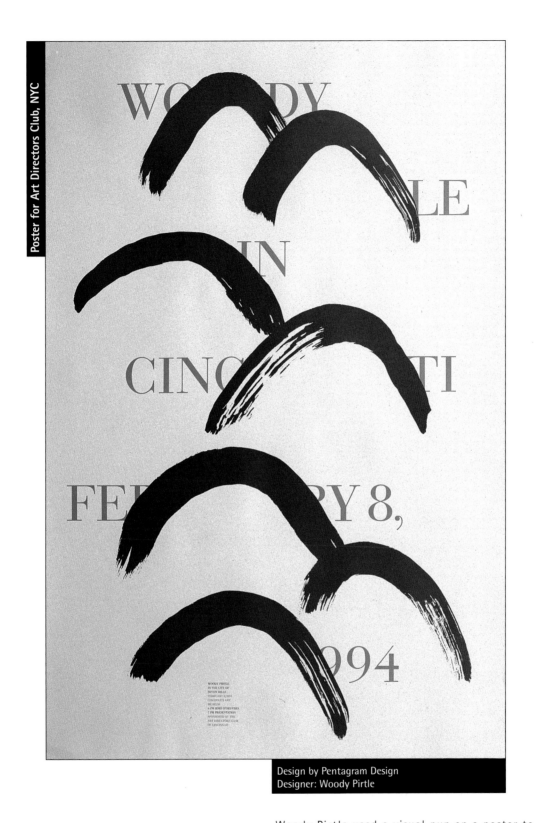

Poster for Art Directors Club, NYC

Design by Pentagram Design
Designer: Woody Pirtle

Woody Pirtle used a visual pun on a poster to announce his speaking engagement at the Art Directors Club of Cincinnati. Portions of headline letterforms were replaced with arched brushstrokes representing the City of Seven Hills.

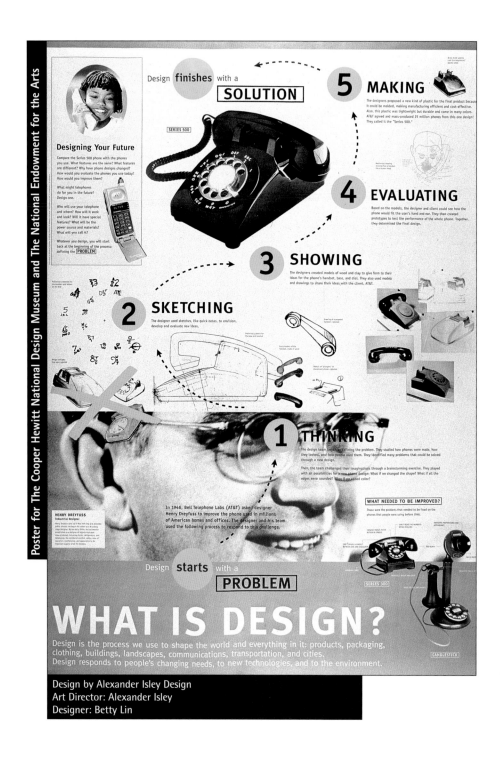

Poster for The Cooper Hewitt National Design Museum and The National Endowment for the Arts

Using his characteristic wit and penchant for iconographic Americana, Alex Isley created a poster that explains the design profession to children in a step-by-step format reminiscent of layouts from vintage issues of *Popular Mechanics*.

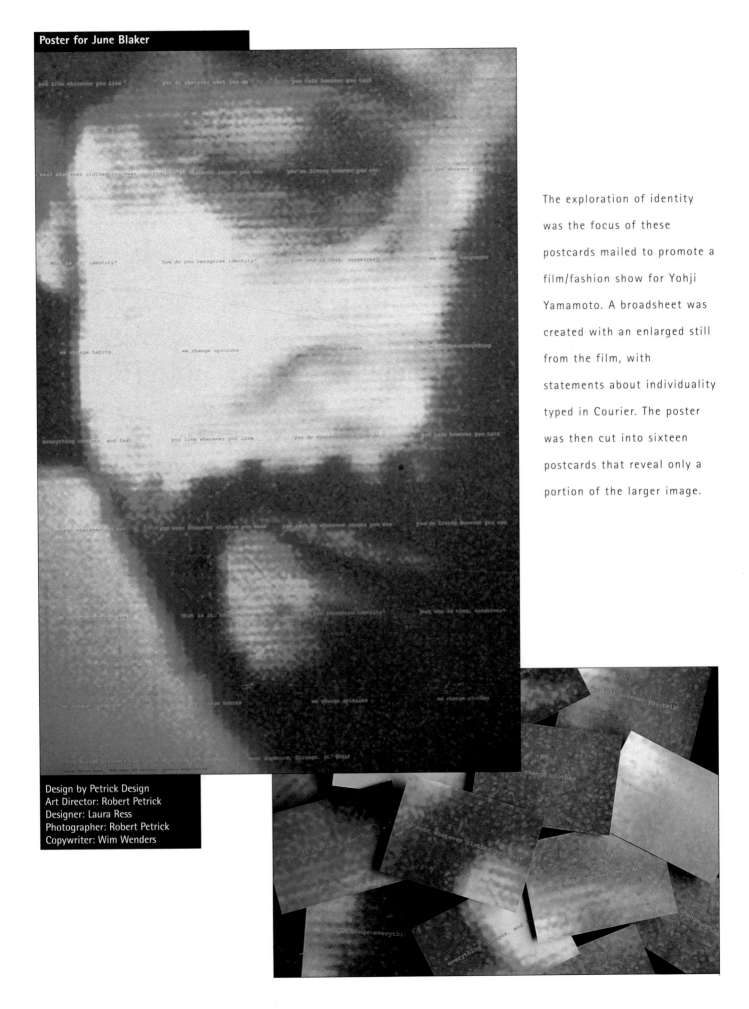

Poster for June Blaker

The exploration of identity was the focus of these postcards mailed to promote a film/fashion show for Yohji Yamamoto. A broadsheet was created with an enlarged still from the film, with statements about individuality typed in Courier. The poster was then cut into sixteen postcards that reveal only a portion of the larger image.

Design by Petrick Design
Art Director: Robert Petrick
Designer: Laura Ress
Photographer: Robert Petrick
Copywriter: Wim Wenders

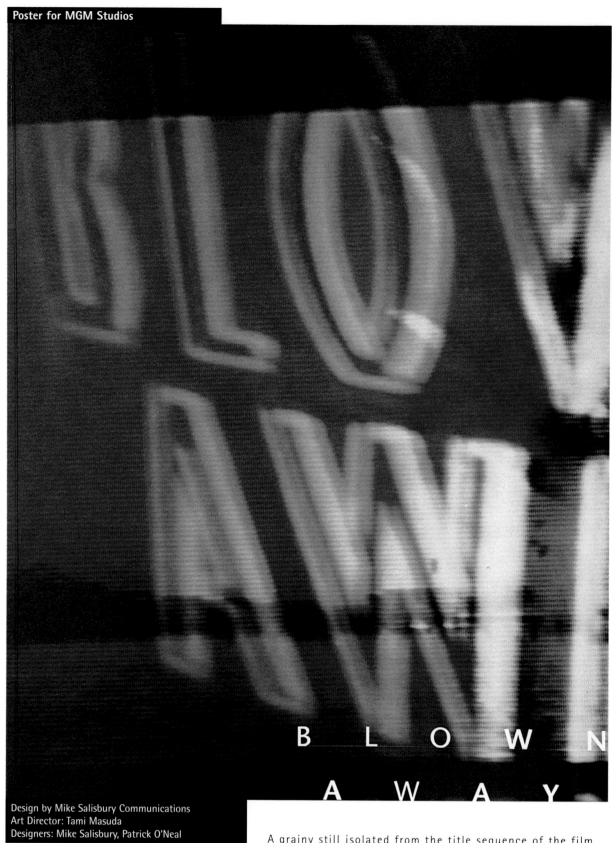

Design by Mike Salisbury Communications
Art Director: Tami Masuda
Designers: Mike Salisbury, Patrick O'Neal

A grainy still isolated from the title sequence of the film *Blown Away* provides impact and hints at the release's gritty action in this promotional book by Mike Salisbury Communications.

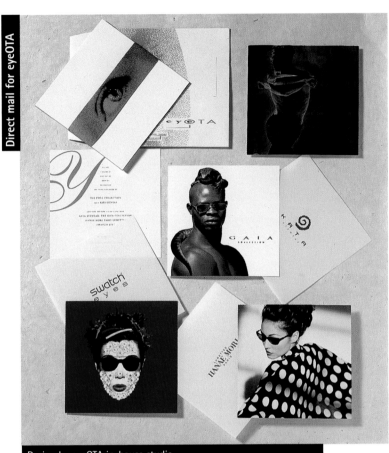

Direct mail for eyeOTA

Design by eyeOTA in-house studio
Art Director: David Kilvert
Designers: Krista Kilvert, David Kilvert

To differentiate between product lines for
eyeOTA, a mailer includes cards promoting
each line with distinctive fashion photography
ranging from the fanciful to the dramatic.
Translucent vellum sheets with the product
logo separate the cards.

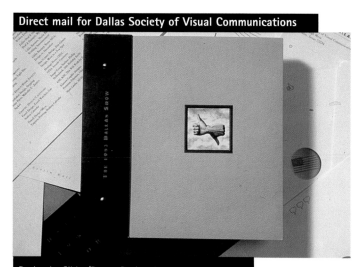

Direct mail for Dallas Society of Visual Communications

Design by Sibley/Peteet Design, Inc.
Art Director: Rex Peteet
Designers: Rex Peteet, Derek Welch
Illustrators: Rex Peteet, Derek Welch, Mike Schroeder
Photographer: Phil Hollenbeck

The thumbs-up thumbs-down icon placed at the center of the cover for this call for entries to the Dallas Society of Visual Communicators instantly conveys the essence of competition. The icon is repeated as a motif throughout the booklet.

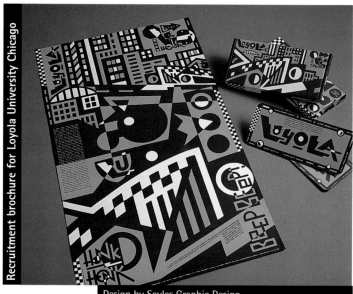

Recruitment brochure for Loyola University Chicago

Design by Sayles Graphic Design
Designer: John Sayles

Graphics reflecting a traffic theme are crammed on a page in this booklet promoting the frenetic fun of Loyola University's fraternity and sorority rush.

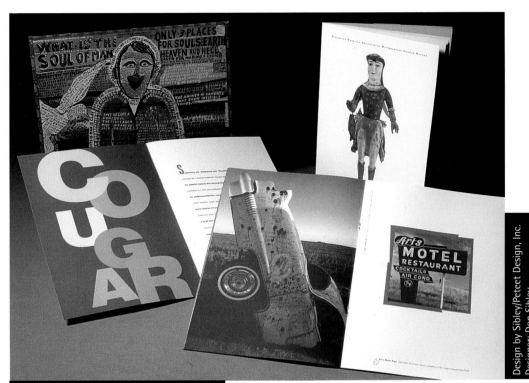

Icons of Americana, from roadside signs to folk art, grace the cleanly designed and clutter-free pages of a promotion for Weyerhaeuser paper.

Direct mail for Weyerhaeuser

Design by Sibley/Peteet Design, Inc.
Designer: Don Sibley

The mode of shelter used by so many homeless people—a cardboard carton—is the key image in this mailer for a nonprofit organization. The image of a crouching homeless man is literally boxed in by corrugated markings.

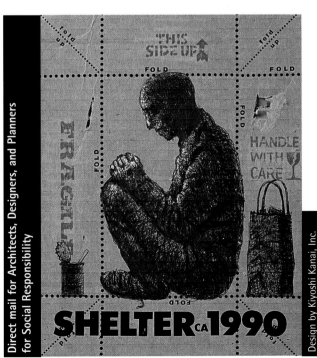

Direct mail for Architects, Designers, and Planners for Social Responsibility

Design by Kiyoshi Kanai, Inc.
Designer: Kiyoshi Kanai

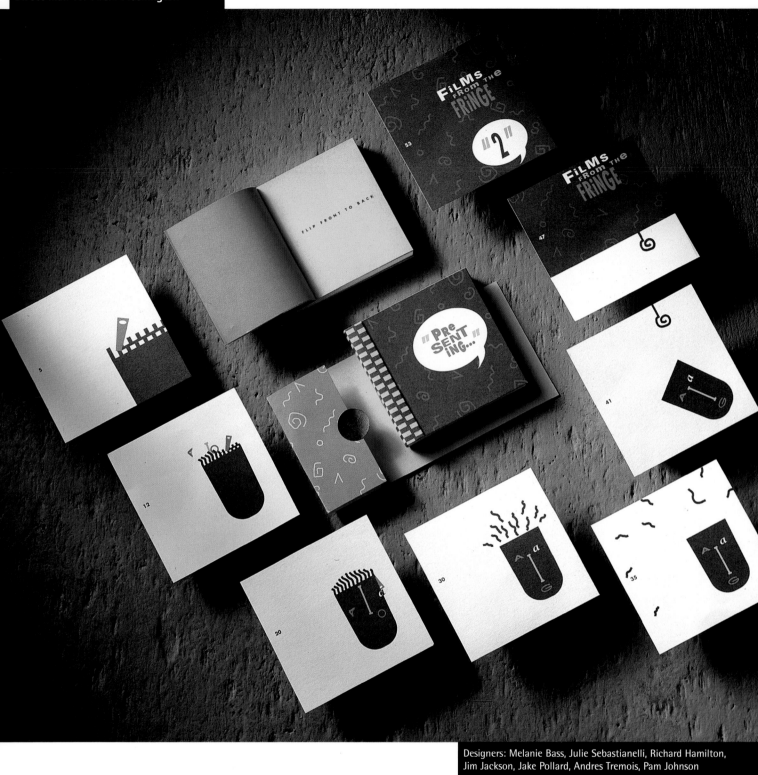

Designers: Melanie Bass, Julie Sebastianelli, Richard Hamilton, Jim Jackson, Jake Pollard, Andres Tremois, Pam Johnson

A flip book was created to promote an animated film festival for the AIGA Washington: Opening pages create a kind of title sequence with type, while the remaining pages establish a whimsical mood with type and squiggly hair that dances off the page.

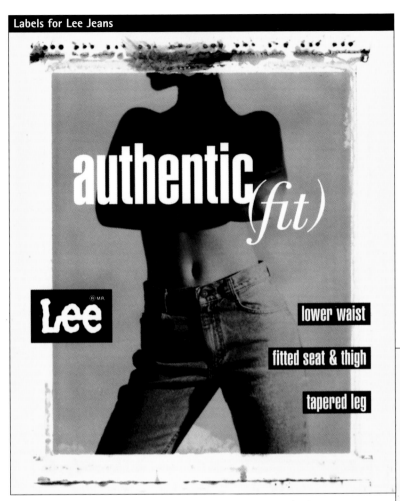

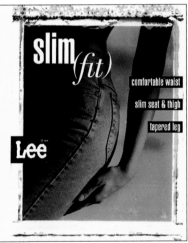

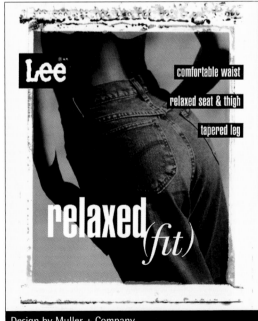

These labels for Lee Jeans present the differences in styles with parentheses around the word "fit" for added emphasis. The use of shadowy, uncropped photography adds a certain edge.

Design by Muller + Company
Designer: David Schultz
Art Director: John Muller
Photographer: Mike Regnier

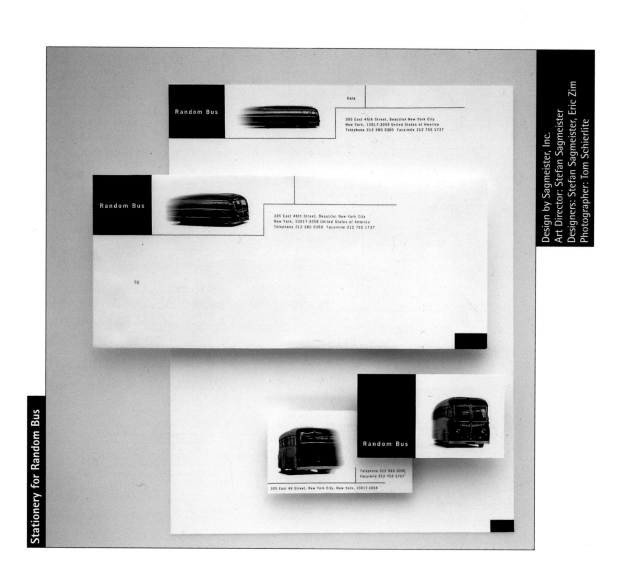

Design by Sagmeister, Inc.
Art Director: Stefan Sagmeister
Designers: Stefan Sagmeister, Eric Zim
Photographer: Tom Schierlite

Stationery for Random Bus

Whimsy and fun zoom across letterhead for Random Bus, with an image of a toy bus doctored up in Photoshop. The sense of movement continues with rules and type that fall horizontally across the page.

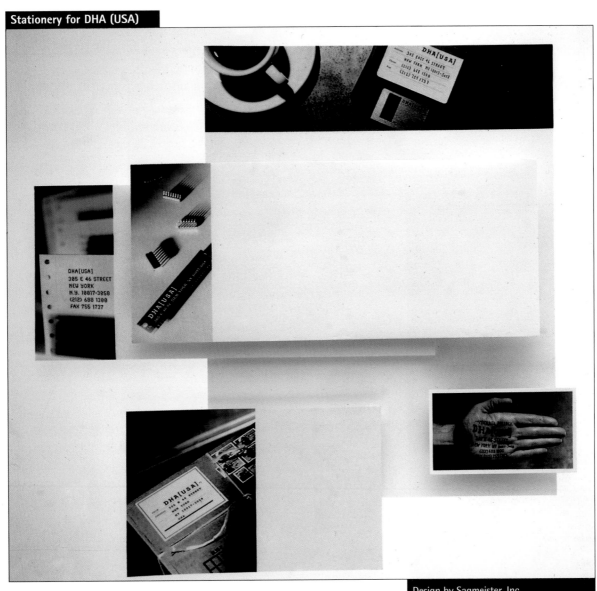

Design by Sagmeister, Inc.
Art Director/Designer: Stefan Sagmeister
Photographer: Tom Schierlite

An unusual photographic approach was taken for the letterhead design for DHA (USA). Elements in the photographs instantly communicate the high-tech business's focus with shots of computer-related tools of the trade. Necessary copy is cleverly incorporated into the images themselves.

CARHARTT JACKET
at BLUE ös 1.598,-

BLUE Clothing
in Dornbirn, Marktplatz
Bregenz, Bahnhofstraße
und Feldkirch, Marktgasse

Blue Posters

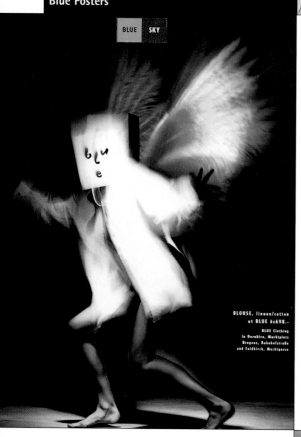

BLOUSE, linnen/cotton
at BLUE ös698.-

BLUE Clothing
in Dornbirn, Marktplatz
Bregenz, Bahnhofstraße
und Feldkirch, Marktgasse

The solution was in the bag for clothing retailer Blue: It allowed the designers to use friends to model the clothing on a limited budget, as well as promoting the line as being fun to wear.

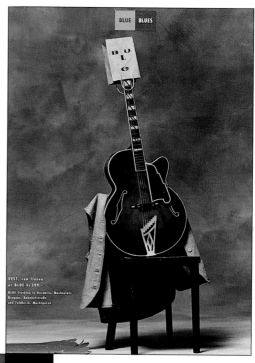

VEST, raw linnen
at BLUE ös 399,-

BLUE Clothing in Dornbirn, Marktplatz
Bregenz, Bahnhofstraße
und Feldkirch, Marktgasse

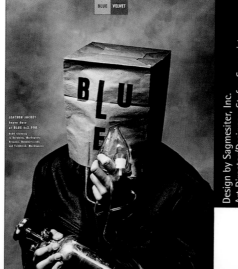

LEATHER JACKET
happy days
at BLUE ös2.598,-

BLUE Clothing
in Dornbirn, Marktplatz
Bregenz, Bahnhofstraße
und Feldkirch, Marktgasse

Design by Sagmeister, Inc.
Art Director/Designer: Stefan Sagmeister
Photographer: Tom Schierlitz

Graffito/Active8 Web site

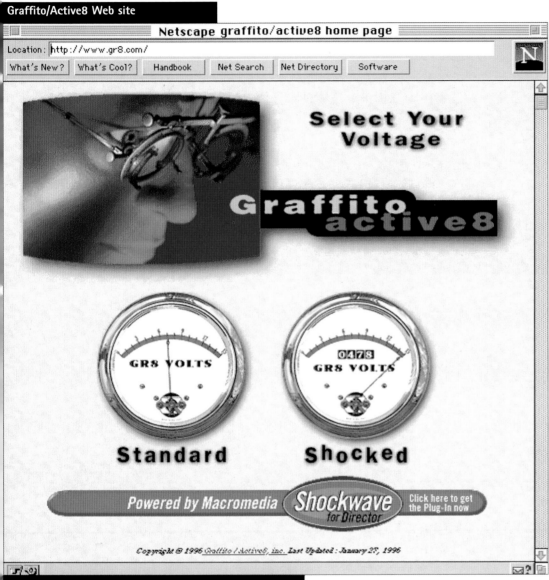

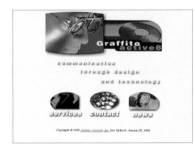

Design by Graffito/Active8
Designers: Tim Thompson, Jon Majerik
Illustrator: Josh Field
Programmer: Jon Majerik
Photographers: Ed Whitman, Taran Z., Michael Northrup

This Web site for Graffito/Active8 eschews the typical visual clutter so often found on the Internet for a clean, easy-to-navigate format that is highly graphical. Type is kept at a minimum to allow the design studio's work to speak for itself.

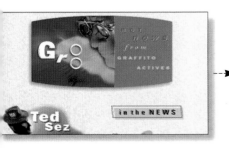

Dear Food Lovers,

Chinese New Year is coming up soon. Why not make a special New Year's Feast? We provide two recipes in the Quick Cook section of What's Cooking.

Our Valentine's Day feature in the Market Basket section of Fresh this Week offers heart-healthy tips for year-round cooking.

And don't forget to fill out a Feedback form if you haven't yet done so. We value input from you about your cooking habits to guide us in recipe selection for our site. It's especially important to hear from you this week, because next week we'll be changing our questions to focus on bread machines.

If you've sent an e-mail to us and haven't heard back, please be patient, because we are swamped with requests right now, but we do answer every e-mail question Also, please be sure your e-mail address is correct when you send your question. We've had a number of our responses returned because of faulty addresses.

Happy Chinese New Year!

What to cook? What to eat? An age-old problem. Check out these solutions.

 Ketchum Cookbook

We're building a cookbook! Here you'll find deliciously easy appetizers; bread machine bread that tastes as good as grandma's; main dishes made in minutes; good things to grill; tantalizing, deceptively lowfat desserts... More tempting recipes will be added continually to this database.

 Quick Cook

Fast and good. These recipes help meet the dinnertime crunch. Even if you left work late.

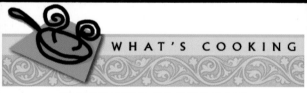

KETCHUM COOKBOOK

 Here's a library of our favorite recipes. Search by recipe category or by key ingredient. Keep your key ingredient general (to find steak, search beef; to find potatoes, search vegetables). Or browse through the whole collection.

Search by Category.....................
```
Appetizers
Breads
Cakes
Condiments
```
Find

What to cook? What to eat? An age-old problem. Check out these solutions.

Ketchum Cookbook

We're building a cookbook! Here you'll find deliciously easy appetizers; bread machine bread that tastes as good as grandma's; main dishes made in minutes; good things to grill; tantalizing, deceptively lowfat desserts... More tempting recipes will be added continually to this database.

Quick Cook

What's fresh, what's hot, what's happening? Here's the place to find out.

Celebrity Chef

Who's making food news? Who's influencing what we buy and how we eat? Meet our guest

Market Basket

CELEBRITY CHEF

Gary Danko started cooking when he was six. And he hasn't stopped since. Today, he is chef of The Dining Room at the elegant Ritz-Carlton, San Francisco, preparing fabulous dishes that have won him many accolades, including the James Beard Best American Chef: California, award last spring. As a child, Gary's first culinary adventures began with Betty Crocker cookbooks. Today, this French-trained chef wins critical acclaim from national wine and food critics. Gary shares a recipe for Grilled Beef with Dried Tomatoes and Artichoke Hearts, which he has adapted for home

Design by Red Dot Interactive
Creative Director: Judith Banning

Ketchum Kitchen's Web site puts a homey face on a division of this large advertising and public-relations firm. The site is a working test kitchen, with recipes and cooking tips. A cozy-kitchen atmosphere is created with casual line drawings of steaming coffee cups and sizzling pans; scrolled and floral backgrounds evoke a kitchen-wallpaper touch.

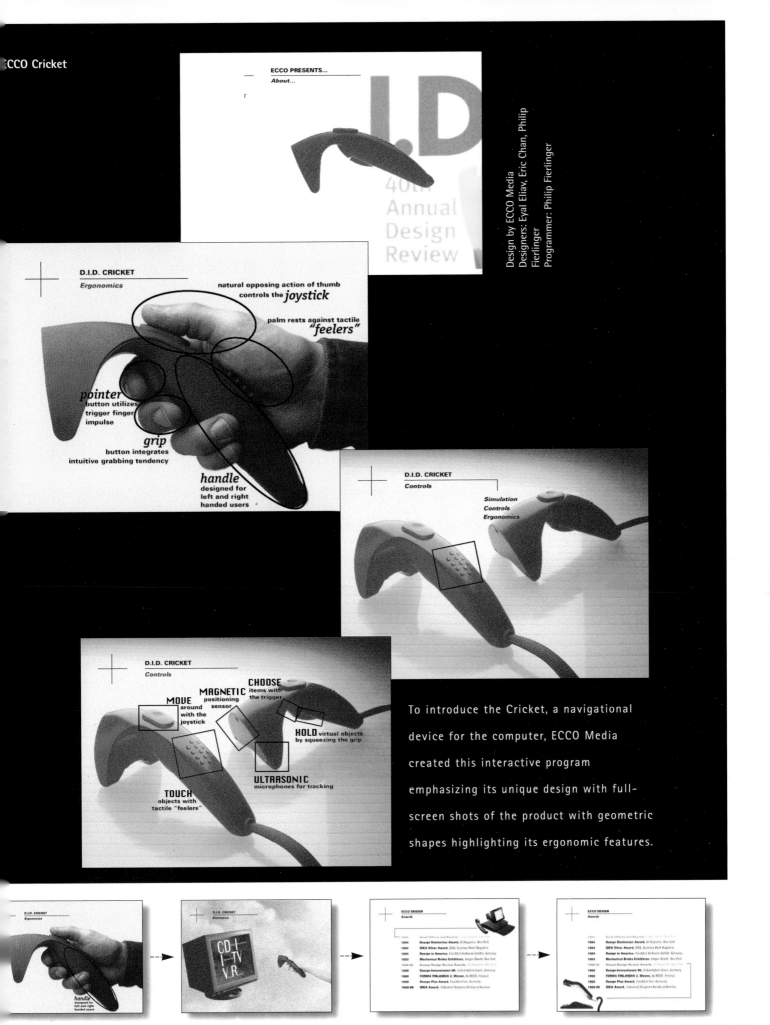

ECCO PRESENTS...
About...

I.D
40th
Annual
Design
Review

Design by ECCO Media
Designers: Eyal Eliav, Eric Chan, Philip Fierlinger
Programmer: Philip Fierlinger

D.I.D. CRICKET
Ergonomics

natural opposing action of thumb controls the *joystick*

palm rests against tactile *"feelers"*

pointer button utilizes trigger finger impulse

grip button integrates intuitive grabbing tendency

handle designed for left and right handed users

D.I.D. CRICKET
Controls

Simulation
Controls
Ergonomics

D.I.D. CRICKET
Controls

MOVE around with the joystick

MAGNETIC positioning sensor

CHOOSE items with the trigger

HOLD virtual objects by squeezing the grip

TOUCH objects with tactile "feelers"

ULTRASONIC microphones for tracking

To introduce the Cricket, a navigational device for the computer, ECCO Media created this interactive program emphasizing its unique design with full-screen shots of the product with geometric shapes highlighting its ergonomic features.

D.I.D. CRICKET
Ergonomics

handle designed for left and right handed users

D.I.D. CRICKET
Simulation

CD
I
TV
VR

ECCO DESIGN
Awards

ECCO DESIGN
Awards

The use of subtle graphic wit conveys the design sensibilities of Primo Angeli's design firm on its Web site. The home page is organized with simple graphic icons to steer users to areas of interest. Other pages use a dramatic black-and-white format with logos and borders highlighted in red.

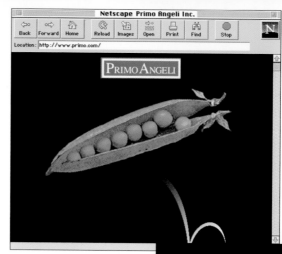

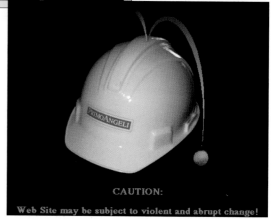

CAUTION:
Web Site may be subject to violent and abrupt change!

Web site for Primo Angeli Inc.

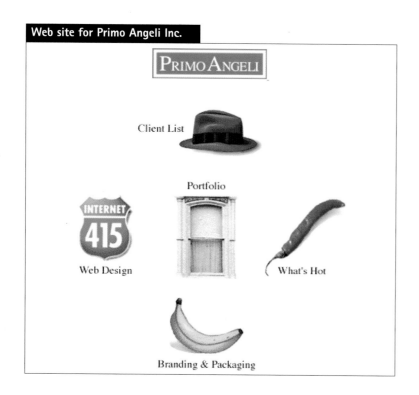

PRIMO ANGELI

Client List

Portfolio

INTERNET
415
Web Design

What's Hot

Branding & Packaging

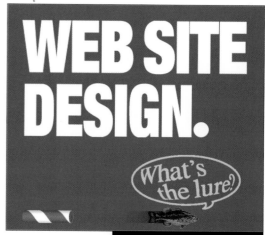

WEB SITE DESIGN.

What's the lure?

WEB DESIGN

On the ocean that comprises the Internet, powerful signals and memorable messages are the best lures for fishing.

Design by Primo Angeli, Inc.
Creative Director: Primo Angeli
Art Directors: Primo Angeli, Brody Hartman
Designers: Philippe Becker, Dom Moreci
Illustrator: Mark Jones
Programmer: Dom Moreci

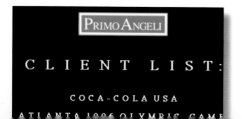

PRIMO ANGELI

CLIENT LIST:

COCA-COLA USA
ATLANTA 1996 OLYMPIC GAME

ATLANTA

Henry Weinhard's
Root Beer

BROWN & HALL

Soul Coughing Interactive press kit for Warner Bros. Records

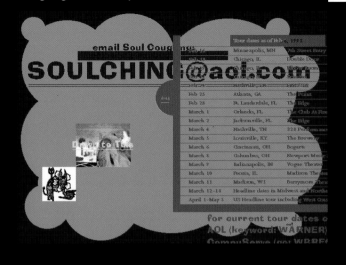

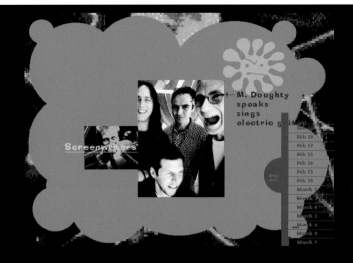

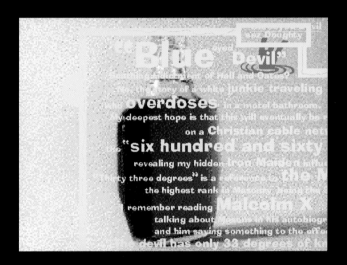

Design by Aufuldish & Warinner
Art Director: Bob Aufuldish; Kim Biggs (Warner Bros. Records)
Creative Director: Jeri Heiden (Warner Bros. Records)
Programmer: Bob Aufuldish

This interactive press kit for the rock band Soul Coughing employs an irreverent, upbeat style created through the use of amorphic background shapes, jarring color combinations, and highly pixellated images.

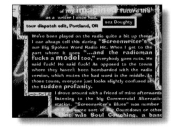

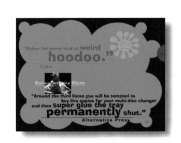

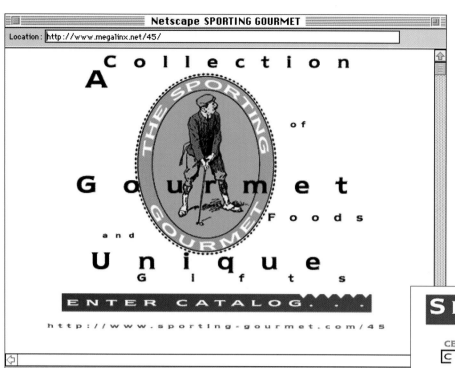

Catalog for Sporting Gourmet

An online catalog for the Sporting Gourmet employs an easy to navigate format to direct viewers to a wide range of gift items. The design employs an ample use of white space, with product categories called out in colored type. The long vertical page format reduces the number of necessary links.

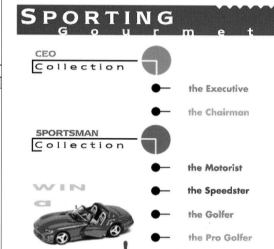

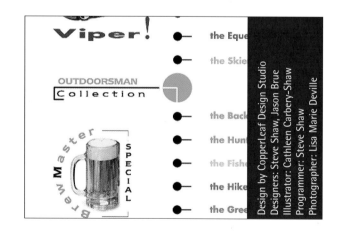

Design by CopperLeaf Design Studio
Designers: Steve Shaw, Jason Brue
Illustrator: Cathleen Carbery-Shaw
Programmer: Steve Shaw
Photographer: Lisa Marie Deville

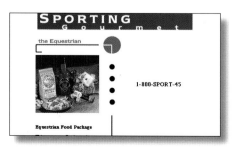

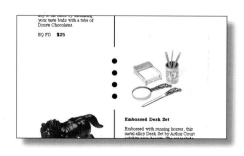

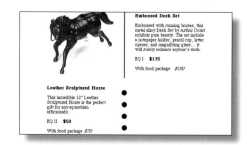

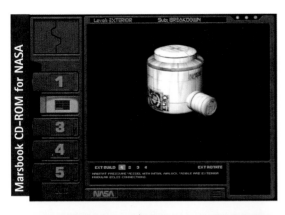

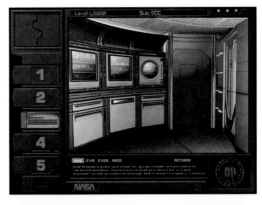

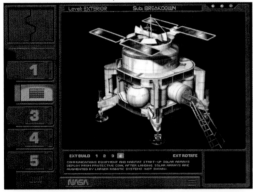

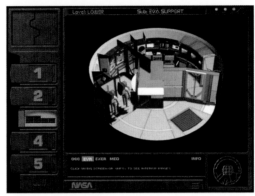

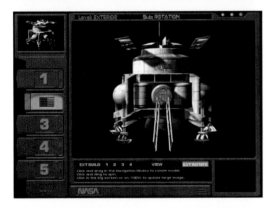

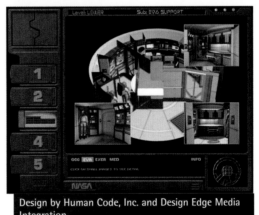

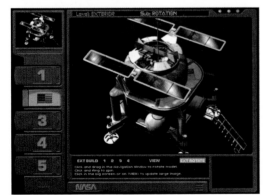

Design by Human Code, Inc. and Design Edge Media Integration
Designers: Chipp Walters, Lindsay Gupton, Reed McCullough, Nathan Moore, David Gutierrez
Programmer: Gary Gattis

Screens within this complex and highly detailed interface for *Marsbook CD*, produced for NASA as a guide to its Initial Planned Mars Habitat, has the appearance of a futuristic space control panel, with beveled matte-gray control buttons, black background, and illuminated type.

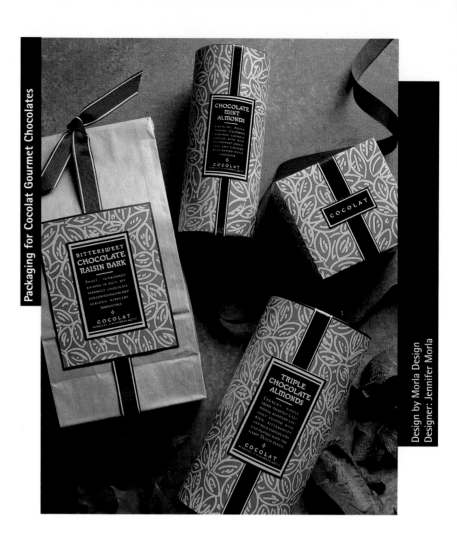

Design by Morla Design
Designer: Jennifer Morla

Labels and tubes illustrated with a abstract leaf pattern, affixed with pastel-toned labels and printed on tactile recycled paper stock give packages for Cocolat chocolates an upmarket yet homey image. A black ribbon adds a sophisticated touch.

Packaging for Converse sneakers

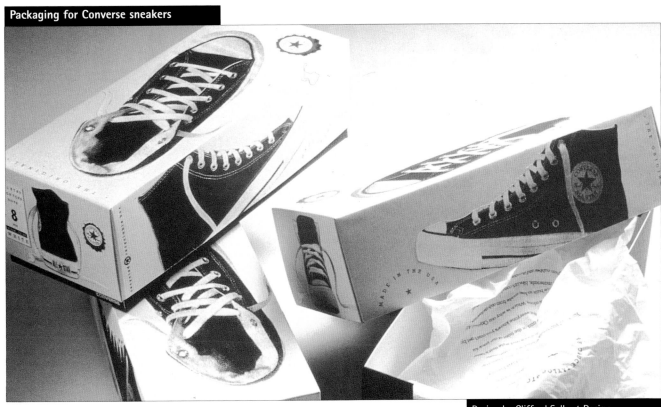

Design by Clifford Selbert Design
Art Director: Clifford Selbert
Designers: Melanie Lowe, Linda Kondo

These boxes for Converse sneakers humorously play with perspective: The outside of the boxes hint at their contents by showing the images of the shoes shot from the front, back, top and sides.

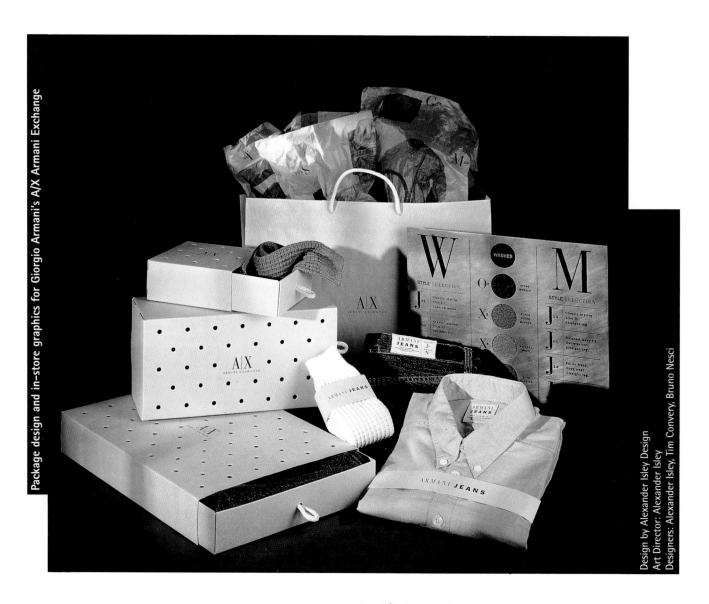

Design by Alexander Isley Design
Art Director: Alexander Isley
Designers: Alexander Isley, Tim Convery, Bruno Nesci

For A/X Armani Exchange, designer Alexander Isley reflects the stores' minimalist interiors with his package designs and in-store graphics that have an industrial edge: Gift boxes have die-cut perforations and shopping bags sport handles made of rope.

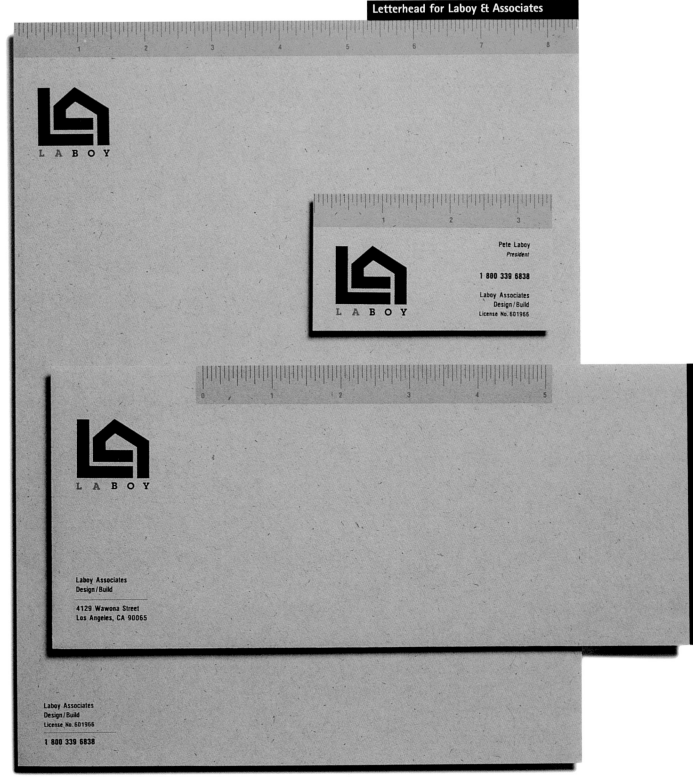

Design by Adele Bass & Company
Designer: Adele Bass

Sometimes simplicity is best: Stationery for Laboy edged
in a ruler instantly identifies this company's interests in
construction. A logo designed to look like a house
cements the image.

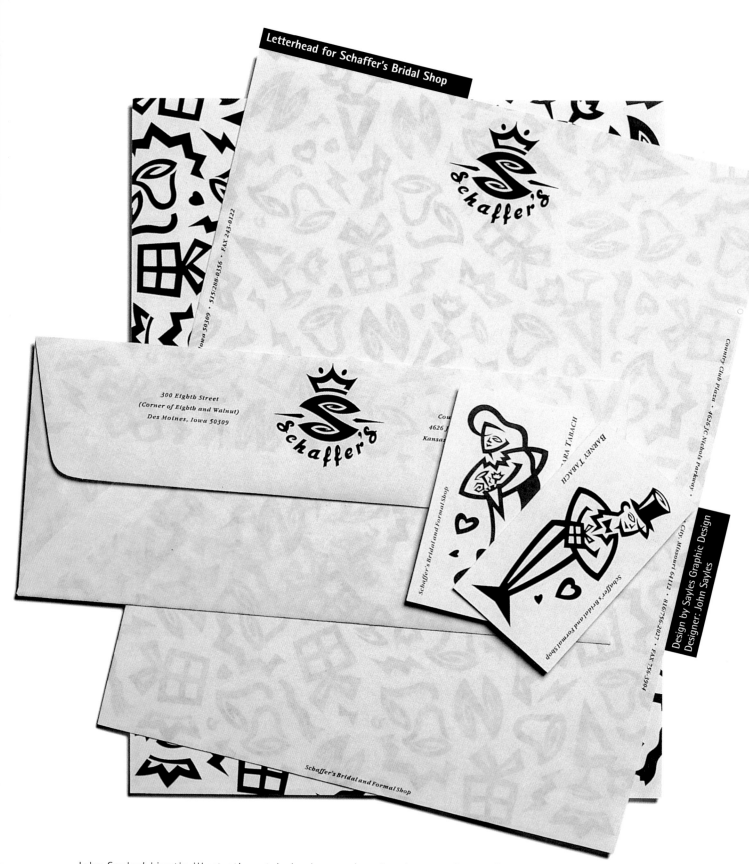

Letterhead for Schaffer's Bridal Shop

Schaffer's

300 Eighth Street
(Corner of Eighth and Walnut)
Des Moines, Iowa 50309

Schaffer's Bridal and Formal Shop

Design by Sayles Graphic Design
Designer: John Sayles

John Sayles' kinetic illustration style lends a modern touch to stationery for this
bridal and formal-wear shop. The background design of printed pieces is composed
of a jumble of nuptial symbols, such as wedding bells, gift boxes, and tiny hearts.

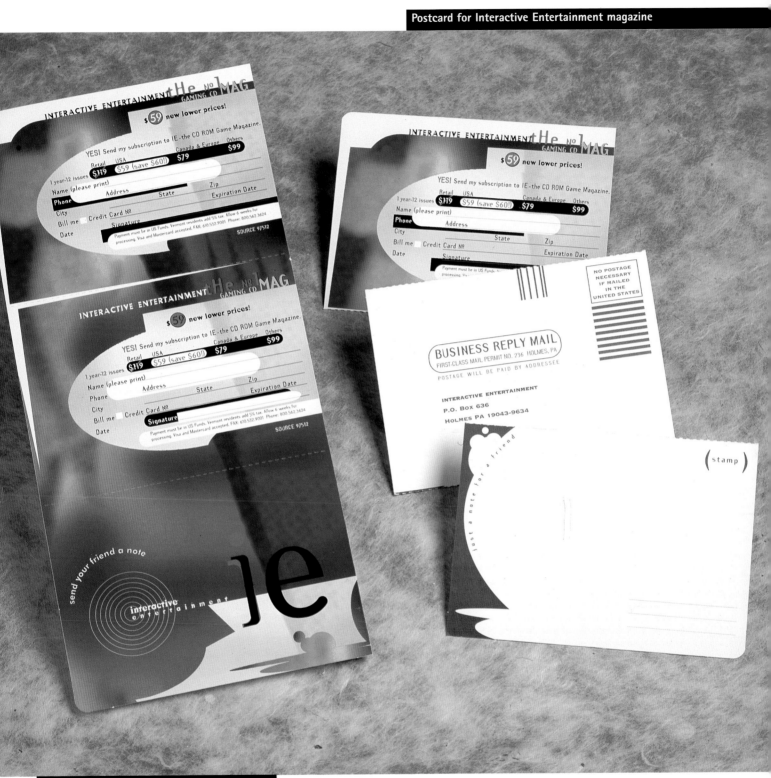

Design by Ida Cheinman, Rick Salzman

Subscription cards for a CD-ROM computer gaming publication emulate the computer-screen environment with a format that feels as though the reader is scrolling through content. The appearance of three-dimensional, floating letterforms and text set in amorphic shapes add to the free-flowing experience.

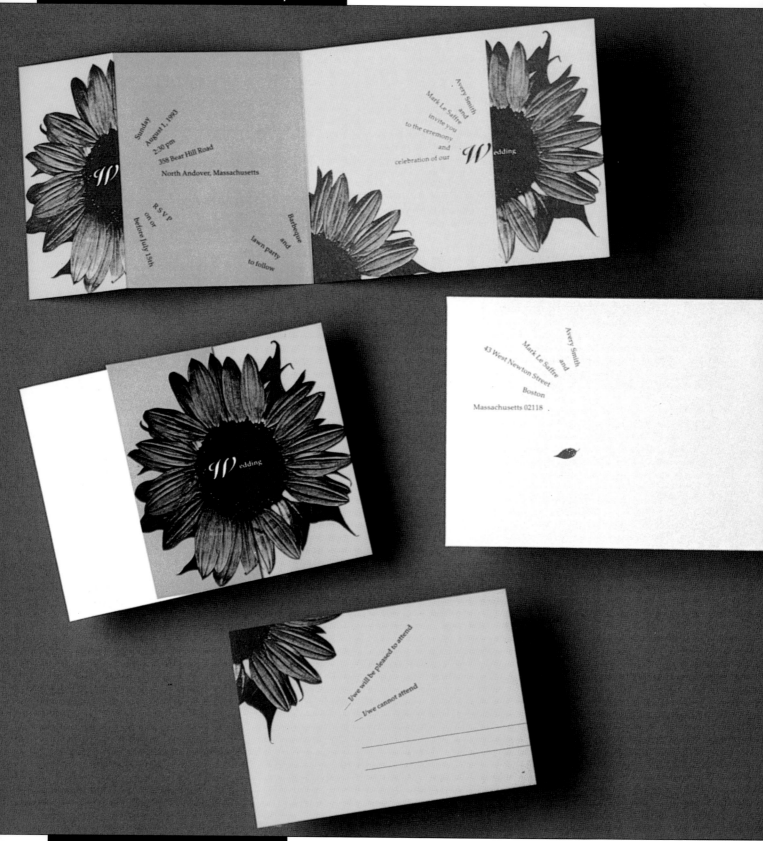

Design by Laughlin/Winkler, Inc.
Art Directors/Designers: Mark Laughlin, Ellen Winkler

This wedding invitation captures both the essence of summer and the casual spirit of the event itself with a sunflower motif with petals replaced by lines of copy. The theme is hinted at on the envelope with splayed type and a single petal.

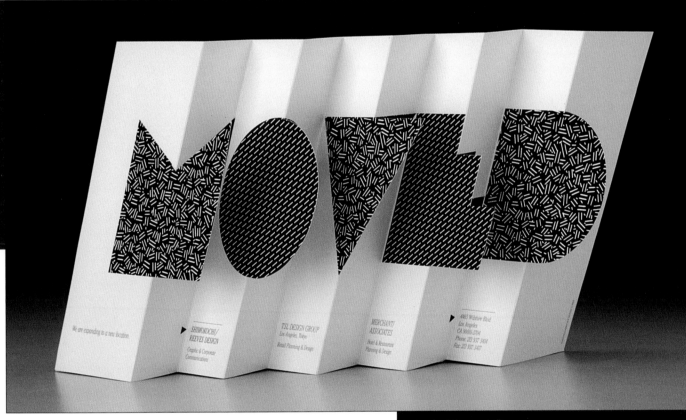

Design by Shimokochi/Reeves
Art Directors/Designers: Mamoru Shimokochi, Anne Reeves

Italic letterforms are often used to convey motion, but in this moving

announcement, the card itself is fashioned to be a tilting parallelogram.

The accordion pleats humorously emphasize the design firm's expansion.

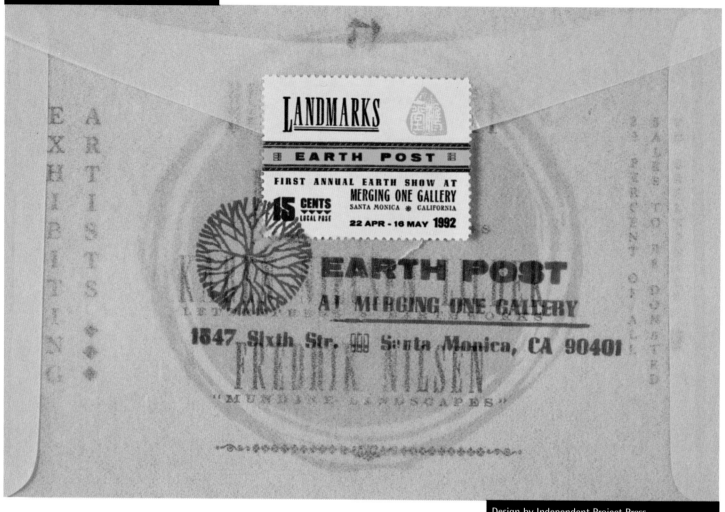

Design by Independent Project Press
Art Directors/Designers: Bruce Licher, Karen Licher
Photographer: Bruce Licher

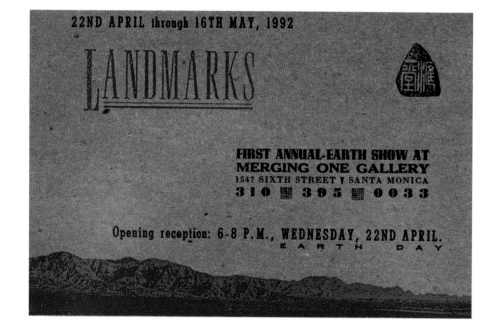

This vellum envelope subtly reveals the invitation that awaits inside to an Earth Day art exhibit. The message of environmental preservation is carried out with earth-toned inks printed on chipboard using a letterpress.

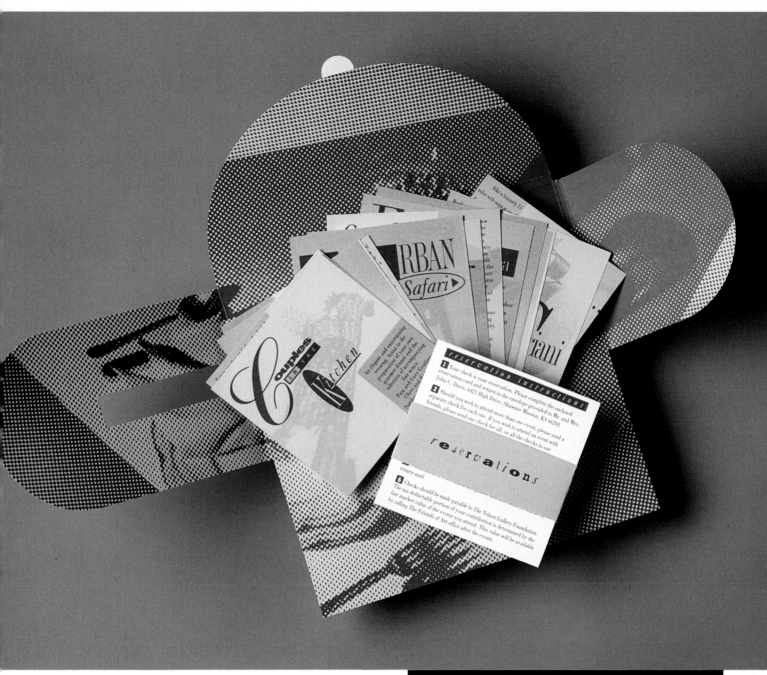

Design by Muller + Company
Art Director: John Muller
Designer/Photographer: Peter Corcoran

Invitation for Kansas City Art Institute

For the Couples in the Kitchen fund-raising dinner series, Muller + Company created an envelope that folded like a cloth napkin, with halftone images of a table setting. Inside, a stack of cards designed with screened images of food and drink describe individual events.

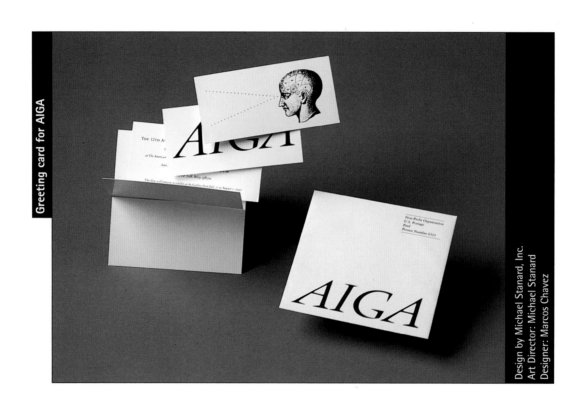

Greeting card for AIGA

Design by Michael Stanard, Inc.
Art Director: Michael Stanard
Designer: Marcos Chavez

An antique medical drawing illustrating
the portion of the brain controlling
vision is used to announce an exhibit for
the American Institute of Graphic Arts
while maintaining the professional
society's clean, classic identity.

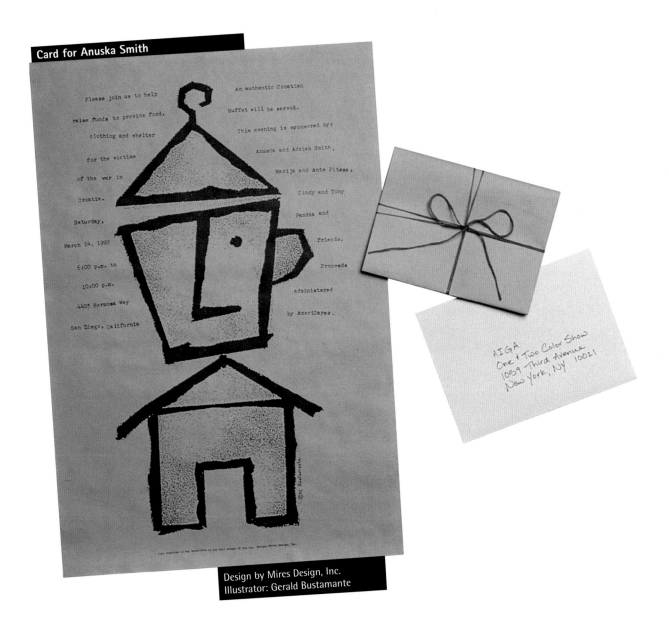

Card for Anuska Smith

Please join us to help raise funds to provide food, clothing and shelter for the victims of the war in Croatia.

Saturday, March 14, 1992

6:00 p.m. to 10:00 p.m.

4405 Hermosa Way

San Diego, California

An authentic Croatian buffet will be served.

This evening is sponsored by:

Anuska and Adrien Smith,

Marija and Ante Piteas,

Cindy and Tony Pandza and friends.

Proceeds administered by AmeriCares.

Design by Mires Design, Inc.
Illustrator: Gerald Bustamante

AIGA
One & Two Color Show
1059 Third Avenue
New York, NY 10021

A fund-raiser for victims of the Croatian war is poignantly announced with an illustration that pulls together the elements of food, clothing, and shelter to create a touching anthropomorphic image. The use of a typewriter font and simple paper stock conveys the charitable spirit.

Card for Greater Cincinatti Tall Stacks Commission, Inc.

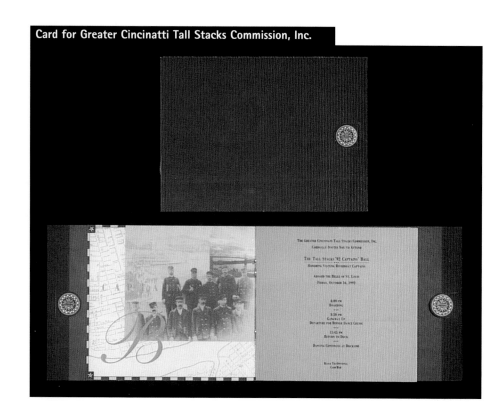

This invitation to the Tall Stacks Captains Ball in Cincinnati pays tribute to nineteenth-century high society with a fold-out sepia-toned format that incorporates alternating vintage images of riverboats and social events. An antique map and compass add additional nautical touches.

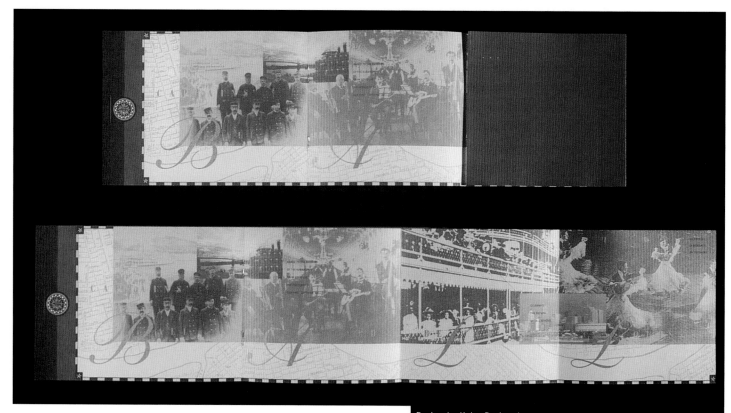

Design by Kolar Design, Inc.
Designers: Kelly Kolar, Deborah Vatter, Vicky Zwissler

Design by Mires Design, Inc.
Art Director/Designer: José Serrano

A woodcut illustration in the muscular WPA style is the centerpiece of this rowing regatta announcement. The elongated letters used in the title reflect long rowing oars.

Christmas card for Rickabaugh Graphics

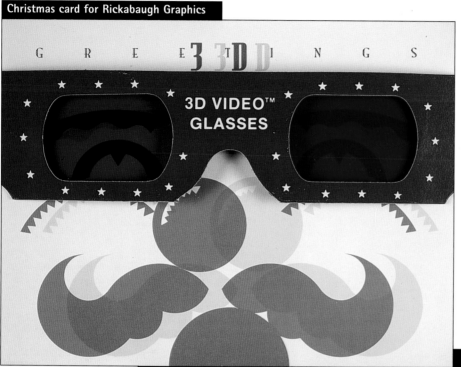

Design by Rickabaugh Graphics
Designer: Mark Krumel
Illustrator: Tony Meuser

Hoping to raise the spirits of its clients, Rickabaugh Graphics mailed a 3-D holiday card, complete with special glasses. In boldface type the studio reveals the three *D*s it wishes for the season: "dazzling," "delightful," and "delicious."

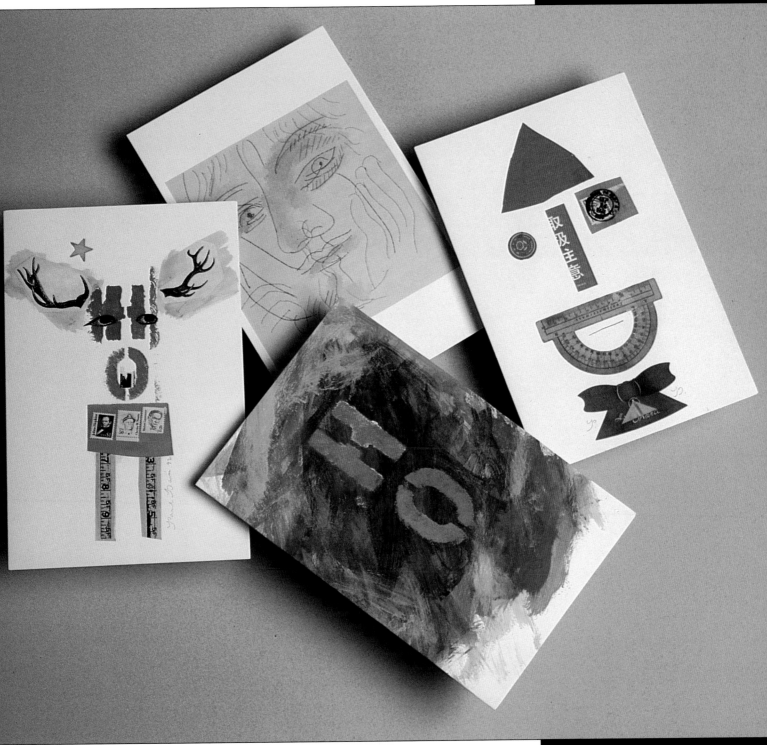

Design by Paul Davis Studio
Designer: Paul Davis

Paul Davis' distinctive illustration style is revealed in four holiday cards that display his understated humor and interest in myriad techniques and media, including collage, painting, and pastels.

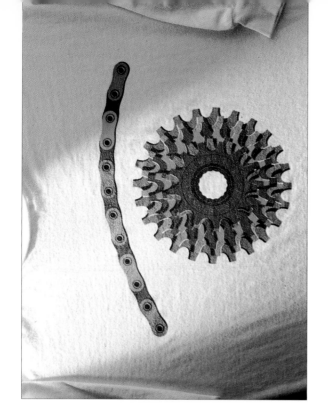

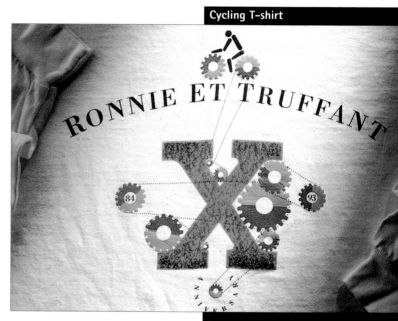

Design by Hornall Anderson Design Works
Art Director: Jack Anderson
Designer: Julie Keenan
Illustrators: Julie Keenan, John Anicker

To commemorate the tenth anniversary of a cycling event, a T-shirt with a motif based on cycling mechanisms was created: The number *10* is fashioned from multicolored gears and a section of chain in one example, while gears provide a decorative element on another. For the following year, the number *11* was represneted with bicycle pumps.

The unrefined lettering, imperfect color trapping, and overall cut-and-paste appearance of this layout helps create an edgy look for a snowboard client marketing to young adults.

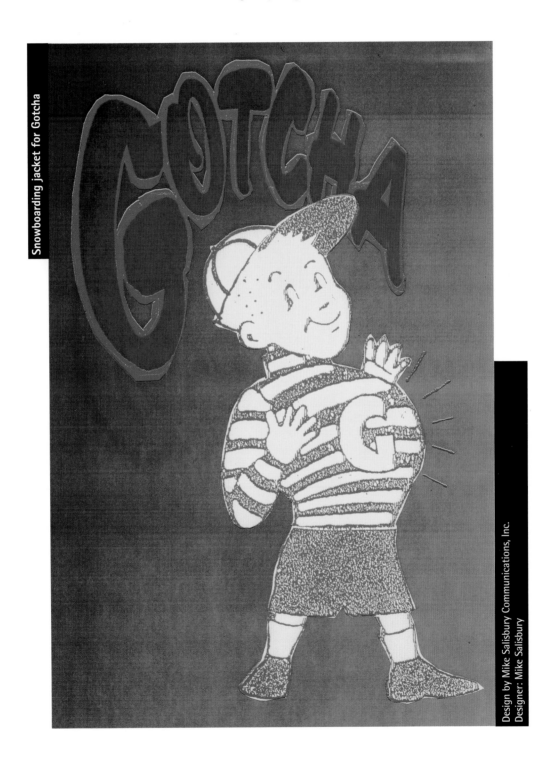

Snowboarding jacket for Gotcha

Design by Mike Salisbury Communications, Inc.
Designer: Mike Salisbury

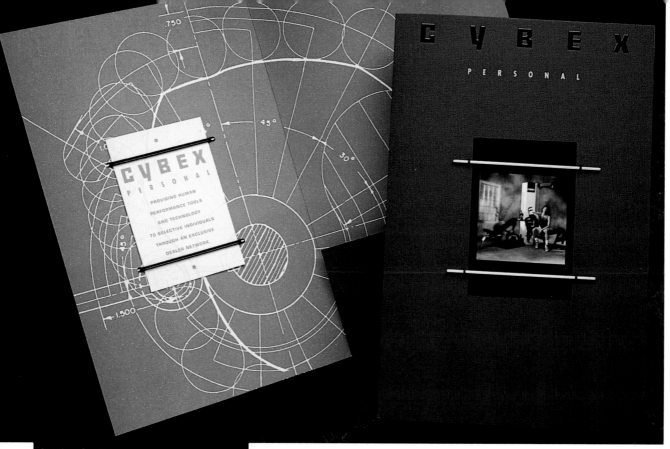

Catalog for Cybex

Strength, performance, and beauty are emphasized in this catalog for fitness equipment. The parallel bars framing the cover image symbolize barbells, and an architectural drawing inside demonstrates the trajectory of the weight machines. Painterly images of fine physiques attest to the product's effectiveness.

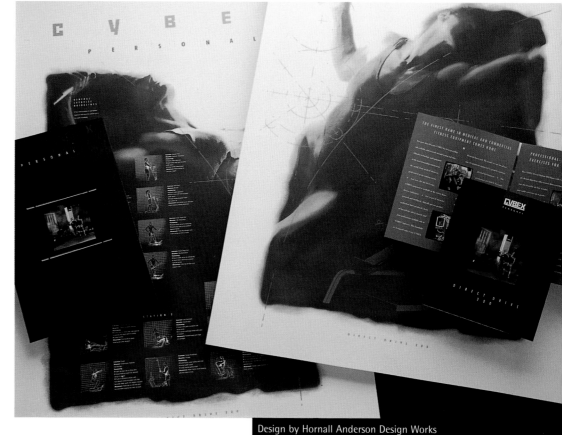

Design by Hornall Anderson Design Works
Art Director: Jack Anderson
Designers: Jack Anderson, David Bates, Jeff McClard, Julie Keenan

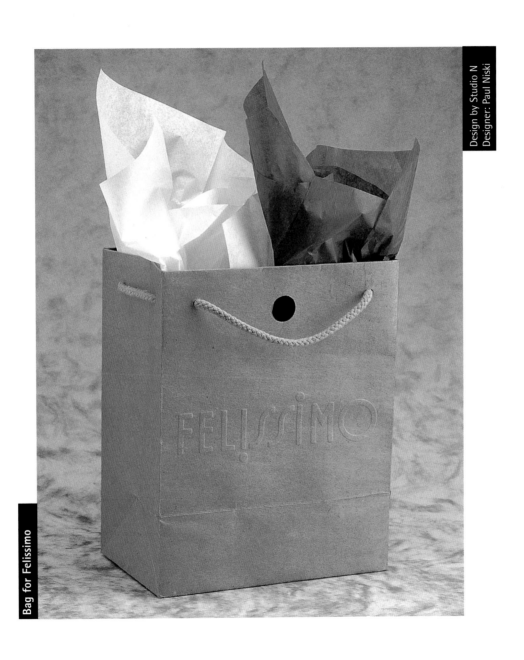

Design by Studio N
Designer: Paul Niski

Bag for Felissimo

To promote Felissimo, an eclectic upscale New York department store, Studio N designed an understated shopping bag with sturdy rope handles and an embossed store logo with a flopped letter *l*.

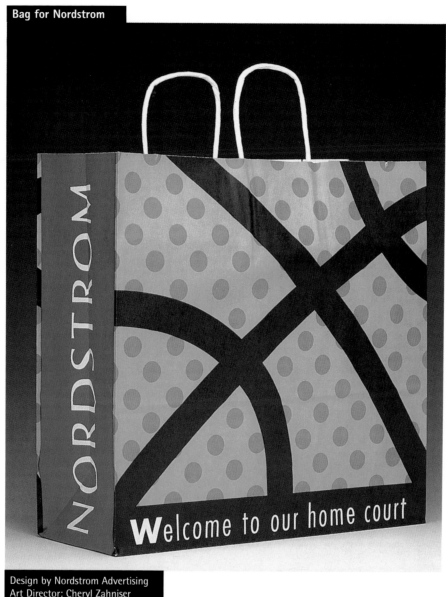

Bag for Nordstrom

NORDSTROM

Welcome to our home court

Design by Nordstrom Advertising
Art Director: Cheryl Zahniser
Designer/Illustrator: Eric Bay

To illustrate an in-store promotion for the
National Collegiate Athletic Association's
Final Four basketball tournament, Nordstrom
Advertising produced a shopping bag with an
upbeat, abstract design based on a close-up
perspective of a basketball's seams.

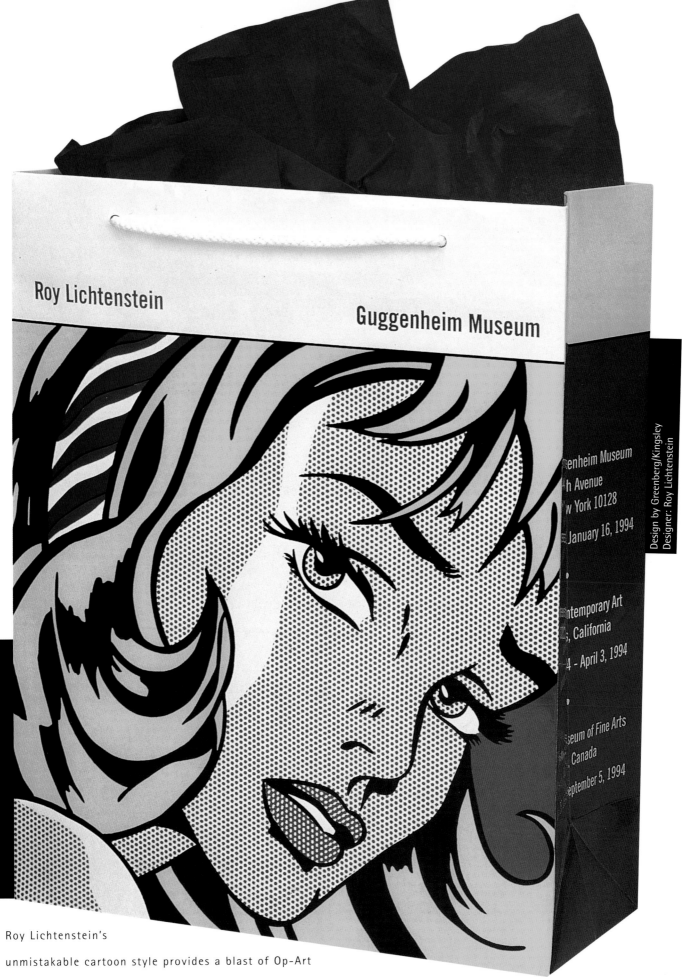

Roy Lichtenstein

Guggenheim Museum

Bag for Guggenheim Museum, Roy Lichtenstein

...genheim Museum
...h Avenue
...w York 10128

...January 16, 1994

...ntemporary Art
..., California

...4 - April 3, 1994

...seum of Fine Arts
... Canada

...September 5, 1994

Design by Greenberg/Kingsley
Designer: Roy Lichtenstein

Roy Lichtenstein's

unmistakable cartoon style provides a blast of Op-Art

color on this shopping bag prepared in conjunction with an exhibit at New York's

Guggenheim Museum.

The trompe l'oeil relief of parcels
appearing on bags for Le Central adds a
winsomely subtle counterpoint to the
sophisticated logo design on the flip side.

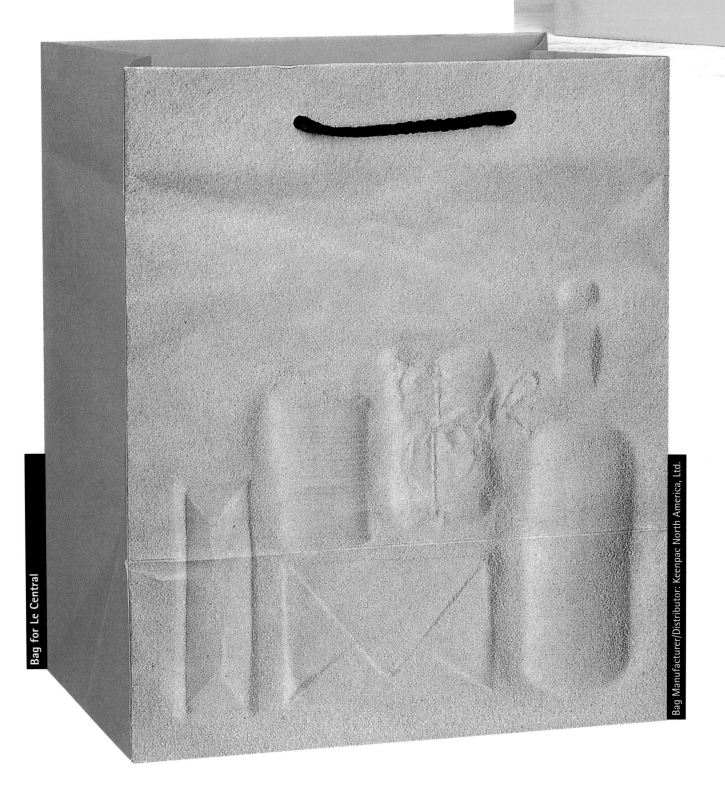

Bag for Le Central

Bag Manufacturer/Distributor: Keenpac North America, Ltd.

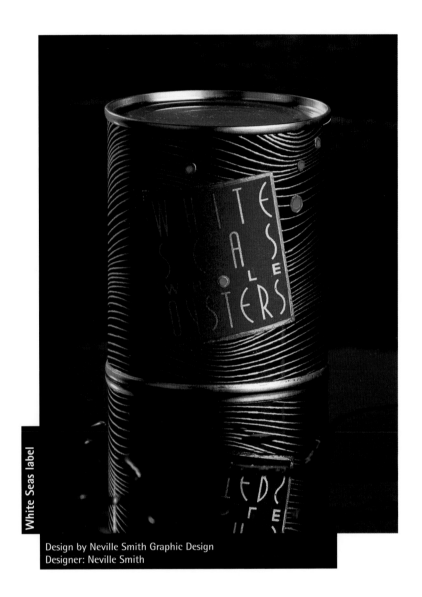

White Seas label

Design by Neville Smith Graphic Design
Designer: Neville Smith

The waves on these labels for gourmet canned oysters bring out the product's fresh qualities, while touches of royal red, purple, and gold give the packaging an upscale image.

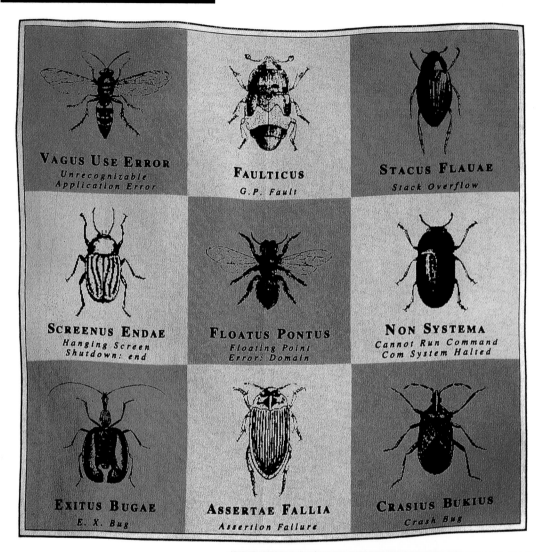

VAGUS USE ERROR
*Unrecognizable
Application Error*

FAULTICUS
G.P. Fault

STACUS FLAUAE
Stack Overflow

SCREENUS ENDAE
*Hanging Screen
Shutdown: end*

FLOATUS PONTUS
*Floating Point
Error: Domain*

NON SYSTEMA
*Cannot Run Command
Com System Halted*

EXITUS BUGAE
E. X. Bug

ASSERTAE FALLIA
Assertion Failure

CRASIUS BUKIUS
Crash Bug

Design by Charney Design
Designer: Carol Inez Charney

T-shirts created for beta testers of C++ spoof the many forms of
computer bugs with images of insects and humorously fake Latin
names relating to software errors.

Design by Val Gene Associates
Art Director: Lacy Leverett

This menu design for the Pepperoni Grill is a delicious exercise in baroque excess, with cupids and highly ornamental patterns in jewel tones. The tall, condensed restaurant logo adds a contemporary touch.

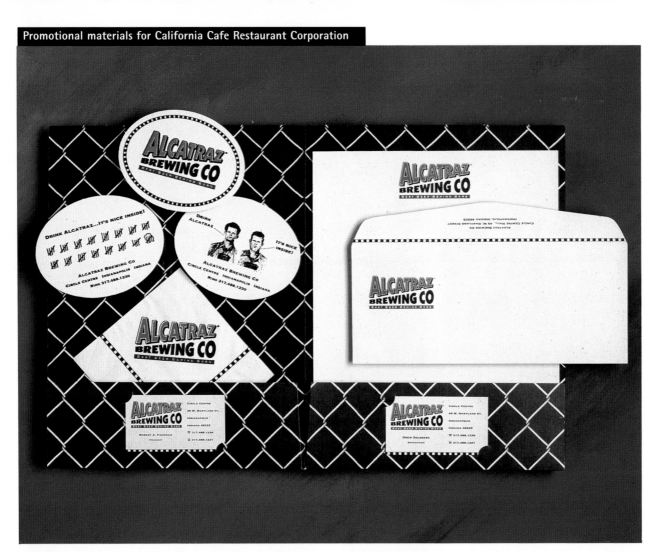

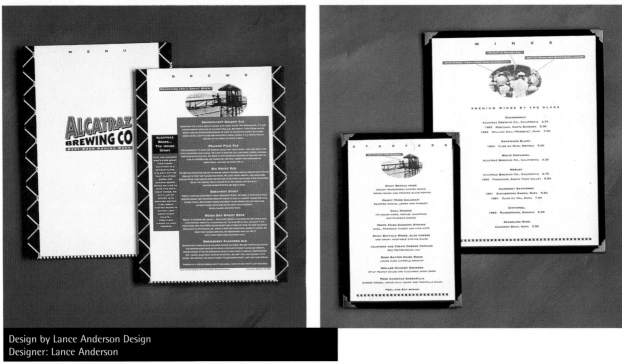

Design by Lance Anderson Design
Designer: Lance Anderson

This identity program for Alcatraz Brewing Company raises a frosty mug to the fabled island jail with a chain-link fence motif accenting folders and menus. The skewed perspective of the three-dimensional logo lettering pays tribute to a 1950s prison escape movie.

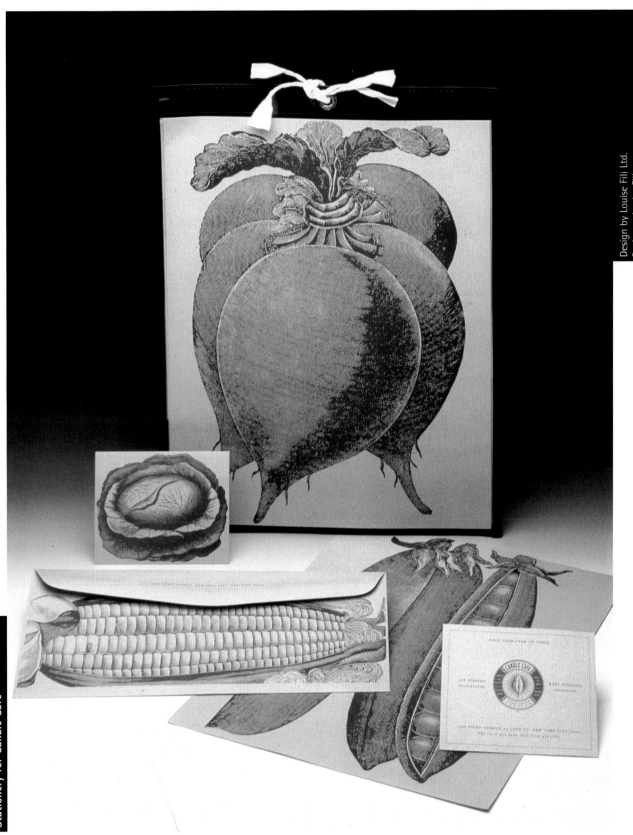

Design by Louise Fili Ltd.
Designer: Louise Fili

Stationery for Candle Cafe

The freshness of the food served at the Candle Cafe is emphasized

in print pieces illustrated with highly detailed images from a

vintage seed catalog.

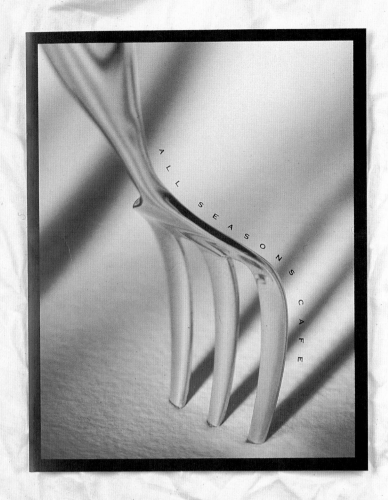

A L L S E A S O N S C A F E

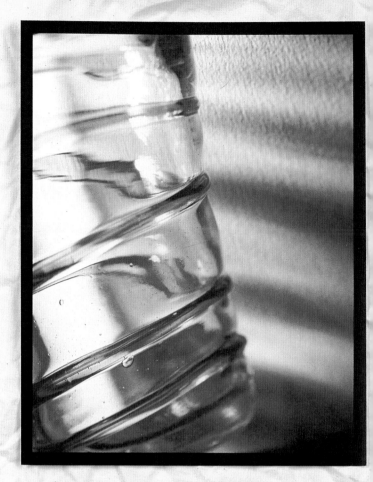

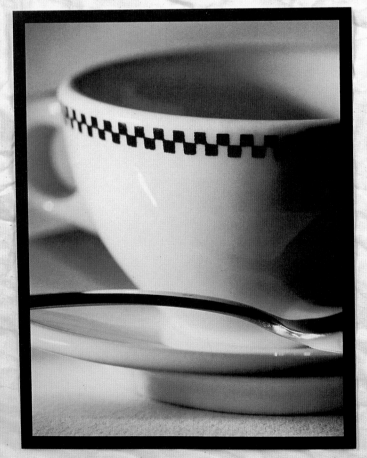

The spirit of the wild west stampedes across this menu design for the Disney-operated Crockett's Tavern, with its wood-grain cover, background images of hunting and exploring and touches of leather and wood. A paper coonskin cap completes the childhood fantasy.

Menu for Crockett's Tavern

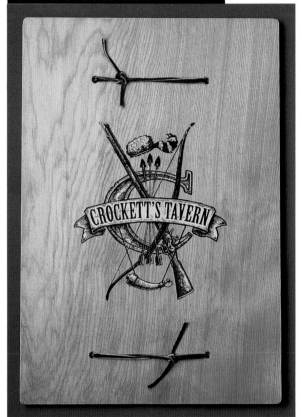

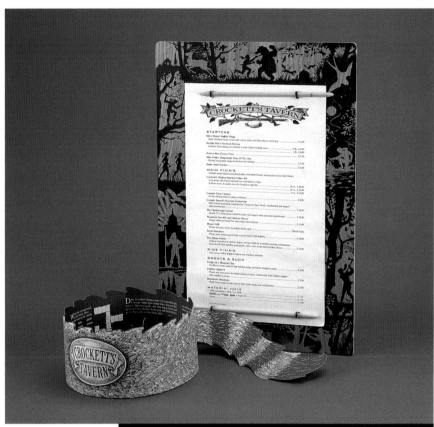

Design by Disney Design Group
Art Directors: Jeff Morris, Renée Schneider
Designers: Thomas Scott, Michael Mohjer
Illustrator: Michael Mohjer

enu for Hyatt Hotels Corp.

Menus for the All Seasons Cafe, with their pure, sensuous photographic images of the dining experience, convey a casual urban chic.

ign by Associates Design
Director: Chuck Polonsky
igner: Jill Arena
otographer: Dave Slavinski
mputer Artist: John Arena

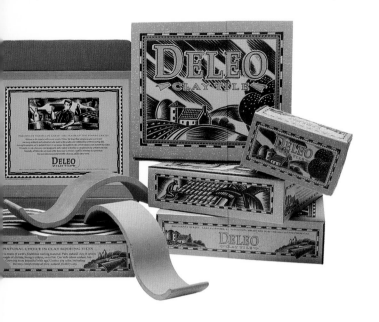

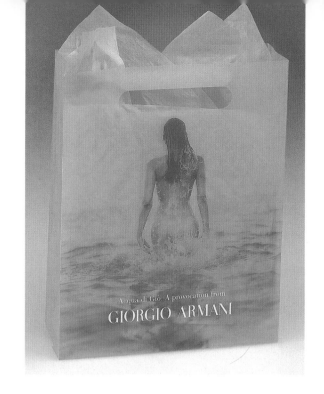

Acqua di Giò. A provocation from
GIORGIO ARMANI

COLOR

COLOR communicates instantly. Even before the text in a layout is read and the words are registered and processed, the color scheme has already conveyed something on another, subconscious, level. Color often has loaded political, social, and emotional connotations. During the Cold War, to be called "red" in America was to be branded the worst kind of traitor. Everyone knows that yellow has long been associated with cowards. And if you devote yourself to protecting the environment, you are known to be "green."

It takes a discriminating eye to determine what color or color scheme works best to create the biggest impact on an audience. It also takes an innovative mind to make the most of limited choices when budgetary concerns restrict the amount of color that can be used on press. On these pages are many examples of ways designers found to stretch their color options, such as changing paper colors instead of inks to broaden a color spectrum, or applying a third color by hand to a 2-color run.

BRIAN CRONIN / T 212 254 6312 F 212 260 3158

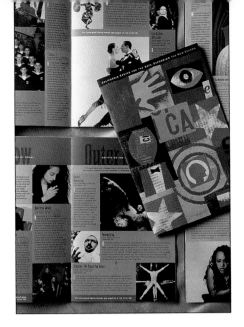

Trends in color reflect the cultural concerns of the day. Recently it has become popular to promote "green" or "natural" products in an earthy color scheme that reflects their natural resources. Packaging designed in brown, black, and beige tones printed on fibrous kraft paper remains a popular option for products sold in health food stores, or for graphics found in the now-ubiquitous upscale coffee bars.

Desktop publishing technology has facilitated the ability to achieve special effects by applying and layering color in a design. In fact, highly layered and saturated color has become synonymous with design in the early-to-mid 1990s, especially in CD-ROM interfaces and in Web site designs. Now the tendency is away from overindulgence and toward a more limited use of color within layouts that incorporate more white space. This restrained approach comes as a welcome relief as media forms proliferate the landscape and add to the sensory overload. When communicating with color, graphic designers are smart to realize that it's not always the one who shouts the loudest that gets the most attention.

BLUE SKY DESIGN

JOANNE C. LIT
Vice President & Creative
10300 Sunset Drive, Suite 353, Mia
Telephone 305·271·2063 Facsim

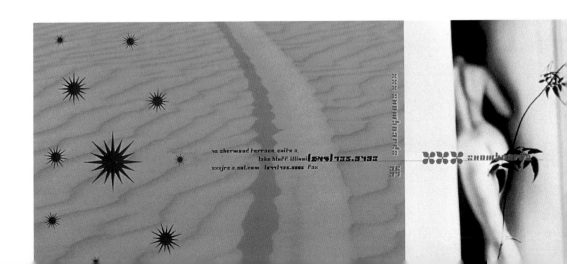

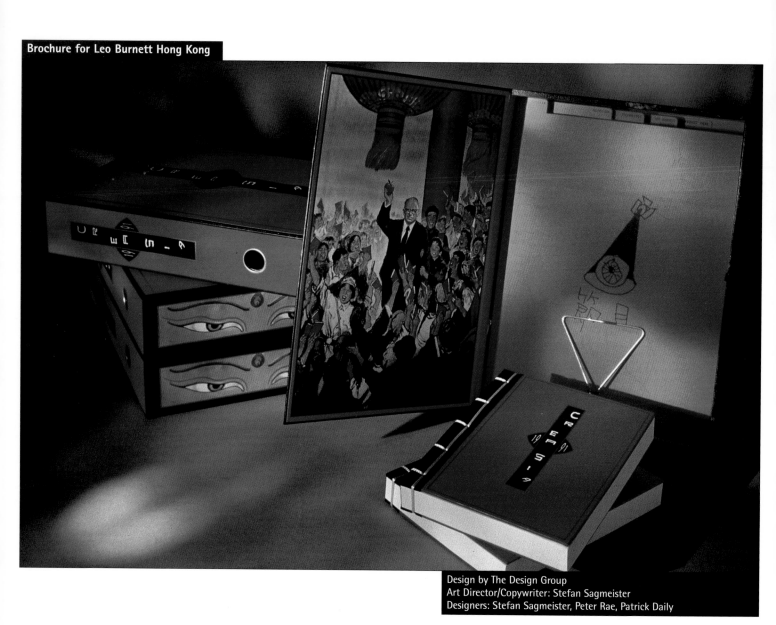

Design by The Design Group
Art Director/Copywriter: Stefan Sagmeister
Designers: Stefan Sagmeister, Peter Rae, Patrick Daily

This piece was created for an advertising conference in Hong Kong. The choice of red for the cover reflects the national color of Communist China; the notebook is styled to mimic the Red Book.

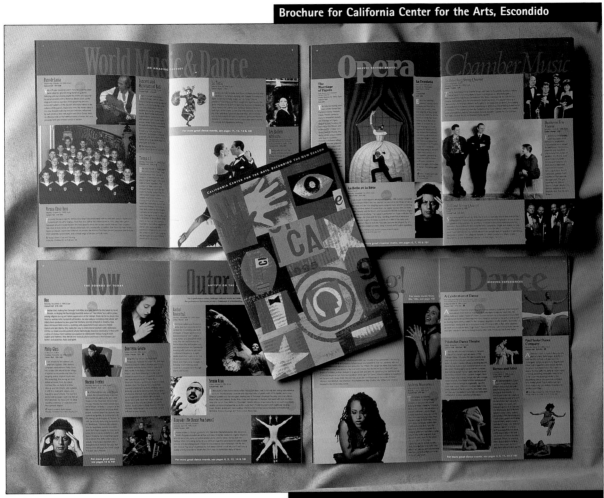

Design by Mires Design, Inc.
Art Director: John Ball
Designers: John Ball, Kathy Carpentier-Moore
Illustrator: Gerald Bustamante

This brochure promotes events at the California Center for the Arts with an upbeat color-block format with each hue identifying an art form. The colors are united as a patchwork on the booklet's cover.

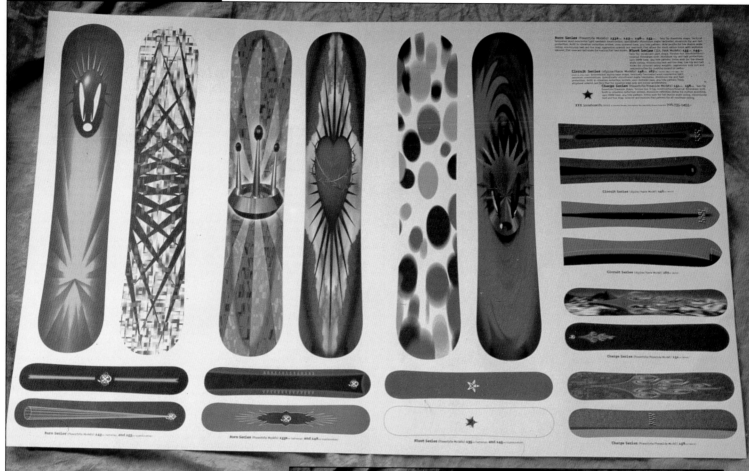

A brochure created for a snowboard manufacturer avoids the category's standard-issue garishness with a soft, sepia-toned image of a snowboarder on the cover and displays of the product on cream-colored paper.

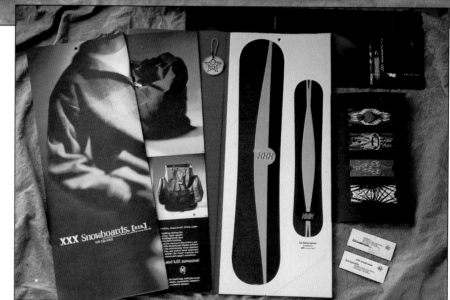

Design by Segura, Inc.
Art Director/Designer: Carlos Segura
Illustrators: Tony Klassen, Carlos Segura
Photographer: Jeff Sciortino

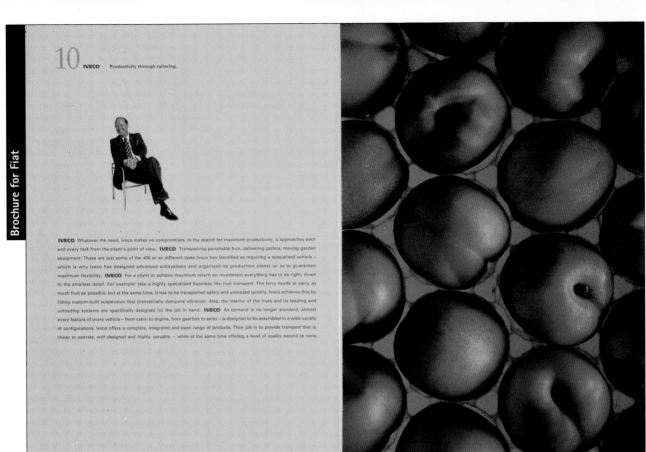

10 **IVECO** Productivity through tailoring.

IVECO Whatever the need, Iveco makes no compromises. In the search for maximum productivity, it approaches each and every task from the client's point of view. **IVECO** Transporting perishable fruit, delivering pallets, moving garden equipment. These are just some of the 400 or so different tasks Iveco has identified as requiring a specialised vehicle – which is why Iveco has designed advanced subsystems and organised its production plants so as to guarantee maximum flexibility. **IVECO** For a client to achieve maximum return on investment everything has to be right, down to the smallest detail. For example: take a highly specialised business like fruit transport. The lorry needs to carry as much fruit as possible, but at the same time, it has to be transported safely and unloaded quickly. Iveco achieves this by fitting custom-built suspension that dramatically dampens vibration. Also, the interior of the truck and its loading and unloading systems are specifically designed for the job in hand. **IVECO** As demand is no longer standard, almost every feature of every vehicle – from cabin to engine, from gearbox to axles – is designed to be assembled in a wide variety of configurations. Iveco offers a complete, integrated and open range of products. Their job is to provide transport that is cheap to operate, well designed and highly versatile – while at the same time offering a level of quality second to none.

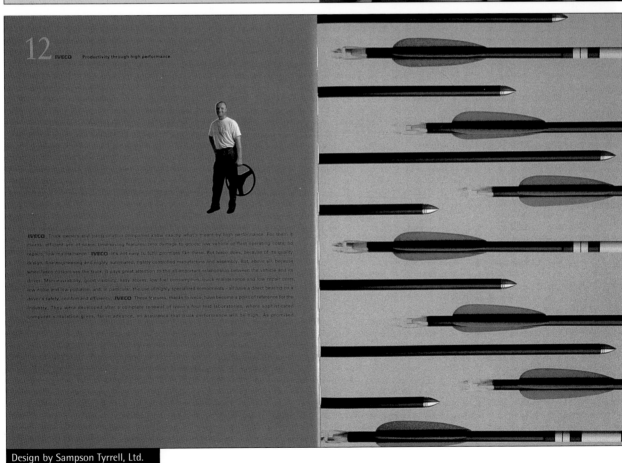

12 **IVECO** Productivity through high performance.

IVECO Truck owners and transportation companies know exactly what's meant by high performance. For them it means: efficient use of space; time-saving features; zero damage to goods; low vehicle or fleet operating costs; no repairs; low maintenance. **IVECO** It's not easy to fulfil promises like these. But Iveco does, because of its quality design, fine engineering and highly automated, tightly controlled manufacture and assembly. But, above all, because when Iveco customises the truck, it pays great attention to the all-important relationship between the vehicle and its driver. Manoeuvrability, good visibility, easy access, low fuel consumption, quick maintenance and low repair costs, low noise and low pollution, and, in particular, the use of highly specialised components – all have a direct bearing on a driver's safety, comfort and efficiency. **IVECO** These features, thanks to Iveco, have become a point of reference for the industry. They were developed after a complete renewal of Iveco's four test laboratories, where sophisticated computer simulation gives, far in advance, an assurance that truck performance will be high. As promised.

Design by Sampson Tyrrell, Ltd.
Art Director: David Freeman
Designer: Shane Greaves

A division of Fiat that develops customized trucks for shipping is promoted in a booklet with spreads saturated with brilliant colors that appear as backgrounds to text pages and in close-up photographs of fragile goods.

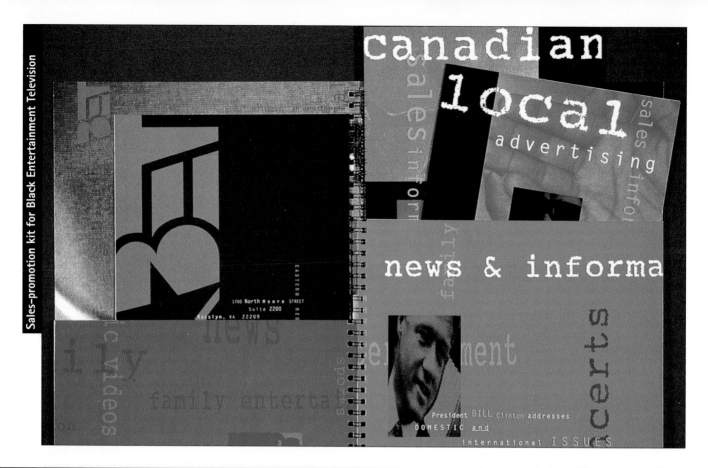

Sales-promotion kit for Black Entertainment Television

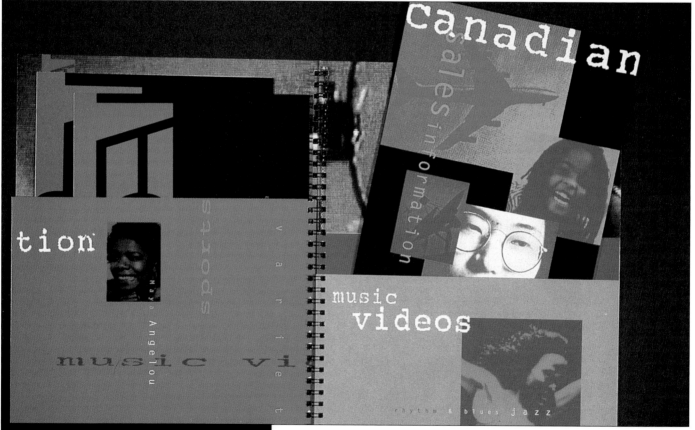

Design by Supon Design Group, Inc.
Art Directors: Supon Phornirunlit, Andrew Dolan
Creative Director: Scott Perkins
Designer: Andrew Berman
Project Directors: LaTanya Butler, Angela Scott, Matilda Ivey

A dynamic look for the Black Entertainment Television cable network is created through a sales-promotion kit designed in shades of green, blue, orange, and yellow. Type also appears in color for extra punch.

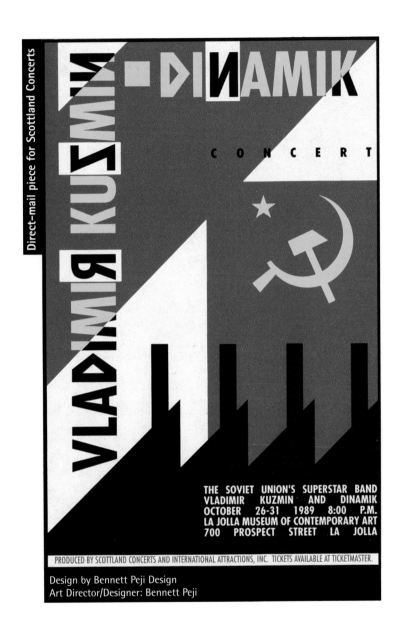

Direct-mail piece for Scottland Concerts

VLADIMIR KUZMIN DINAMIK

CONCERT

THE SOVIET UNION'S SUPERSTAR BAND
VLADIMIR KUZMIN AND DINAMIK
OCTOBER 26-31 1989 8:00 P.M.
LA JOLLA MUSEUM OF CONTEMPORARY ART
700 PROSPECT STREET LA JOLLA

PRODUCED BY SCOTTLAND CONCERTS AND INTERNATIONAL ATTRACTIONS, INC. TICKETS AVAILABLE AT TICKETMASTER.

Design by Bennett Peji Design
Art Director/Designer: Bennett Peji

This poster for a performance of
Russian musicians pays homage to the
post-revolution Constructivist
movement with bold geometric lines
and a color palette synonymous with
the former Communist state.

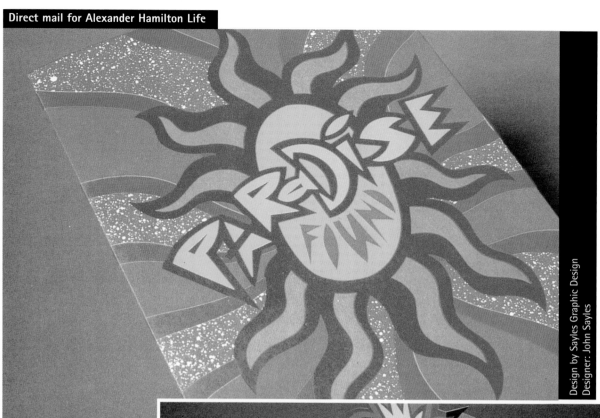

Design by Sayles Graphic Design
Designer: John Sayles

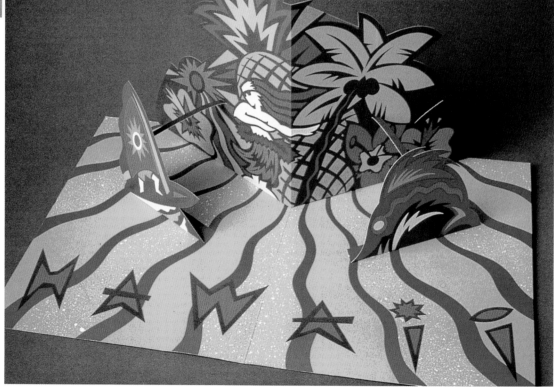

A tropical color scheme illustrating all things Hawaiian—surfing, hula dancing, palm trees, and pineapples—pops up in this promotional mailer for an Alexander Hamilton Life sales meeting. You can almost smell the tanning lotion.

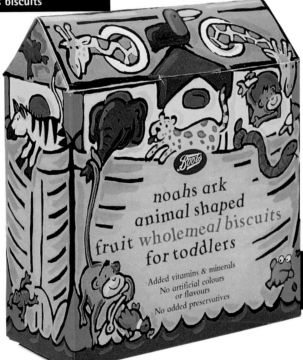

Design by Newell and Sorrell
Art Directors: Frances Newell, John Sorrell
Designer: Angela Porter
Illustrator: Tania Hart Newton

A broad palette of nursery colors adds to the whimsy of the Noah's ark illustration on this package of cookies for toddlers from Boots.

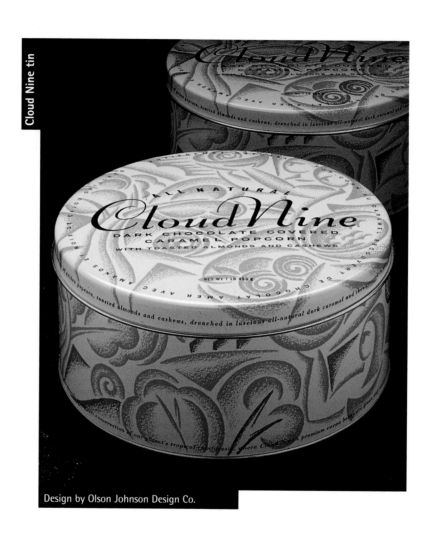

Cloud Nine tin

Design by Olson Johnson Design Co.

An illustration of a floral design in soft tones of peach and green on an ecru tin creates an up-market, ethereal package design for Cloud Nine confections.

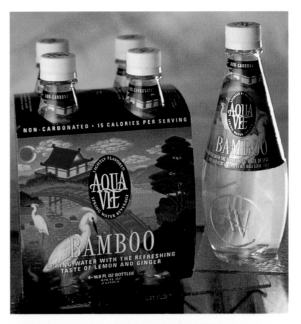

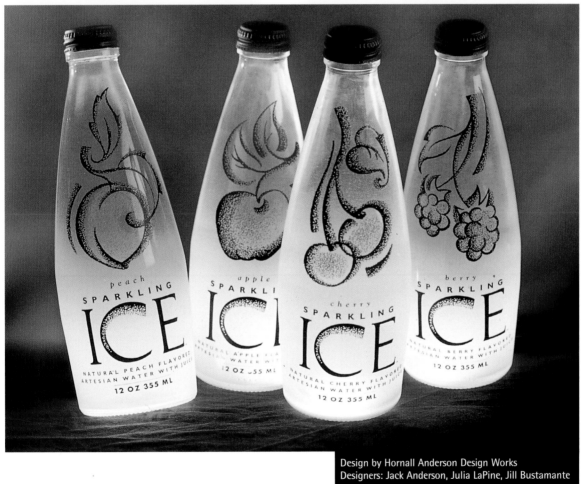

Design by Hornall Anderson Design Works
Designers: Jack Anderson, Julia LaPine, Jill Bustamante

Bottles tinted in cool tones and illustrated with frosty line drawings of fruit,
promise the pure refreshment offered by this sparkling beverage. The accents
in black provide contrast and add to its upscale image.

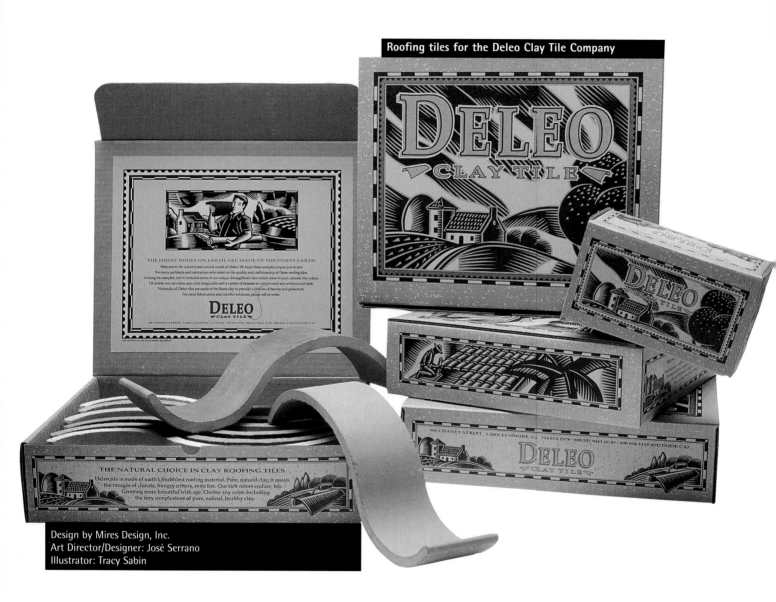

Roofing tiles for the Deleo Clay Tile Company

THE FINEST ROOFS ON EARTH ARE MADE OF THE FINEST EARTH

THE NATURAL CHOICE IN CLAY ROOFING TILES

Design by Mires Design, Inc.
Art Director/Designer: José Serrano
Illustrator: Tracy Sabin

The richness of the earth is conveyed in the color scheme of this packaging for Deleo clay tiles. The corrugated cardboard boxes with woodcut illustrations of farmland draw attention to the natural source of the materials and to the product's subtle russet colors.

The warmth and richness of the fine coffee-drinking experience is reflected in the warm hues of red, orange, and green on packaging for Starbucks and creates a foil for the bold green-and-white Starbucks logo.

Packaging for Starbucks

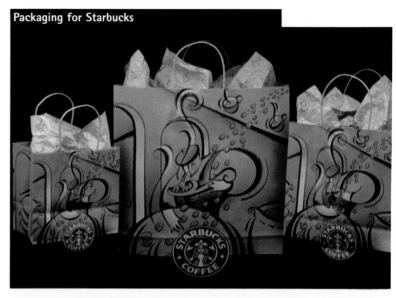

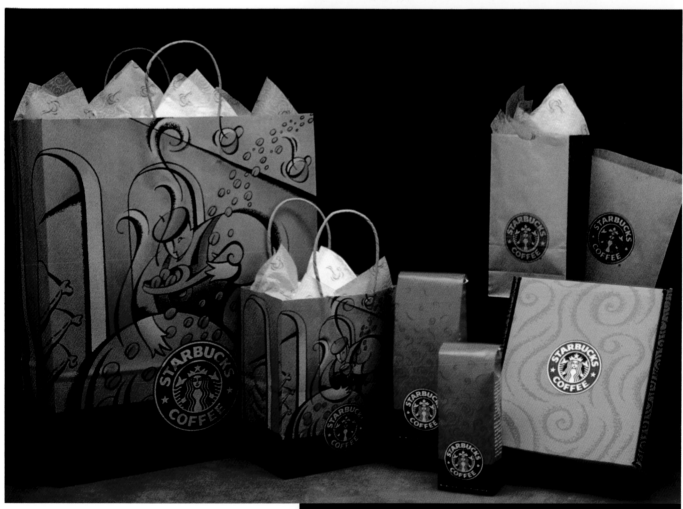

Design by Hornall Anderson Design Works
Designers: Jack Anderson, Julie Tanagi-Lock, Mary Hermes, David Bates, Julie Keenan
Illustrator: Julia LaPine
Photographer: Tom McMackin

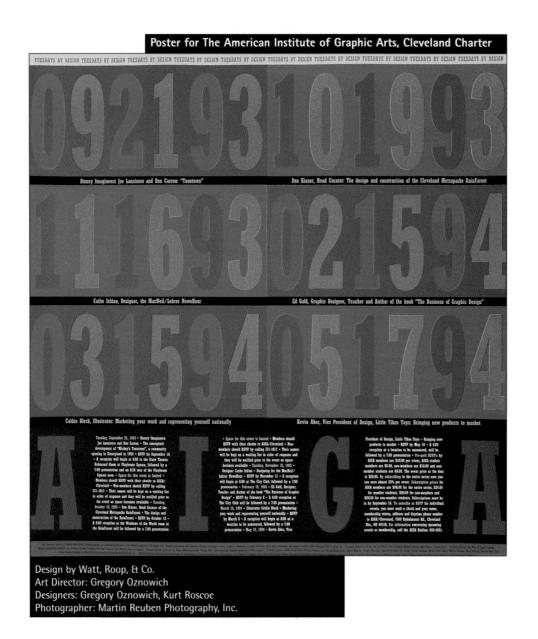

Design by Watt, Roop, & Co.
Art Director: Gregory Oznowich
Designers: Gregory Oznowich, Kurt Roscoe
Photographer: Martin Reuben Photography, Inc.

Mark your calendars: bright, solid PMS colors highlight the prominent dates on this poster promoting the Tuesdays by Design speaker series hosted by the AIGA.

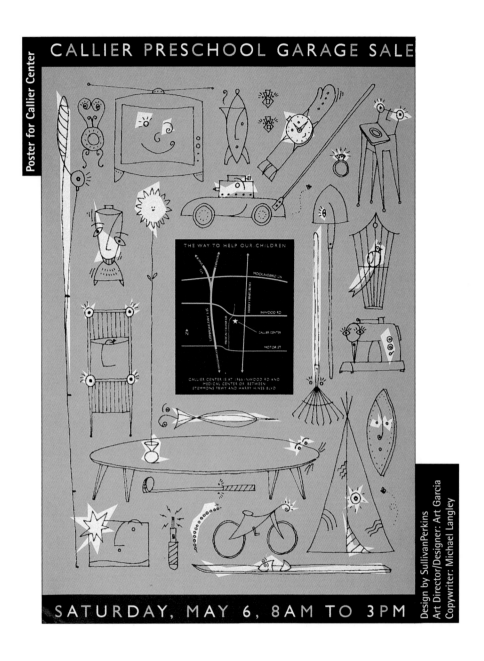

For this poster advertising a garage sale, a 1960s flavor was created through the use of an illustration style of that decade and the choice of a mustard color for the background.

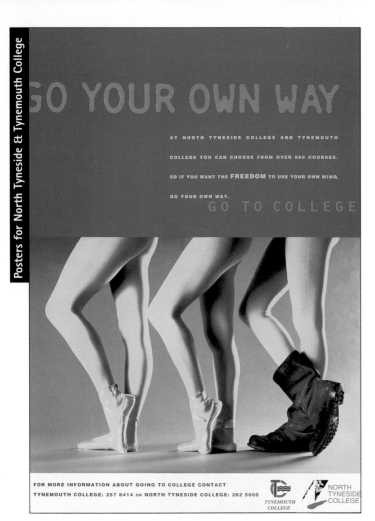

GO YOUR OWN WAY

AT NORTH TYNESIDE COLLEGE AND TYNEMOUTH

COLLEGE YOU CAN CHOOSE FROM OVER 600 COURSES.

SO IF YOU WANT THE FREEDOM TO USE YOUR OWN MIND,

GO YOUR OWN WAY.

GO TO COLLEGE

FOR MORE INFORMATION ABOUT GOING TO COLLEGE CONTACT
TYNEMOUTH COLLEGE: 257 8414 OR NORTH TYNESIDE COLLEGE: 262 5000

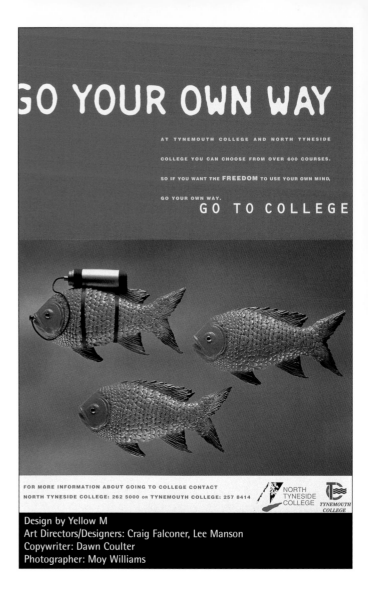

GO YOUR OWN WAY

AT TYNEMOUTH COLLEGE AND NORTH TYNESIDE

COLLEGE YOU CAN CHOOSE FROM OVER 600 COURSES.

SO IF YOU WANT THE FREEDOM TO USE YOUR OWN MIND,

GO YOUR OWN WAY.

GO TO COLLEGE

FOR MORE INFORMATION ABOUT GOING TO COLLEGE CONTACT
NORTH TYNESIDE COLLEGE: 262 5000 OR TYNEMOUTH COLLEGE: 257 8414

Design by Yellow M
Art Directors/Designers: Craig Falconer, Lee Manson
Copywriter: Dawn Coulter
Photographer: Moy Williams

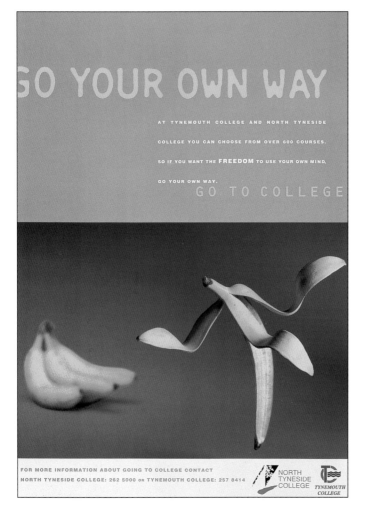

GO YOUR OWN WAY

AT TYNEMOUTH COLLEGE AND NORTH TYNESIDE

COLLEGE YOU CAN CHOOSE FROM OVER 600 COURSES.

SO IF YOU WANT THE FREEDOM TO USE YOUR OWN MIND,

GO YOUR OWN WAY.

GO TO COLLEGE

FOR MORE INFORMATION ABOUT GOING TO COLLEGE CONTACT
NORTH TYNESIDE COLLEGE: 262 5000 OR TYNEMOUTH COLLEGE: 257 8414

Individual style and freedom of choice is the focus of these posters, where visual punch lines are created within a format that divides the page into a top half in arresting shades of orange, red, blue, or aqua with contrasting type, and a bottom half with a visual joke.

GO YOUR OWN WAY

AT NORTH TYNESIDE COLLEGE AND TYNEMOUTH

COLLEGE YOU CAN CHOOSE FROM OVER 600 COURSES.

SO IF YOU WANT THE **FREEDOM** TO USE YOUR OWN MIND,

GO YOUR OWN WAY.

GO TO COLLEGE

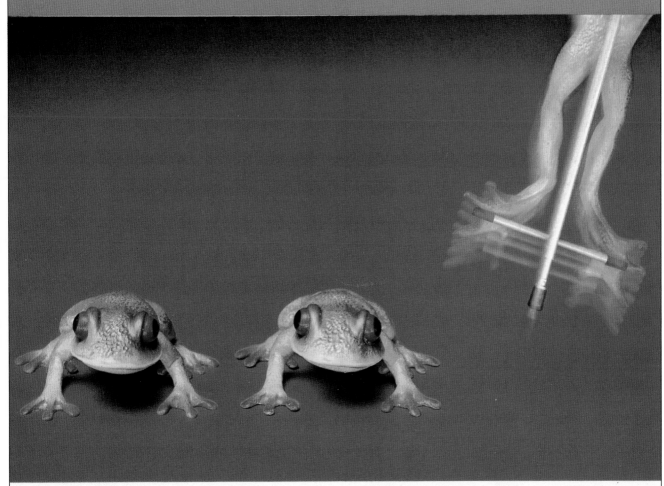

FOR MORE INFORMATION ABOUT GOING TO COLLEGE CONTACT

TYNEMOUTH COLLEGE: 257 8414 OR NORTH TYNESIDE COLLEGE: 262 5000

 TYNEMOUTH COLLEGE

 NORTH TYNESIDE COLLEGE

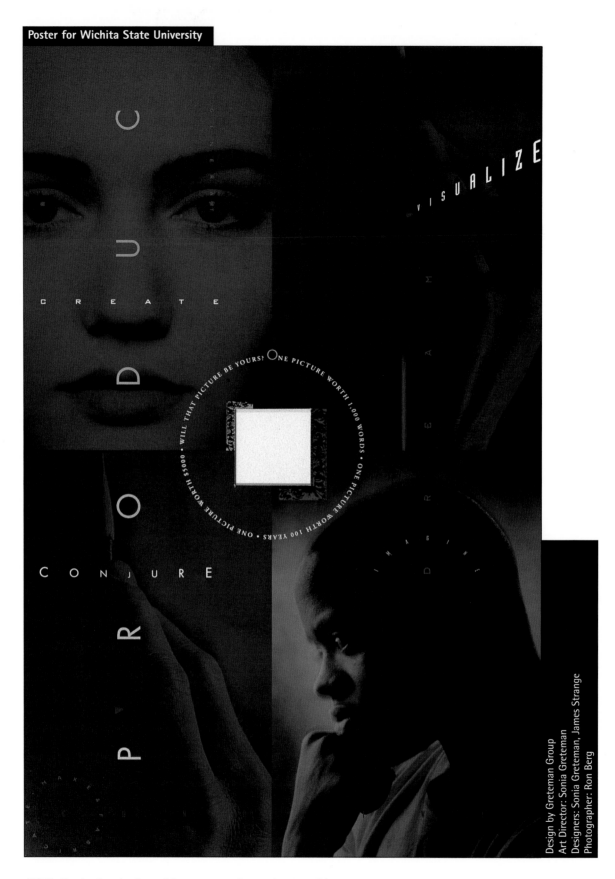

Design by Greteman Group
Art Director: Sonia Greteman
Designers: Sonia Greteman, James Strange
Photographer: Ron Berg

With its dusky shades of brown, purple, and gray, this poster advertising a fine-arts competition draws viewers into a dreamlike aura that explores the creative thought process.

Design by Independent Project Press
Designer: Bruce Licher

The Independent Project Press and the rock band R.E.M. share an aesthetic sensibility and a concern for environmental issues. These special Christmas mailings to fan club members use the IPP's letterpress printing techniques on recycled papers with inks in earthy shades of green, russet, and gold.

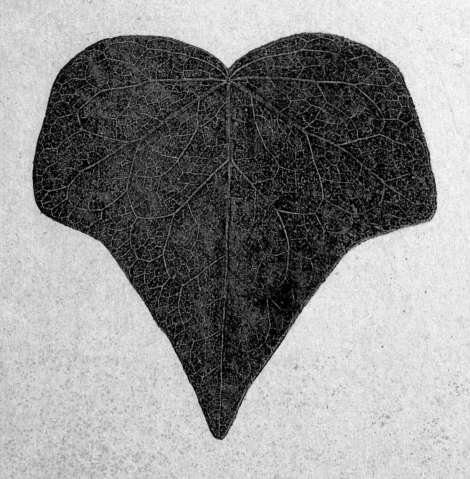

INDEPENDENT
PROJECT PRESS

Design by Independent Project Press
Art Directors/Designers: Bruce Licher, Karen Licher
Illustrator: Karen Licher

For the cover of a folder for the Independent Project Press, an actual leaf was run through the press and inked in a matching shade of green. The earthy tones of the paper stock and lettering give the leaf even greater prominence.

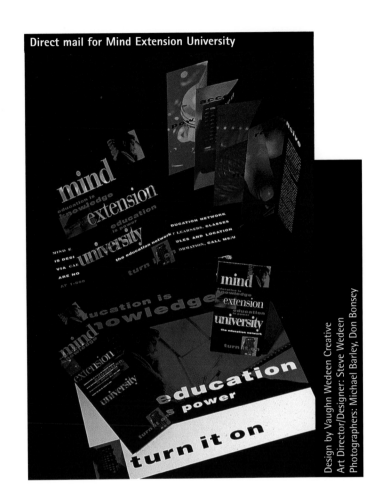

Direct mail for Mind Extension University

Design by Vaughn Wedeen Creative
Art Director/Designer: Steve Wedeen
Photographers: Michael Barley, Don Bonsey

Red draws you into these posters for an educational provider; black adds weight and seriousness; and white type gives the buzzwords and phrases their prominence.

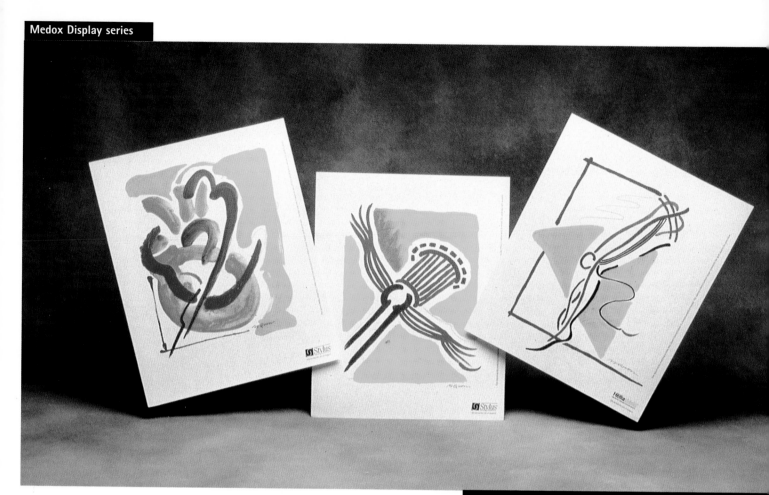

Design by Mike Quon Design Office
Art Director: Nancy Artino
Designer/Illustrator: Mike Quon

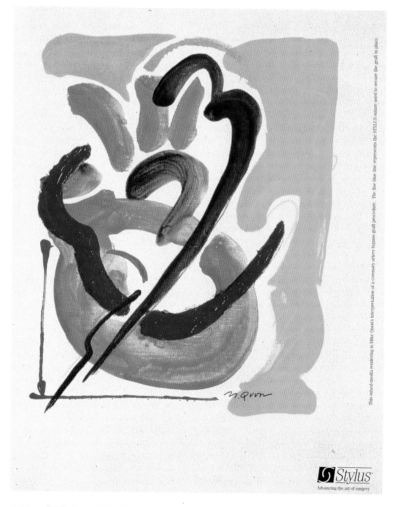

This series of posters and displays aimed at vascular surgeons feature abstract illustrations of medical-related subjects in six shades of bold, essentially primary colors. The application of the hues in brushstroke adds to their depth and impact.

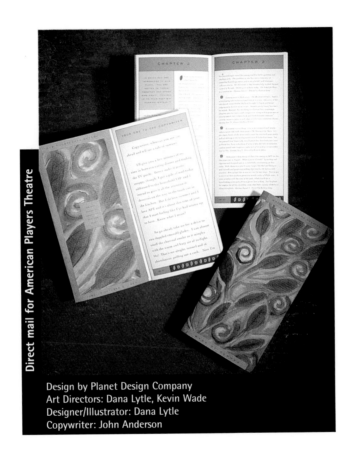

Direct mail for American Players Theatre

Design by Planet Design Company
Art Directors: Dana Lytle, Kevin Wade
Designer/Illustrator: Dana Lytle
Copywriter: John Anderson

The rich, vibrant colors of summer enliven this brochure for an outdoor theater

company. Inside, text is bordered in the same blue and yellow as the watercolor cover.

Drama often comes in the form of black-and-white. This annual report for the Progressive Corporation features a cover illustration in white ink on black paper while a variety of balancing wheels captures the eye in an interior photograph. Slight highlights in color add an element of surprise.

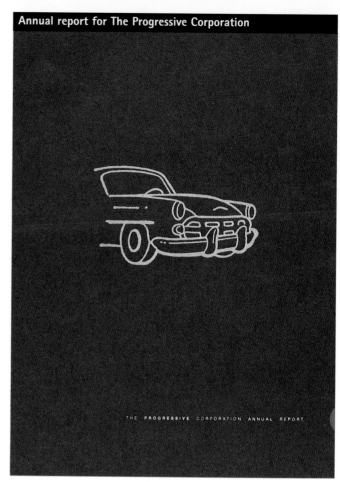

THE PROGRESSIVE CORPORATION ANNUAL REPORT

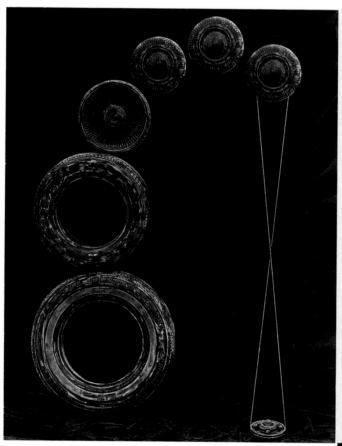

Financial		Highlights			2 · 3

(millions—except per share amounts)

				Average Annual Compounded Rate of Increase (Decrease)	
For the Year	**1993**	**1992**	**% Change**	**1989-1993**	**1984-1993**
Direct premiums written	$ 1,966.4	$ 1,636.8	20	8	23
Net premiums written	1,819.2	1,451.2	25	7	22
Net premiums earned	1,668.7	1,426.1	17	7	21
Total revenues	1,954.8	1,738.9	12	8	22
Income before cumulative effect of accounting change	267.3	139.6	91	20	28
Net income	267.3	153.8	74	20	26
Per share:					
Income before cumulative effect of accounting change	3.58	1.85	94	24	28
Net income	3.58	2.05	75	24	26
Underwriting margin	10.7%	3.5%			
At Year-end					
Consolidated shareholders' equity	$ 997.9	$ 629.0	59	19	29
Common Shares outstanding	72.1	67.1	7	(2)	—
Book Value per Common Share	$ 12.62	$ 7.94	59	20	27
Return on average shareholders' equity	36.0%	34.7%			
Stock Price Appreciation[1]	**1-Year**			**5-Year**	**10-Year**
Progressive	39.8%			40.7%	28.2%
S&P 500	10.1%			14.6%	14.9%

[1]Assumes dividend reinvestment.

Wheels Triptych 1994

Design by Nesnadny + Schwartz
Art Directors: Mark Schwartz, Joyce Nesnadny
Designers: Joyce Nesnadny, Michelle Moelher, Mark Schwartz
Photographer: Zeke Berman
Illustrator: Lavy/Merriam-Webster, Inc.

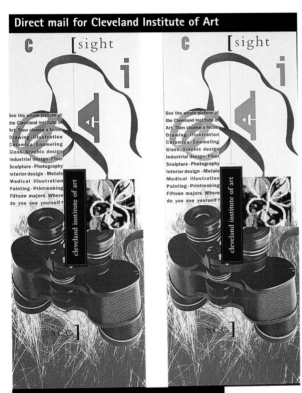

Direct mail for Cleveland Institute of Art

Design by Nesnadny + Schwartz
Art Directors: Joyce Nesnadny, Mark Schwartz
Designers: Joyce Nesnadny, Michelle Moehler
Photographer: Robert Muller, Tony Festa

While this mailer for an art institute is reissued each year, the color scheme changes to keep the graphics looking fresh. Here, the binoculars change color from teal to purple.

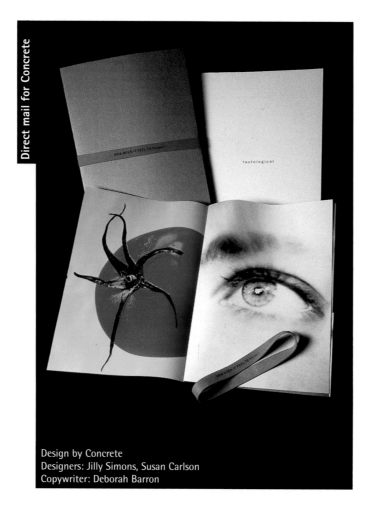

Direct mail for Concrete

Design by Concrete
Designers: Jilly Simons, Susan Carlson
Copywriter: Deborah Barron

With the theme, "How Does it Feel to
Think?" this unbound self-promotion
mailer asks viewers to create visual
associations of their own. In this
spread, the black-and-white
photograph of an eye placed next to a
juicy tomato makes the fruit's almost
surreal richness appear even riper.

Direct mail for Polaroid

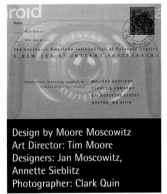

Design by Moore Moscowitz
Art Director: Tim Moore
Designers: Jan Moscowitz,
Annette Sieblitz
Photographer: Clark Quin

The invitation to this party for Polaroid is designed to look like an opening camera aperture. The translucent vellum paper tinted in subtle shades overlaps to create soft gradations of color.

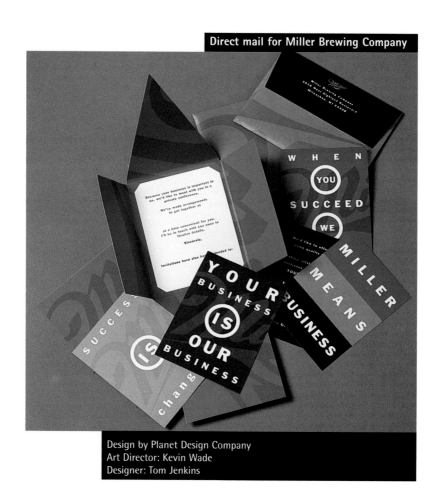

Direct mail for Miller Brewing Company

Design by Planet Design Company
Art Director: Kevin Wade
Designer: Tom Jenkins

Here, Miller Brewing Company's corporate color scheme of red, gold, and black is applied to an invitation for a business-building conference, along with sans serif type and background graphics that play on the logo. The effect shows a fresh, contemporary side of the brewery.

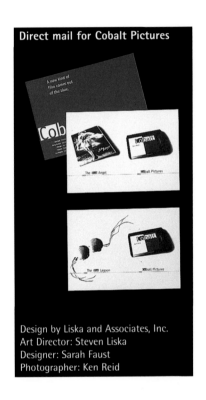

Direct mail for Cobalt Pictures

Design by Liska and Associates, Inc.
Art Director: Steven Liska
Designer: Sarah Faust
Photographer: Ken Reid

A mailer for Cobalt Pictures uses wordplay,

cobalt blue on the covers, and tinted pictures

to promote a new kind of film that "just

comes out of the blue."

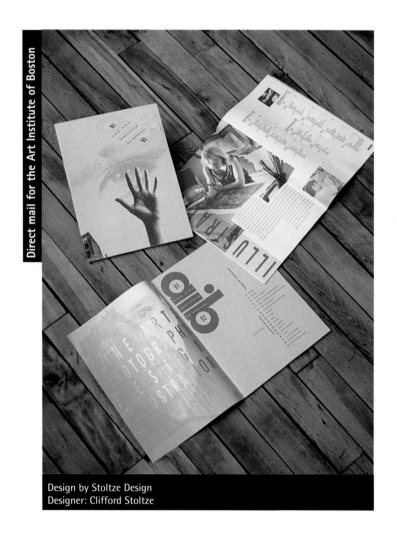

Direct mail for the Art Institute of Boston

Design by Stoltze Design
Designer: Clifford Stoltze

A catalog for study programs at the Art Institute of Boston creates a dreamlike ambiance illustrating the creative process through pages with softly layered photography printed in shades of blue and pink with headline text appearing in a metallic silver PMS.

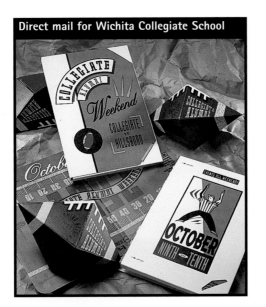

Direct mail for Wichita Collegiate School

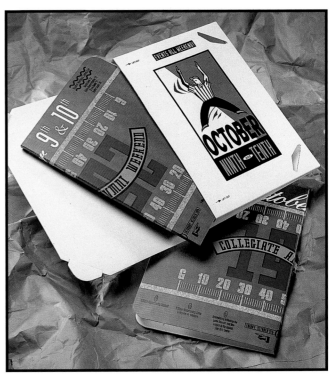

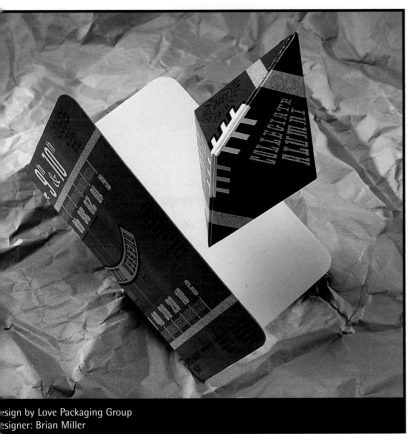

sign by Love Packaging Group
signer: Brian Miller

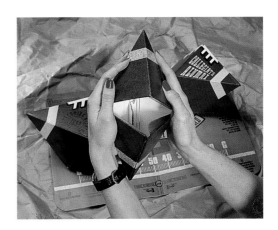

A gridiron spirit bursts out of this mailer for a collegiate alumni-weekend event. When the invitation is opened, a paper football literally pops out. The color scheme matches the gaming spirit, with a cover and interior in playing-field green, and accents in white, yellow, and brown.

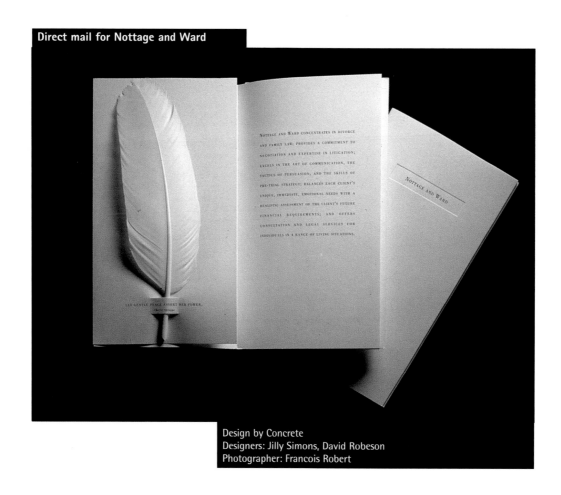

Direct mail for Nottage and Ward

NOTTAGE AND WARD CONCENTRATES IN DIVORCE AND FAMILY LAW; PROVIDES A COMMITMENT TO NEGOTIATION AND EXPERTISE IN LITIGATION; EXCELS IN THE ART OF COMMUNICATION, THE TACTICS OF PERSUASION, AND THE SKILLS OF PRE-TRIAL STRATEGY; BALANCES EACH CLIENT'S UNIQUE, IMMEDIATE, EMOTIONAL NEEDS WITH A REALISTIC ASSESSMENT OF THE CLIENT'S FUTURE FINANCIAL REQUIREMENTS; AND OFFERS CONSULTATION AND LEGAL SERVICES FOR INDIVIDUALS IN A RANGE OF LIVING SITUATIONS.

Design by Concrete
Designers: Jilly Simons, David Robeson
Photographer: Francois Robert

The gentle, peaceful philosophy of this law firm is conveyed through a mailer that soothingly reassures with a white feather placed in a white folder, with text set in clean boxes of justified type.

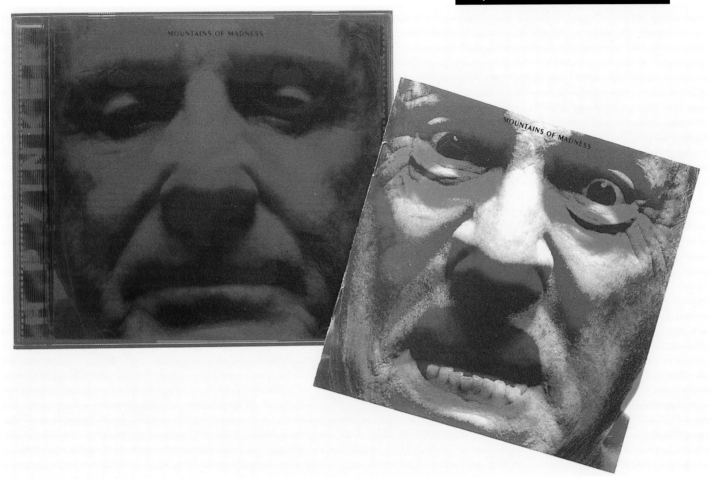

Color was used to create an optical illusion for the H. P. Zinker release, Mountains of Madness. Dual images printed in red and green are transformed when slipped in and out of the red jewel box, which acts as a decoder.

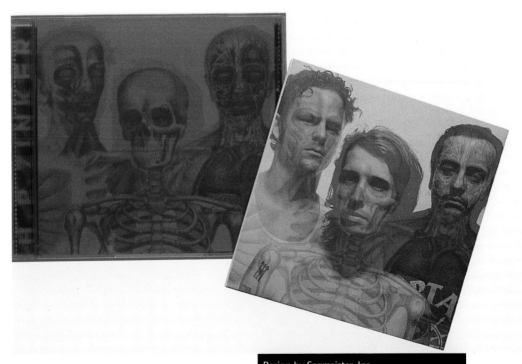

Design by Sagmeister, Inc.
Art Director: Stefan Sagmeister
Designers: Stefan Sagmeister, Veronica Oh
Photographer: Tom Schierlite

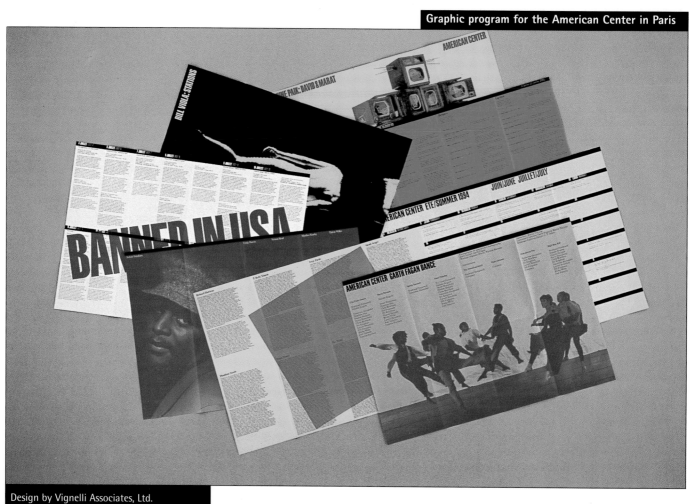

Design by Vignelli Associates, Ltd.
Art Director: Massimo Vignelli
Designers: Rebecca Rose, Chris di Maggio

To create a budget-conscious but high-impact brochure for an arts center, the design firm limited printing to two colors—black and red—on a variety of brightly-colored, lightweight papers. The transparent red ink changes hue, depending on the paper.

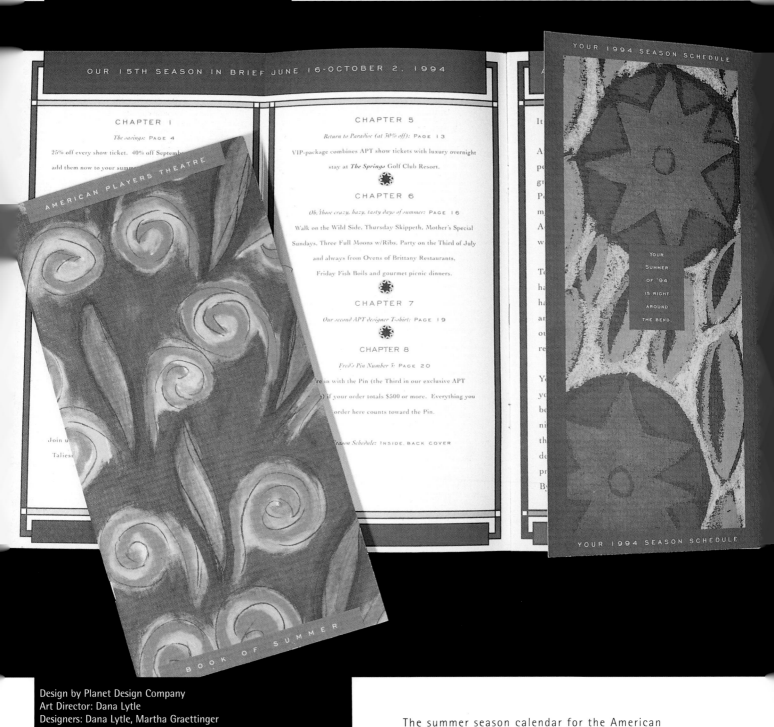

OUR 15TH SEASON IN BRIEF JUNE 16-OCTOBER 2, 1994

CHAPTER 1

The savings: PAGE 4

25% off every show ticket. 40% off Septemb

add them now to your summ

CHAPTER 5

Return to Paradise (at 50% off): PAGE 13

VIP-package combines APT show tickets with luxury overnight

stay at *The Springs* Golf Club Resort.

CHAPTER 6

Oh, those crazy, hazy, tasty days of summer: PAGE 16

Walk on the Wild Side, Thursday Skippeth, Mother's Special

Sundays, Three Full Moons w/Ribs, Party on the Third of July

and always from Ovens of Brittany Restaurants,

Friday Fish Boils and gourmet picnic dinners.

CHAPTER 7

Our second APT designer T-shirt: PAGE 19

CHAPTER 8

Fred's Pin Number 3: PAGE 20

re in with the Pin (the Third in our exclusive APT

) if your order totals $500 or more. Everything you

order here counts toward the Pin.

Season Schedule: INSIDE, BACK COVER

AMERICAN PLAYERS THEATRE

Join u

Taliesi

BOOK OF SUMMER

YOUR 1994 SEASON SCHEDULE

YOUR
SUMMER
OF '94
IS RIGHT
AROUND
THE BEND.

YOUR 1994 SEASON SCHEDULE

Design by Planet Design Company
Art Director: Dana Lytle
Designers: Dana Lytle, Martha Graettinger
Illustrator: Dana Lytle

The summer season calendar for the American

Players Theatre bursts to life with a cover

illustration in rich floral tones and interior pages

accented with color bars in purple, red, and yellow.

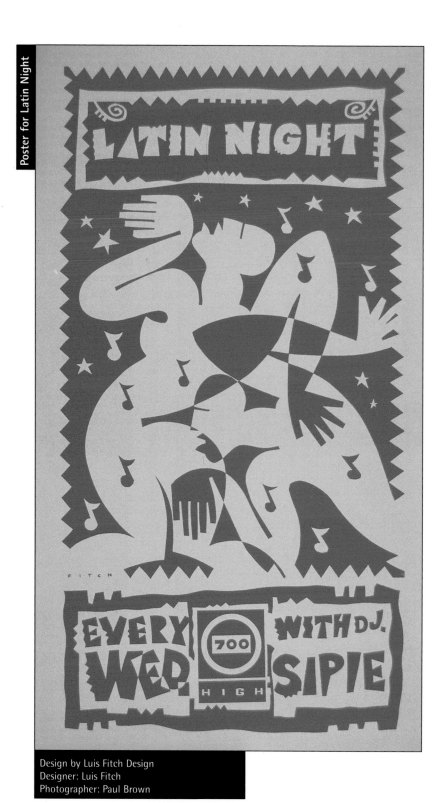

Design by Luis Fitch Design
Designer: Luis Fitch
Photographer: Paul Brown

This poster for a Latin Night at a club sizzles with energy from its silk-screened, woodcut-like image printed in high-contrast red ink on yellow paper.

Football poster for Houlihan's

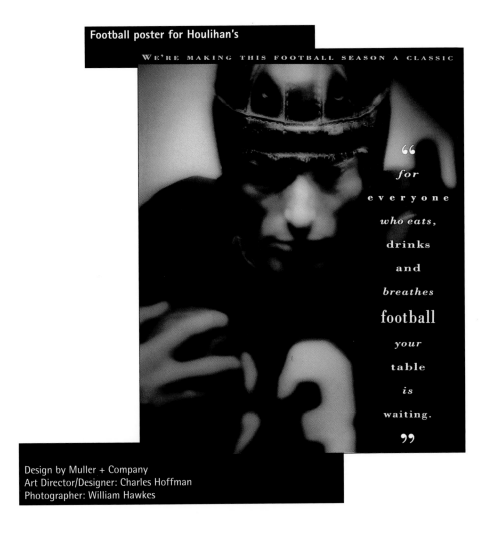

WE'RE MAKING THIS FOOTBALL SEASON A CLASSIC

" *for* everyone *who eats,* drinks and *breathes* football *your* table *is* waiting. "

Design by Muller + Company
Art Director/Designer: Charles Hoffman
Photographer: William Hawkes

A burnished look was given to this softly-focused, almost surreal image of an old-time football player on a poster that was printed in shades of black and gold.

Stationery for the Write Stuff

Design by Mires Design, Inc.
Art Director/Designer: José Serrano
Illustrator: Tracy Sabin

The eco-friendly composition of this recycled
kraft writing paper product is highlighted
with a sophisticated line drawing in black
depicting scholarly desktop accoutrements.

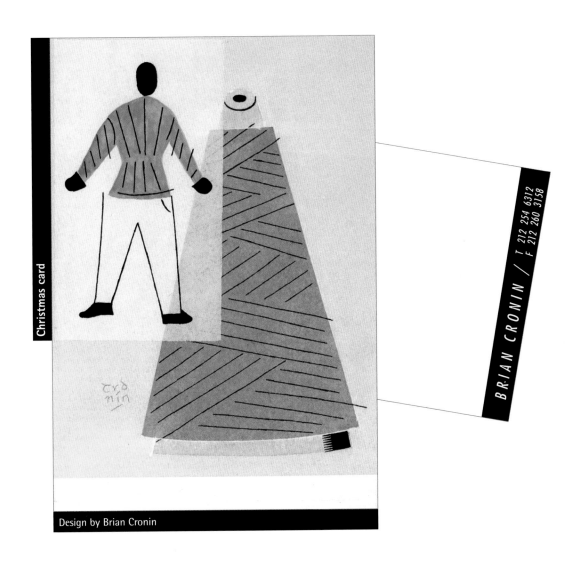

Christmas card

Design by Brian Cronin

BRIAN CRONIN / T 212 254 6312
F 212 260 3158

"Stay Warm," says this holiday greeting with an illustration depicting a cone of wool as a Christmas tree and a person wearing a sweater of the same evergreen color.

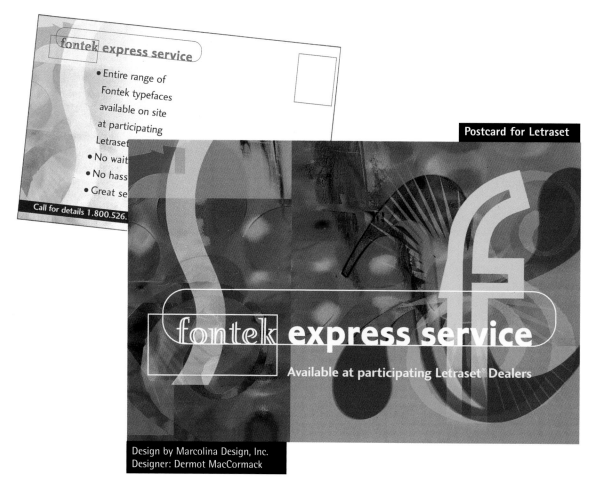

Postcard for Letraset

fontek **express service**

Available at participating Letraset® Dealers

Design by Marcolina Design, Inc.
Designer: Dermot MacCormack

fontek express service

• Entire range of
Fontek typefaces
available on site
at participating
Letraset
• No wait
• No hass
• Great se
Call for details 1.800.526.

A montage of
shapes and letter
forms in vibrant
colors creates an
unmistakable
energy on this
postcard
introducing
Letraset's Fontek
Express service.

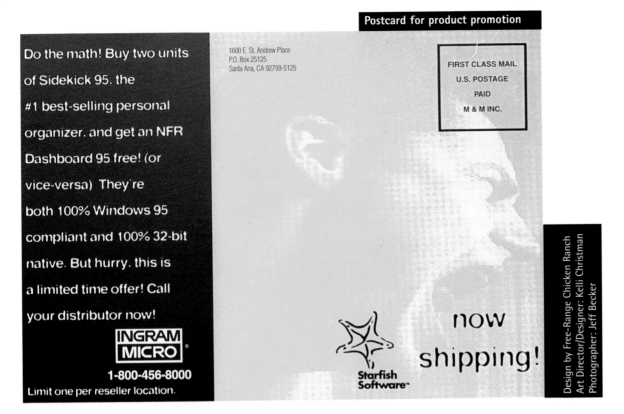

Postcard for product promotion

Do the math! Buy two units of Sidekick 95. the #1 best-selling personal organizer. and get an NFR Dashboard 95 free! (or vice-versa) They're both 100% Windows 95 compliant and 100% 32-bit native. But hurry. this is a limited time offer! Call your distributor now!

INGRAM MICRO®

1-800-456-8000
Limit one per reseller location.

1600 E. St. Andrew Place
P.O. Box 25125
Santa Ana, CA 92799-5125

FIRST CLASS MAIL
U.S. POSTAGE
PAID
M & M INC.

now shipping!

Starfish Software™

Design by Free-Range Chicken Ranch
Art Director/Designer: Kelli Christman
Photographer: Jeff Becker

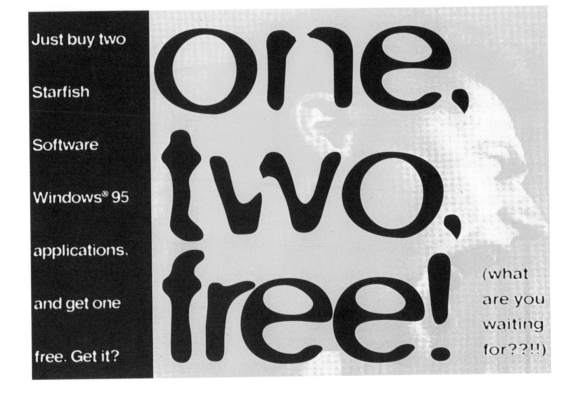

Just buy two Starfish Software Windows® 95 applications. and get one free. Get it?

one. two. free!

(what are you waiting for??!!)

Playfully confrontational text and graphics draw attention to this postcard for a software giveaway. Large-scale type in brown, and a yellow background image of a screaming man, add to the volume. The postcard was also printed in fuchsia and black.

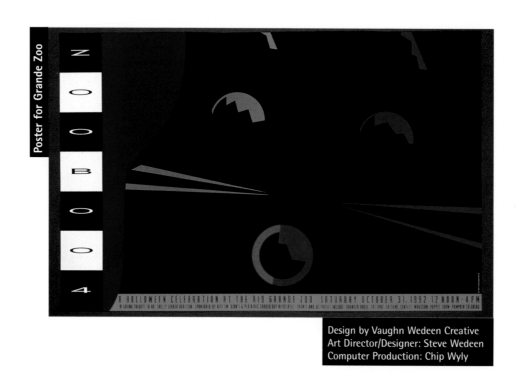

Poster for Grande Zoo

N O O B O O 4

A HALLOWEEN CELEBRATION AT THE RIO GRANDE ZOO SATURDAY OCTOBER 31, 1992 12 NOON-4 PM

Design by Vaughn Wedeen Creative
Art Director/Designer: Steve Wedeen
Computer Production: Chip Wyly

Minimalist applications of brilliant color on a black background form this abstract illustration of a black cat on a poster for a Halloween event at a zoo. Orange type continues the holiday theme, while a headline in a vertical black-and-white band adds balance and contrast.

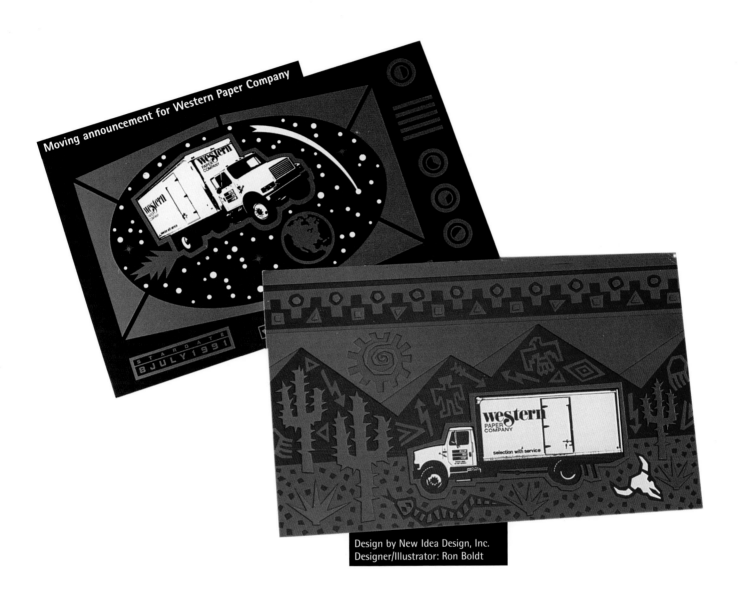

Design by New Idea Design, Inc.
Designer/Illustrator: Ron Boldt

Moving announcements for the Western Paper Company portray the company as being on the move: The company truck appears within an American West motif in desert colors, and as a playful space rocket design in nighttime shades of black, gray, gold, and white.

BIG DAY. Thursday, November 5, during this year's ICSC Deal Making Convention in Dallas, Gary Shafer and the retail partners of Trammell Crow Company invite you to a special after-hours party. It's a great way to end a big day.

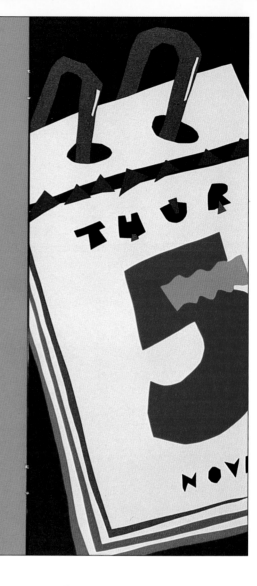

BIG TIME. That evening from 7:30 P.M. to 10:30 P.M. we'll host a buffet and cocktails. Transportation to the party will be provided from the Anatole Hotel, Chantilly Entrance, at 7:15, 7:30 and 7:45 P.M., with return service every fifteen minutes. So make plans to have a great time with us.

Design by SullivanPerkins
Art Director: Ron Sullivan
Designer/Illustrator: Michael Sprong

"Big" was the theme of this invitation to an after-hours party held in conjunction with a business convention, with "Big Day" illustrated with an oversized calendar and "Big Time" with a large watch face. This was not an occasion to use soft colors: big shades of orange, red, and green were selected.

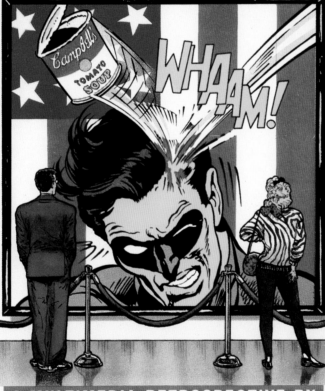

Card for The Dynamic Duo, Inc.

THE ART DIRECTORS CLUB PRESENTS

SUPERHERO
TO
ANTIHERO

COMIC BOOK ART IN THE 1960'S

WHAAM!

A MULTIMEDIA RETROSPECTIVE BY

ARLEN SCHUMER

OF THE DYNAMIC DUO STUDIO
WEDNESDAY OCTOBER 21 12:30 PM
THE ART DIRECTORS CLUB
250 PARK AVENUE AT 19TH STREET
LUNCHEON RESERVATIONS 212-674-0500

Art Director/Designer: Arlen Schumer
Illustrator: The Dynamic Duo, Inc.
Design & Line Art: Arlen Schumer
Color: Sherri Wolfgang

Wham!

A star-spangled flag motif in red, white, and blue puts an all-American spin on a speaker luncheon event about comic-book art in the 1960s by illustrator/historian Arlen Schumer.

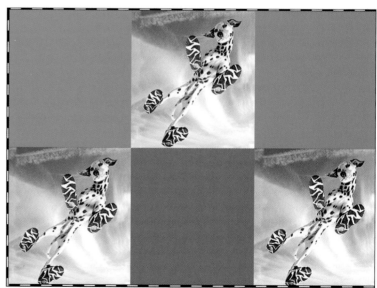

 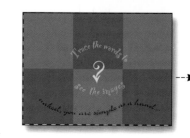 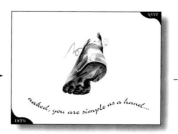

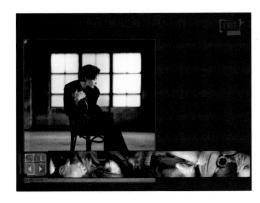
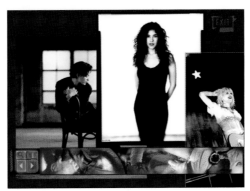

The distinct styles of each of these photographers is enhanced by an appropriate color scheme in their digital portfolios. For MTV photographer Frank Micelotta, a somber black background sets up the realistic, sometimes gritty shots of rock musicians, and provides contrast to the colorful scrolling images on the bottom of the screen. A pale-green marbleized background with white type creates a soft simplicity for the romantic images of Joyce Tenneson, while a vibrant green-and-purple checkerboard pattern sets up the zany, computer-enhanced images of Michel Tcherevkoff.

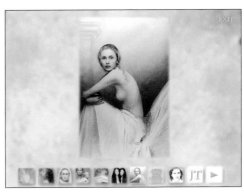

Design by WOW Sight + Sound
Photography: Frank Micelotta, Joyce Tenneson, Michel Tcherevkoff
Designers: Abby Mufson, John Fezzuoglio, Darell Dingerson
Programmers: Abby Mufson, Alec Cove

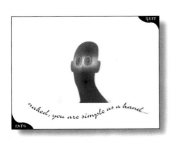

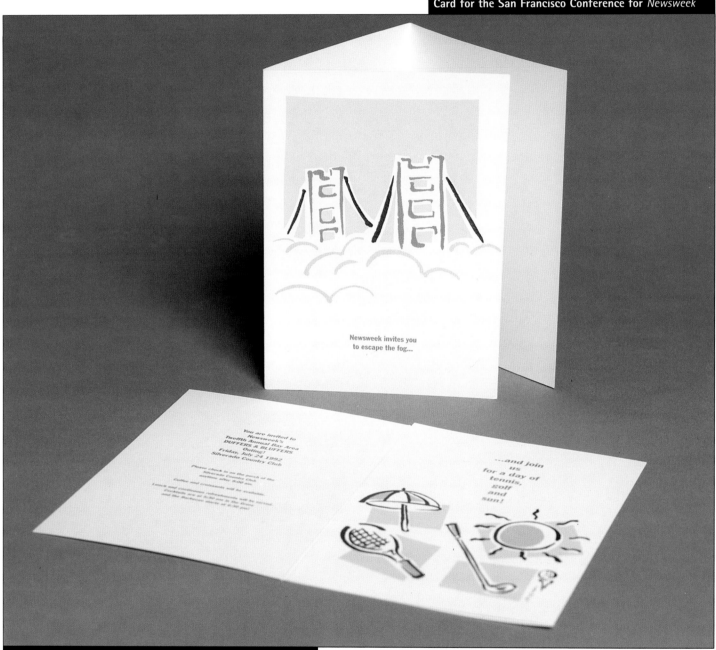

Design by Mike Quon Design Office
Art Director: Tracy Stars
Designer/Illustrator: Mike Quon

Pure escapism is found in the cool greens and

lavenders of this invitation to relax from work

at a golf and tennis outing.

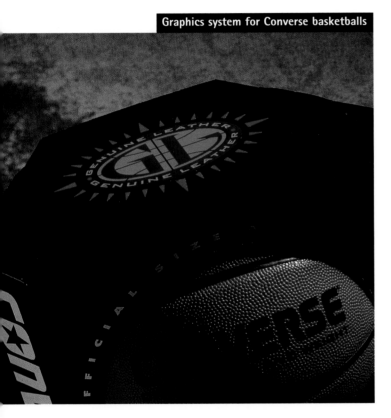

Graphics system for Converse basketballs

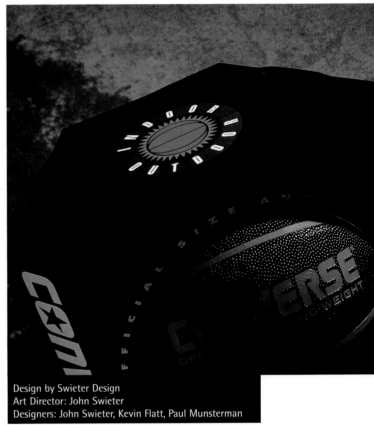

Design by Swieter Design
Art Director: John Swieter
Designers: John Swieter, Kevin Flatt, Paul Munsterman

A black background appearing on Converse's basketball packaging conveys a serious, professional quality. Key features of the balls are called out in logos incorporating basketball seams in bright shades of red, green, purple, and yellow.

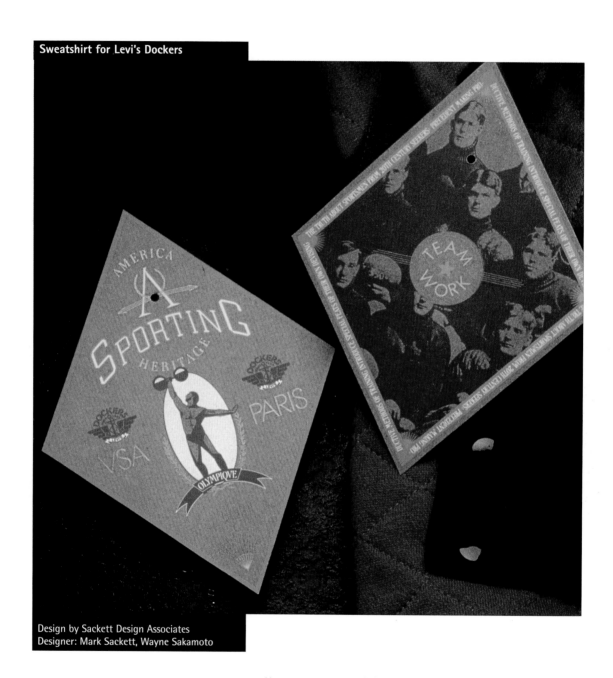

Sweatshirt for Levi's Dockers

Design by Sackett Design Associates
Designer: Mark Sackett, Wayne Sakamoto

Hang tags created for a line of sweatshirts with a turn-of-the-century sporting club theme reflect the nostalgic spirit with a sepia-toned image of a rugby team printed on gray paper. Logos appear on the reverse side on a matte gold background. Aqua borders on both sides add a contemporary touch.

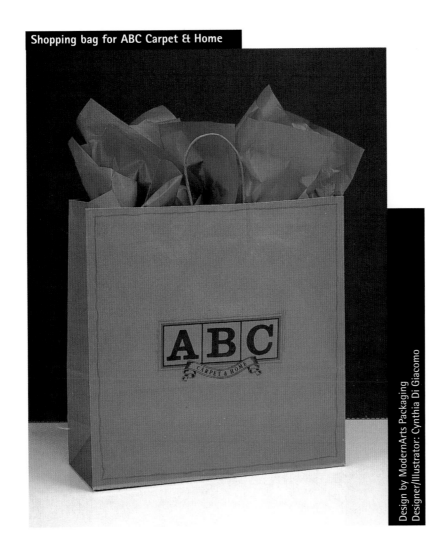

Shopping bag for ABC Carpet & Home

Design by ModernArts Packaging
Designer/Illustrator: Cynthia Di Giacomo

The ABC Carpet & Home department store in New York offers everything from conservative Oriental rugs to funky hand-blown stemware. These shopping bags reflect that diversity of style with a traditional serif logo printed on natural kraft paper and edged in a hand-drawn fuchsia border.

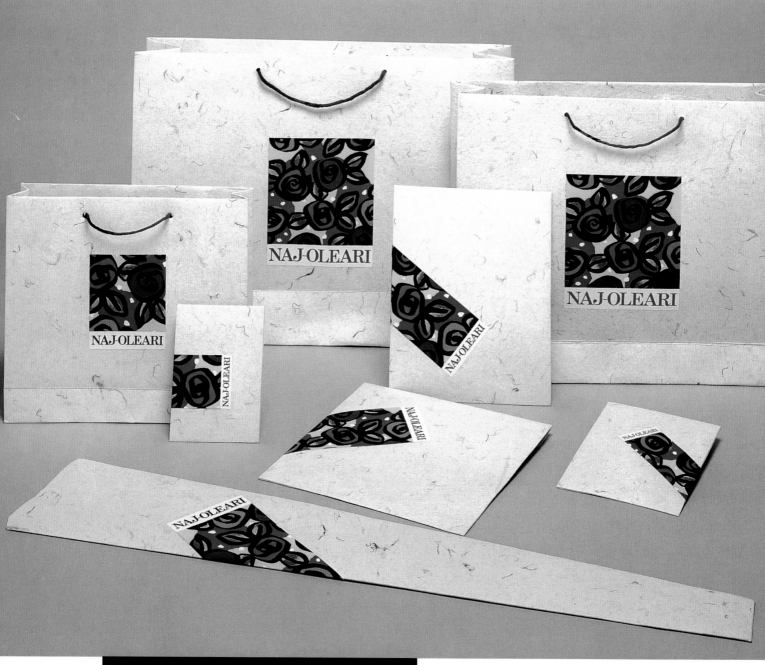

Design by Angelo Sganzerla
Art Director/Designer: Angelo Sganzerla
Illustrator: Maurizia Dova

Naj-Oleari produces colorful cotton clothes. The company's packaging features a label in a riot of primary and secondary colors applied on handmade paper embedded with cotton threads of many hues.

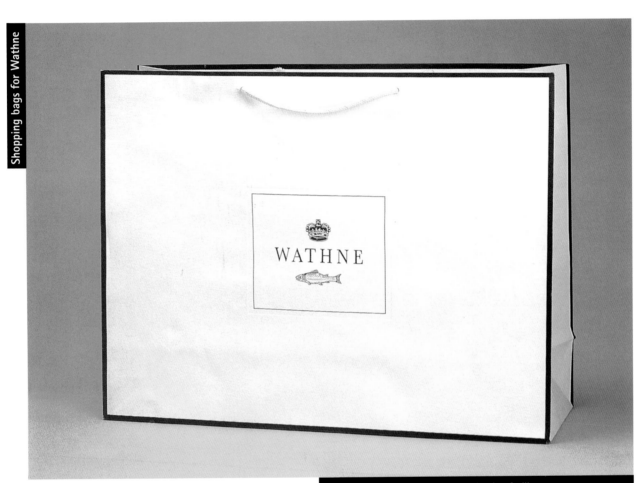

Bag Manufacturer: ModernArts production facility

This elegantly understated shopping-bag design for Wathne is bordered in green; during the winter holidays, the bag is trimmed in gold.

Shopping bag for Coach

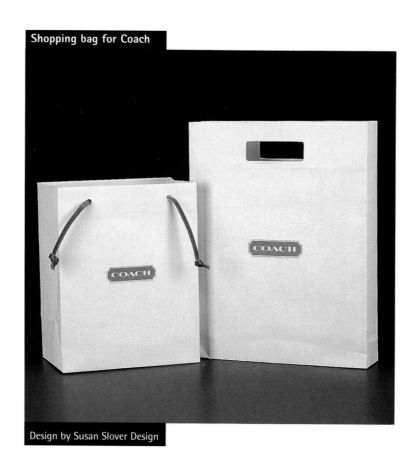

Design by Susan Slover Design

Coach makes leather goods in many colors, but their trademark color is chestnut brown. Here, the logo appears in that shade on a cream-colored paper stock. Durable chestnut leather handles are a whimsical matching touch.

Shopping bag for Tommy Hilfiger

Tommy Hilfiger's all-American style appears on shopping bags sporting a red, white, and blue motif in the same large color blocks that regularly crop up in his clothing designs.

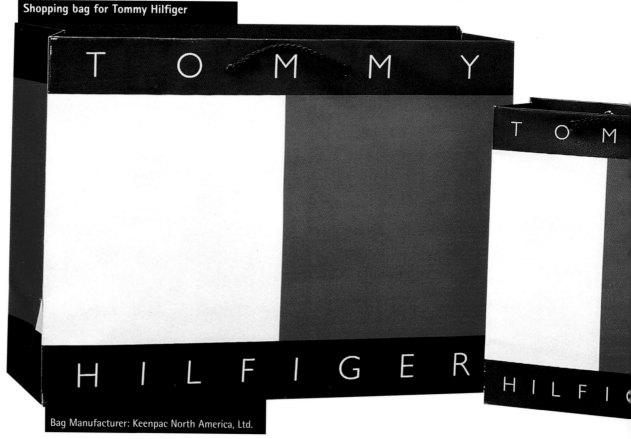

Bag Manufacturer: Keenpac North America, Ltd.

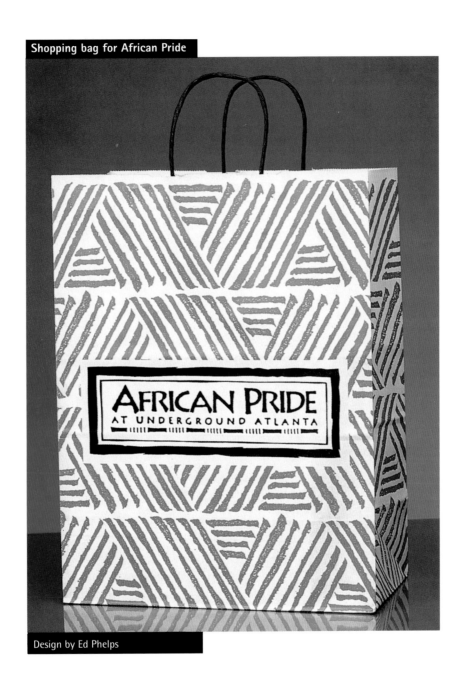

Shopping bag for African Pride

AFRICAN PRIDE
AT UNDERGROUND ATLANTA

Design by Ed Phelps

This African Pride shopping bag employs a primitive, hand-drawn pattern in a striking color scheme of brown printed on cream paper with black type, highlighted with black handles.

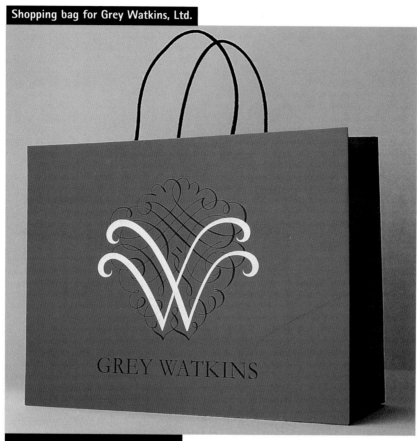

Shopping bag for Grey Watkins, Ltd.

Design by George Tscherny, Inc.
Art Director/Designer: George Tscherny
Illustrator: Lynne Buchman

Gray Watkins, Ltd. manufactures decorative fabrics with traditional design influences. The regal store logo—a *W* based on a flourished Victorian typeface—is matched by the bag's imperial purple paper.

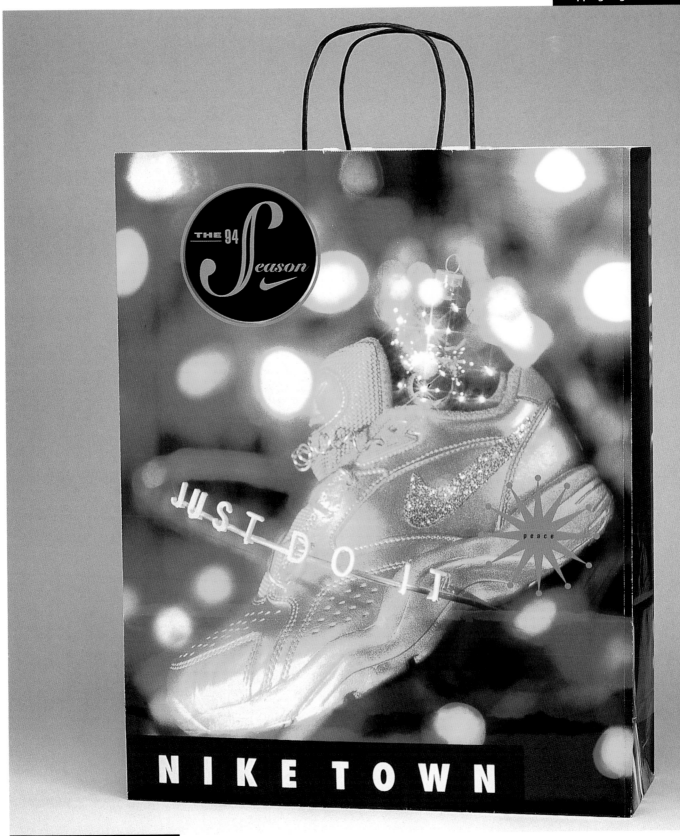

Design by Set Point Paper Co. Inc.

Holiday shopping bags for Niketown carry the glow of the season with
images of ornamented shoes in saturated holiday colors of red and gold.
The black-and-white logo provides a relief from the visual overload.

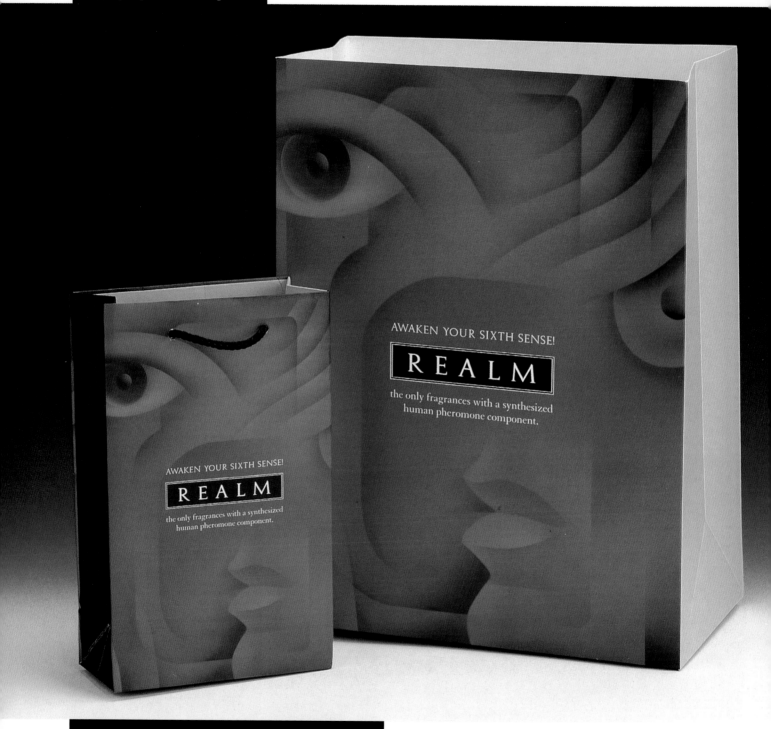

AWAKEN YOUR SIXTH SENSE!

R E A L M

the only fragrances with a synthesized
human pheromone component.

Design by 1185 Design
Art Director/Designer: Andy Harding

Red is often used to convey passion and energy in fragrance packaging and advertising. These shopping bags for a fragrance that employs a human pheromone use red to bring out the product's heady, sensual pleasures.

Shopping bag for Giorgio Armani Acqua di Gio

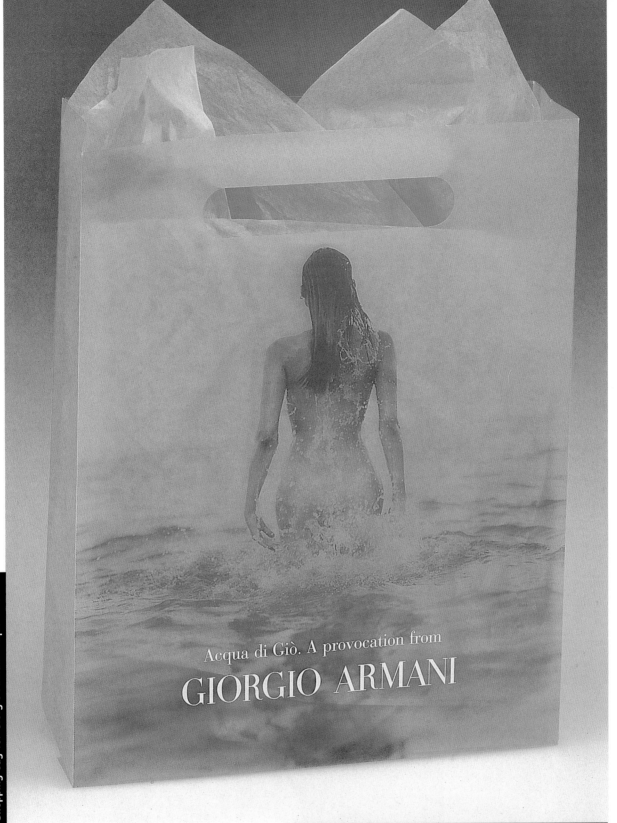

Acqua di Giò. A provocation from

GIORGIO ARMANI

Design by Megan Swift

The lightness of this fragrance is emphasized in translucent bags that reflect water's refreshing qualities with a black-and-white image of a woman wading. Aqua tissue completes the theme and makes the bag's logo emerge into view.

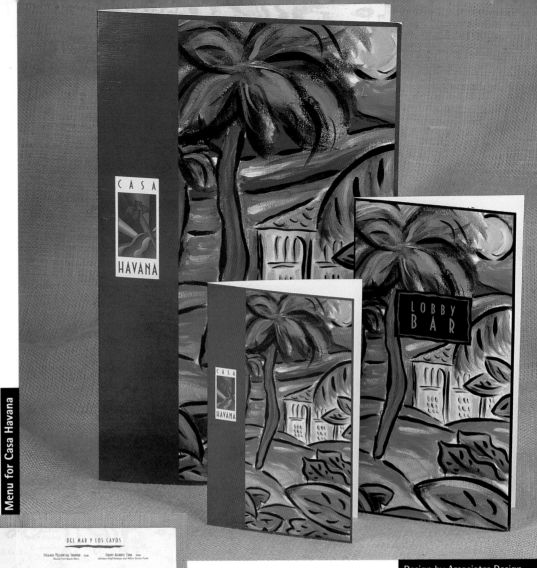

Menu for Casa Havana

TAPAS

SMOKED CHICKEN AND BLACK BEAN CREPES 8.50
With Salsa Verde

PEEKY TOE CRAB CAKES 9.50
With West Indian Guacamole,
Island Chips and Salsa

YUCA STUFFED SQUID 9.50
With a Sour Orange Mojo,
Greens and Tartar Salsa

SEARED WAFERS OF CURACAO-SCENTED FOIE GRAS 14.50
On a Cuban Bread "Shortstack" with Exotic Fruits Caramel

SAVORY CRAB FLAN 7.50
Ole Solette Sauce with African
Bird Chile and Guava Salsa

LOBSTER SAUSAGE AND TRUFFLES 12.50
With Habanero Candy and
Huckleberry Potato Quenelles

TAMALE DE EJOTE 6.50
Green Corn and Masa with a Habanero and Pork Picadillo

ISLAND SQUAB 7.50
Chilled with Ancho Chile and Pineapple Salsa

RED PRAWN DUMPLING 8.50
Chipotle Cream and Sweet Mango Relish

SOPA

CUBAN BLACK BEAN SOUP 4.75
With Cilantro Sour Cream

FOUR MINDS GAZPACHO 5.50

CAYMAN CONCH CHOWDER 4.95

ENSALADA

LOBSTER "MOJITO" 12.50
Grilled with Rum, Lime and Mint on White Beans and Mache

FRESH MOZZARELLA AND MESCLUN SALAD 6.75
With Grapefruit Vinaigrette

MAXIMO SALAD 6.95
A Changing House Salad

DEL MAR Y LOS CAYOS

STEAMED YELLOWTAIL SNAPPER 22.50
Passion Fruit Beurre Blanc

CRISPY ACHIOTE TUNA 23.50
Rainbow Fried Potatoes and Yellow Tomato Purée

LOBSTER AND SCALLOPS 26.50
Panfried with Andouille Sausage, Salsa Fresca and Black-Eyed Beans, Finished with Curry

ZARZA AND PEPPER PAINTED GROUPER 22.50
On a Margarita/Habanero Mojo with a
Banana/Plantain Mofo au Poblano

GRILLED SEA BASS 23.50
With Creole Peppers, Roast Garlic, Tomato,
Pumpkin, White Beans and Pancetta

CAYMAN FUSTEL LASAGNA ROSCLAYE-STYLE 25.00
With Crayfish and Lobster Demi and Sun-Dried Tomatoes

RIDE MARE 22.00
Roasted Pepper Purée,
Cucumber Disks and Tapioca Pearls

RICE-WRAPPED SALMON 22.50
Saffron Cream and Merlot Reduction,
Lobster and Truffle Sausage

DEL CORRAL Y GALLINERO

CHURRASCO STEAK 23.00
With Grilled Portabella Mushrooms and Ancho Chile Pasta

BRAISED COUNTRY RIBS 18.00
Meaty Pork Ribs with Creamy Leeks,
Grilled Fig and Fried Pumpkin

GRILLED ORGANIC CHICKEN BREASTS 18.00
With Green Pumpkin Seed Mole,
Herb Dumplings and Fresh Goat Cheese

FILET MIGNON AND CARIBBEAN LOBSTER 24.00
Sweet Potato Mousse, Roasted Pepper and
Corn Relish, Passion Fruit Beurre Blanc

FILET MIGNON 22.00
Grilled over Apple Wood with Roasted Corn and
Garlic Mashed Potatoes, Ancho Chile Sauce

GRILLED HICKORY SMOKED CHICKEN 18.00
With Chilies, Olive Oil, Roasted
Garlic and Mango Salsa

ROAST PORK TENDERLOIN 18.00
With Mole, Plantain Crostata and a Red Onion, Black Bean and Sweet Corn Salsa

Design by Associates Design
Art Director: Chuck Polonsky
Designer: Mary Greco

This menu design for a Cuban-themed
hotel restaurant recreates the
brilliant colors of an island sunset in
a watercolor of a mansion amidst
tropical foliage.

Menu for Nana Grill

The menu design for Nana Grill is the portrait of urban
sophistication with a watercolor still life of a table
setting and a starry night painted in rich, dusky hues.

Design by Associates Design
Art Director: Chuck Polonsky
Designer/Illustrator: Jill Arena

Warm earth tones for ink and paper reflect the restaurant's primitive interior design theme. This color scheme is commonly chosen by upscale coffee houses.

Design by Sayles Graphic Design
Designer: John Sayles
Photographer: Bill Neilans

Graphics system for Timbuktuu Coffee Bar

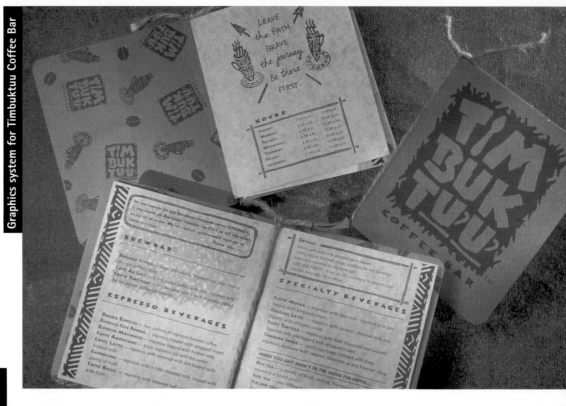

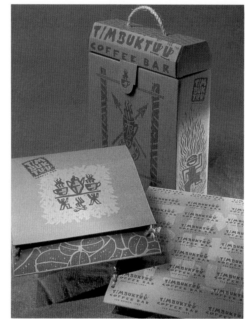

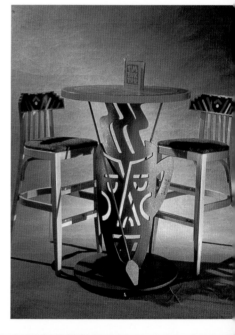

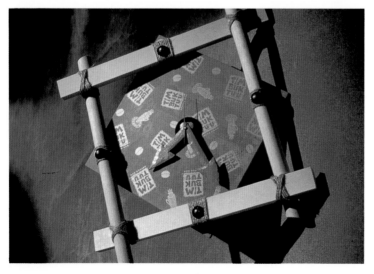

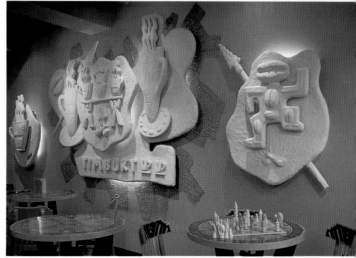

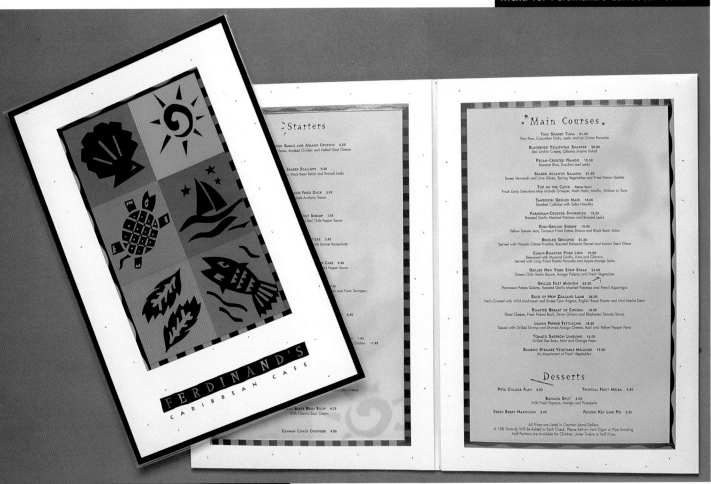

Starters

Main Courses and menu details (partially legible through vellum overlay):

★ Main Courses ★

THAI SEARED TUNA 21.00
Paw Paw, Cucumber Disks, Leeks and an Onion Pancake

BLACKENED YELLOWTAIL SNAPPER 22.00
Sea Urchin Cream, Cilantro Jicama Salad

PECAN-CRUSTED WAHOO 19.50
Basmati Rice, Zucchini and Leeks

SEARED ATLANTIC SALMON 21.50
Sweet Vermouth and Lime Glaze, Spring Vegetables and Fried Potato Galette

TOP OF THE CATCH PRICED DAILY
Fresh Daily Selections May Include Grouper, Mahi Mahi, Marlin, Wahoo or Tuna

TANDOORI GRILLED MAHI 18.00
Sautéed Callaloo with Soba Noodles

PARMESAN-CRUSTED SWORDFISH 18.50
Roasted Garlic Mashed Potatoes and Braised Leeks

RUM-GRILLED SHRIMP 19.95
Yellow Tomato Jam, Coconut-Fried Potato Straws and Black Bean Salsa

BROILED GROUPER 21.00
Served with Wasabi Crème Fraiche, Roasted Balsamic Fennel and Lemon Demi Glace

CUMIN-ROASTED PORK LOIN 19.00
Seasoned with Mustard Garlic, Lime and Cilantro,
Served with Crisp Fried Potato Pancake and Apple Mango Salsa

GRILLED NEW YORK STRIP STEAK 23.00
Green Chile Garlic Sauce, Asiago Polenta and Fresh Vegetables

GRILLED FILET MIGNON 25.00
Parmesan Potato Galette, Roasted Garlic Mashed Potatoes and Pencil Asparagus

RACK OF NEW ZEALAND LAMB 26.00
Herb-Crusted with Wild Mushroom and Sweet Corn Ragout, English Roast Potato and Mint Merlot Demi

ROASTED BREAST OF CHICKEN 18.00
Goat Cheese, Fresh Picked Basil, Straw Onions and Blackened Tomato Sauce

LEMON PEPPER FETTUCCINE 18.50
Tossed with Grilled Shrimp and Shaved Asiago Cheese, Basil and Yellow Pepper Pesto

TOMATO SAFFRON LINGUINE 16.00
Grilled Sea Bass, Mint and Orange Pesto

BAMBOO STEAMER VEGETABLE MELANGE 15.00
An Assortment of Fresh Vegetables

Desserts

PIÑA COLADA FLAN 4.50 TROPICAL FRUIT MELBA 4.50

BANANA SPLIT 3.50
With Fresh Papaya, Mango and Pineapple

FRESH BERRY NAPOLEON 4.95 FROZEN KEY LIME PIE 5.50

All Prices are Listed in Cayman Island Dollars.
A 15% Gratuity Will Be Added to Each Check. Please Refrain from Cigar or Pipe Smoking.
Half Portions are Available for Children Under Twelve at Half Price.

Design by Associates Design
Art Director: Chuck Polonsky
Designer/Illustrator: Jill Arena

Woodcut illustrations in a seaside theme and printed on blocks of tropical colors create a festive, upbeat mood for this Caribbean cafe. The spirit continues inside the menus, where colors emerge subtly through vellum overlays. The color scheme is repeated in a banded border.

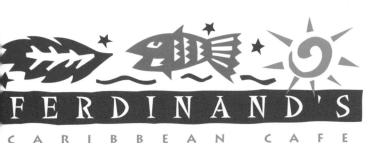

FERDINAND'S
CARIBBEAN CAFE

★ Fruits and Juices ★
FRESH PAPAYA, MANGO OR PASSION FRUIT JUICE 2.95

GRAPEFRUIT 3.50 FRESH SEASONAL BERRIES 6.95 FRESH SEASONAL FRUIT 4.50
Chilled or Broiled with Honey With Whipped Dairy Cream and Brown Sugar Melon, Papaya, Mango or Pineapple

BREAKFAST SMOOTHIES 3.50 CHILLED JUICE 1.50
Orange and Passion Fruit, Mango and Orange, Grapefruit, Prune,
Papaya or Strawberry and Banana V-8, Tomato, Apple or Cranberry

MELANGE OF SEASONAL FRESH FRUIT 5.95

Cereal and Morning Starters
SWISS BIRCHER MUESLI 5.95

SELECTION OF AMERICAN BRAND CEREALS 5.75 WARM OATMEAL 3.75
Topped with Sliced Bananas Sprinkled with Brown Sugar

NATURAL OR FRUIT FLAVORED YOGURT 3.95

From the Griddle
BUCKWHEAT PANCAKES 6.95 BLUEBERRY PANCAKES 7.05
Served with Honey Butter and Vermont Jugged Maple Syrup Served with Honey Butter and Blueberry Maple Syrup

ORANGE AND VANILLA INFUSED FRENCH TOAST 5.95
Sprinkled with Confectioners' Sugar

From the Bakery
FRESHLY BAKED SCONES 3.85 TOAST ASSORTMENT 3.75 MUFFINS 3.50
Served with Whipped Cream White, Multigrain, Raisin and Rye Bran, Raisin, Lemon Poppy Seed
and Raspberry Preserves or Banana Macadamia Nut

ENGLISH MUFFIN AND TOASTED BAGELS 3.75

Breakfast Entrées
EGGS BENEDICT 8.95 TWO SOFT BOILED EGGS 5.95
Served with Grilled Canadian Bacon Served with Multigrain Toast
and Hollandaise Sauce

POACHED EGGS AND GRILLED NORWEGIAN SALMON 10.95
Topped with Paprika Hollandaise

EGGS SARDOU 8.95 TWO EGGS ANY STYLE 7.95
Accompanied with Creamed Artichoke Served with your Choice of
Purée and Fresh Asparagus Breakfast Meat and Home-Fried Potatoes

PETITE FILET MIGNON 13.50
With Two Fried Eggs, Grilled Tomato and Home-Fried Potatoes

Omelettes
CREATE YOUR OWN OMELETTE 8.50
Select Any Combination of Fillings from the Following: Ham, Bacon, Sausage, Canadian Bacon,
Swiss, American and Cheddar Cheese, Allumetes of Carrot, Celery, Red and Yellow Peppers,
Diced Onions, Snow Peas, Zucchini, Sliced Mushrooms and Tomato Concasse

THREE-EGG OMELETTE 7.50 FRITTATA PRIMAVERA 8.50
Accompanied with Home-Fried Potatoes Made with Egg Beaters®, Fresh Julienne of Carrots, Celery,
and your Choice of Breakfast Bakery Item Snow Peas and Zucchini, Tomato Concasse and Broccoli Buds

Continental Breakfasts
FITNESS CONTINENTAL 8.50 EUROPEAN CONTINENTAL 11.95
Selection of Juices, Special K Cereal with 2% Milk, Selection of Tropical Juices, Bagel and Cream Cheese
Bran and Raisin Muffin and with Smoked Salmon, Sliced Bermuda Onion
Coffee, Decaffeinated Coffee or Hot Tea and Capers, Beverage Selection

Beverages
CAFE CUBANO OR DECAFFEINATED COFFEE 1.50 2% MILK OR WHOLE MILK 1.50

SELECTION OF INDIAN BREAKFAST TEAS 1.50 CAPPUCCINO, ESPRESSO OR CAFE AU LAIT 3.00

All Prices are Listed in Cayman Island Dollars. A 15% Gratuity Will Be Added to Each Check.
Please Refrain from Cigar or Pipe Smoking.

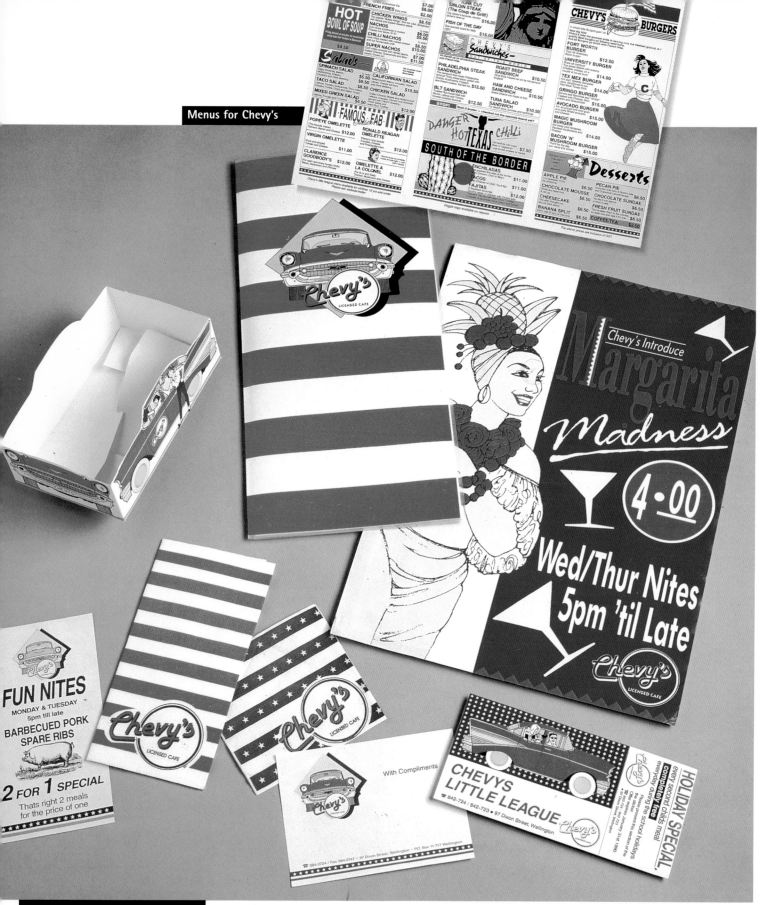

Design by Raven Madd Design Company
Art Director/Designer: Mark Curtis
Illustrators: Mark Curtis, Caroline
Campbell

A patriotic nostalgia for the 1950s is summoned in the graphics for Chevys, with American-flag colors and unwavering good cheer. The scheme works its way into special promotions, such as a holiday children's meal deal featuring a '57 Chevy against a star-spangled background.

The graphics for this menu design for a hotel restaurant in Japan create a festive atmosphere with quirky icons of flora and fauna printed in black on asymmetric shapes of bright primary and secondary colors. A logo in a futuristic typeface adds to the piece's visual zaniness.

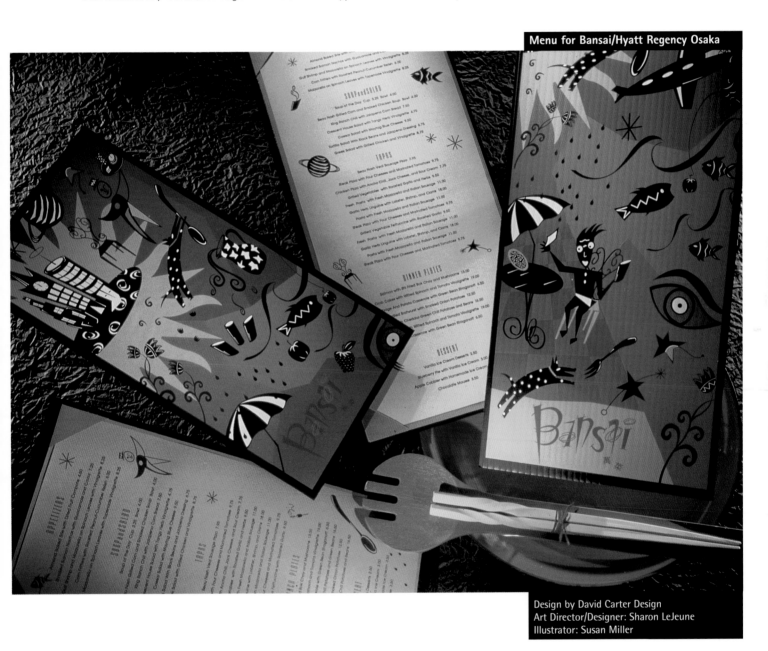

Menu for Bansai/Hyatt Regency Osaka

Design by David Carter Design
Art Director/Designer: Sharon LeJeune
Illustrator: Susan Miller

The element of surprise is
especially appropriate for a poster
promoting a Halloween event.
Here, a tiger's muted shades of
black and gold draw attention to
his scarlet-and-purple mask. Boo!

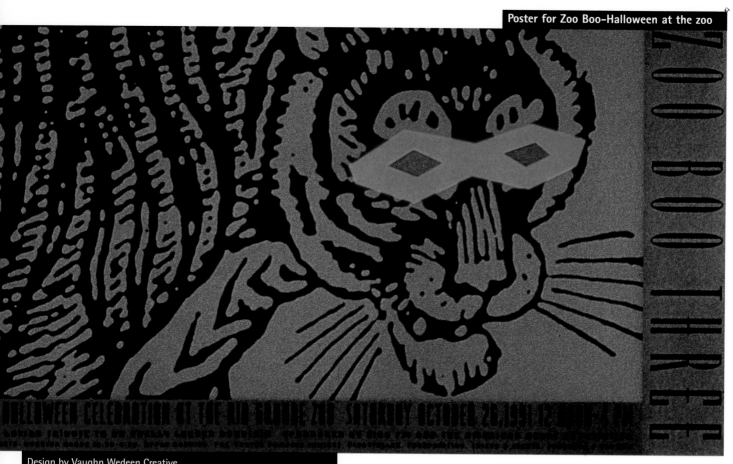

Poster for Zoo Boo–Halloween at the zoo

Design by Vaughn Wedeen Creative
Art Director/Designer: Steve Wedeen

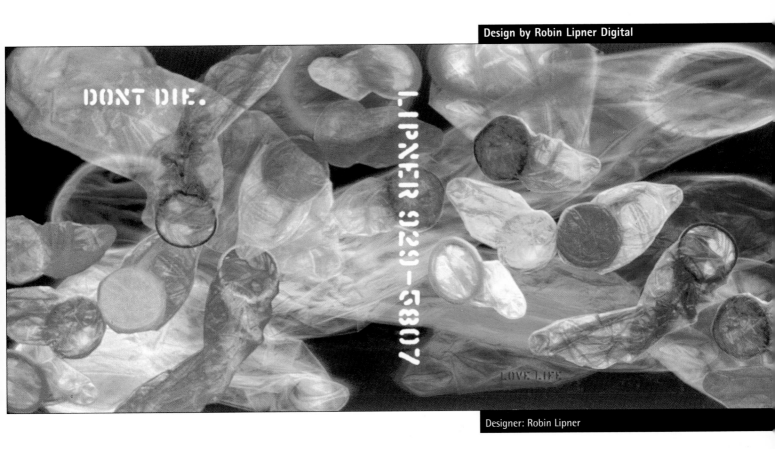

Design by Robin Lipner Digital

DON'T DIE.

LIPNER 929-5807

LOVE LIFE

Designer: Robin Lipner

The boisterous colors of these condoms provide an ironically cheerful landscape for this ad's stark anti-AIDS message. Portions of the image were inverted in Photoshop and the contrast was altered to heighten color.

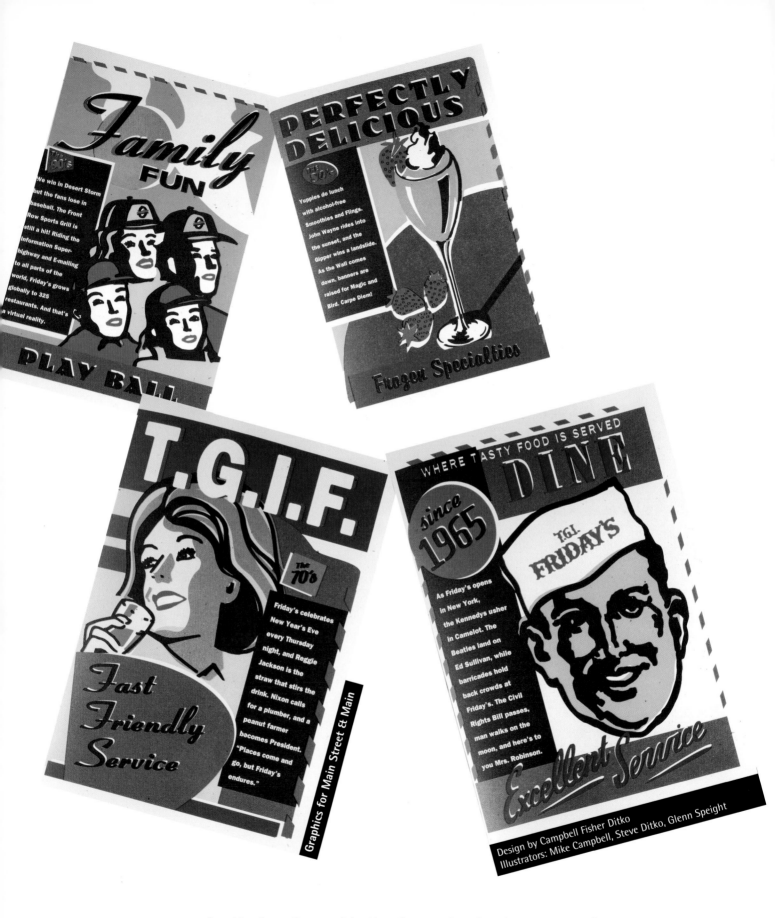

Graphics for a theme celebrating the past four decades were created to have the flat tones and offset look of old labels and matchbook art. A deliberately off-register look creates highlights and shadows in white.

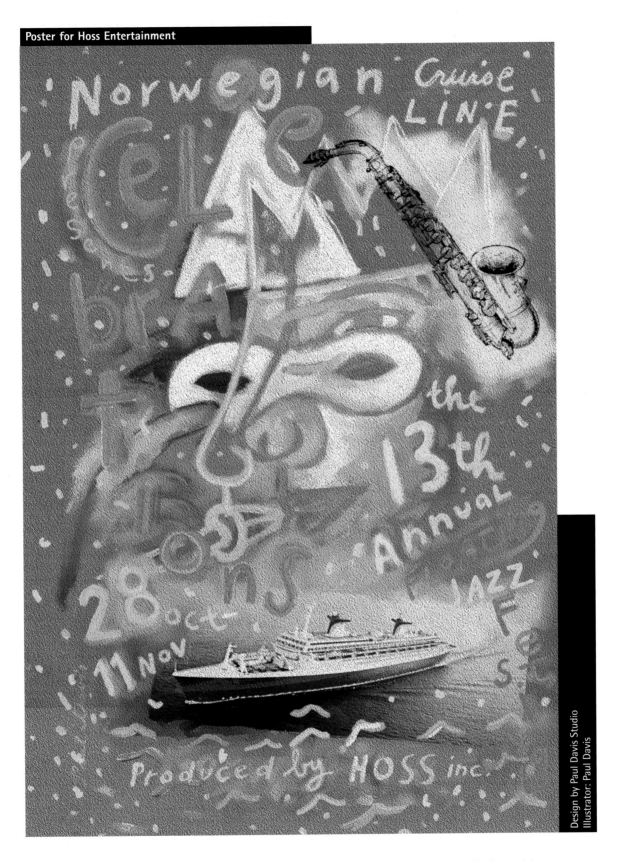

Design by Paul Davis Studio
Illustrator: Paul Davis

Paul Davis' poster promoting a jazz festival aboard a cruise ship features a painting with an improvisational flair in a color scheme that seems to light up an evening sky, complete with floating confetti, spontaneous lettering, and layered images.

BLUE SKY DESIGN

Design by Blue Sky Design
Designers: Robert Little, Joanne Little, Maria Dominguez

The business card for Blue Sky Design
features—you guessed it—a blue sky with
fluffy clouds on one side, with a block of
solid sunny yellow on the other. A logo
designed in red assures readability.

Business card for Blue Sky Design

JOANNE C. LITTLE
Vice President & Creative Director

10300 Sunset Drive, Suite 353, Miami, Florida 33173
Telephone 305·271·2063 Facsimile 305·271·2064

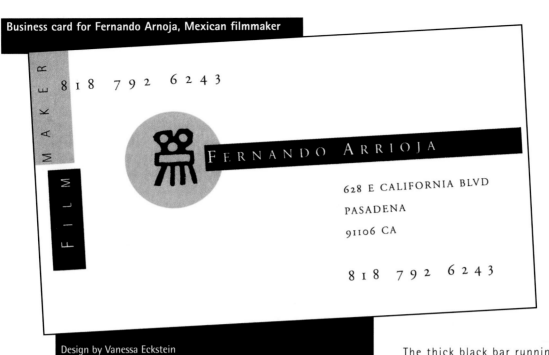

Design by Vanessa Eckstein

The thick black bar running out from a projector makes this filmmaker's name appear to be part of an opening credit sequence to a movie. Highlights in yellow draw attention to key elements.

Business card for Glazer Graphics

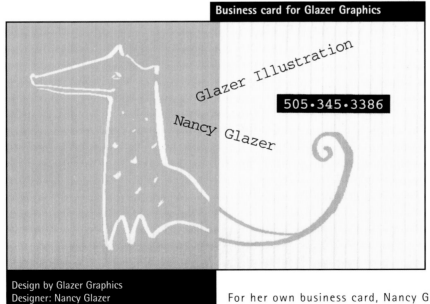

Design by Glazer Graphics
Designer: Nancy Glazer

For her own business card, Nancy Glazer plays with negative and positive elements, with an illustration appearing as a cream-colored line drawing on yellow on one side, and the reverse on the other.

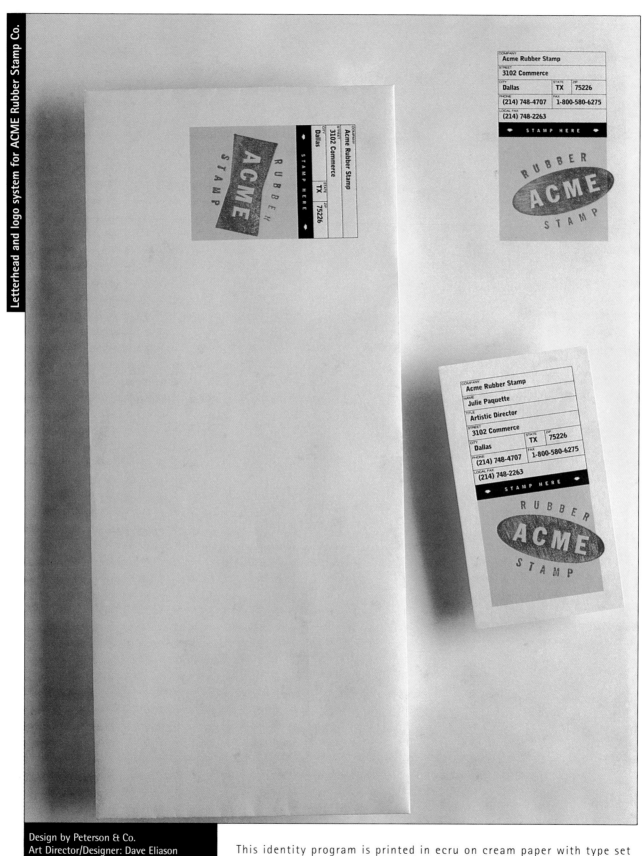

Design by Peterson & Co.
Art Director/Designer: Dave Eliason

This identity program is printed in ecru on cream paper with type set in an industrial-looking grid format. A third color is added when the logo is (appropriately) rubber-stamped in red ink.

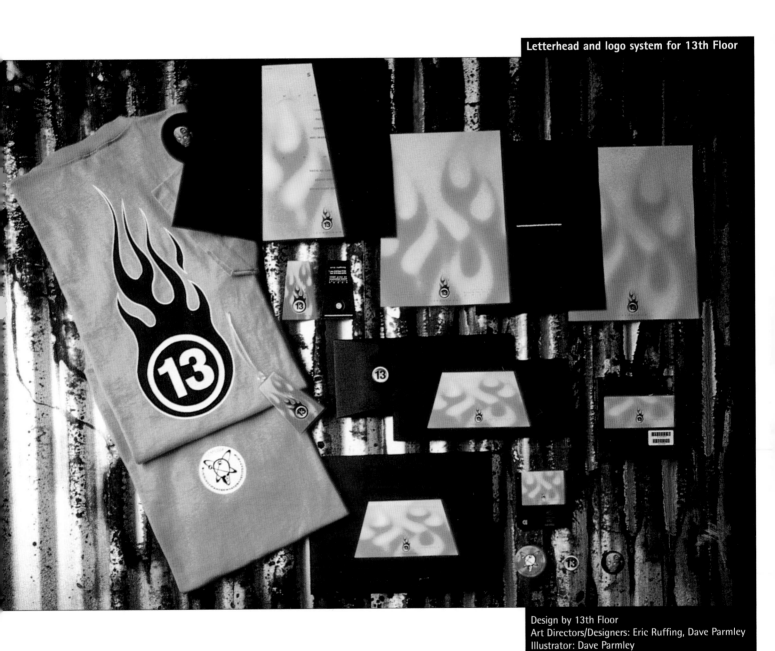

Letterhead and logo system for 13th Floor

Design by 13th Floor
Art Directors/Designers: Eric Ruffing, Dave Parmley
Illustrator: Dave Parmley

Flames in orange and yellow climb seductively up
stationery and other printed pieces for 13th Floor. Added
sizzle is created when the flame labels are applied to
black backgrounds on envelopes and floppy disks.

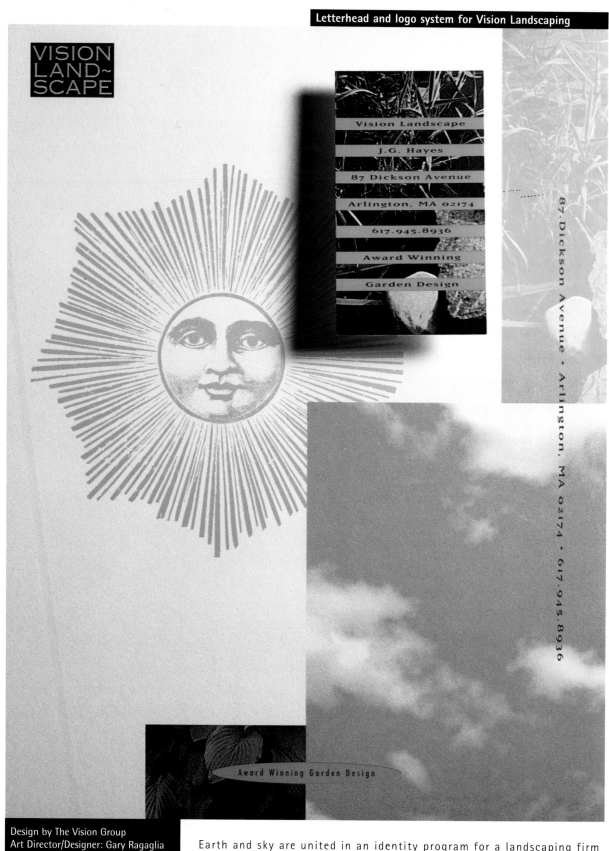

VISION LAND~ SCAPE

Vision Landscape

J.G. Hayes

87 Dickson Avenue

Arlington, MA 02174

617.945.8936

Award Winning

Garden Design

87 Dickson Avenue · Arlington, MA 02174 · 617.945.8936

Award Winning Garden Design

Design by The Vision Group
Art Director/Designer: Gary Ragaglia

Earth and sky are united in an identity program for a landscaping firm through applications of blue and yellow on white paper. A business card is covered with rays of sun in yellow bars with black type.

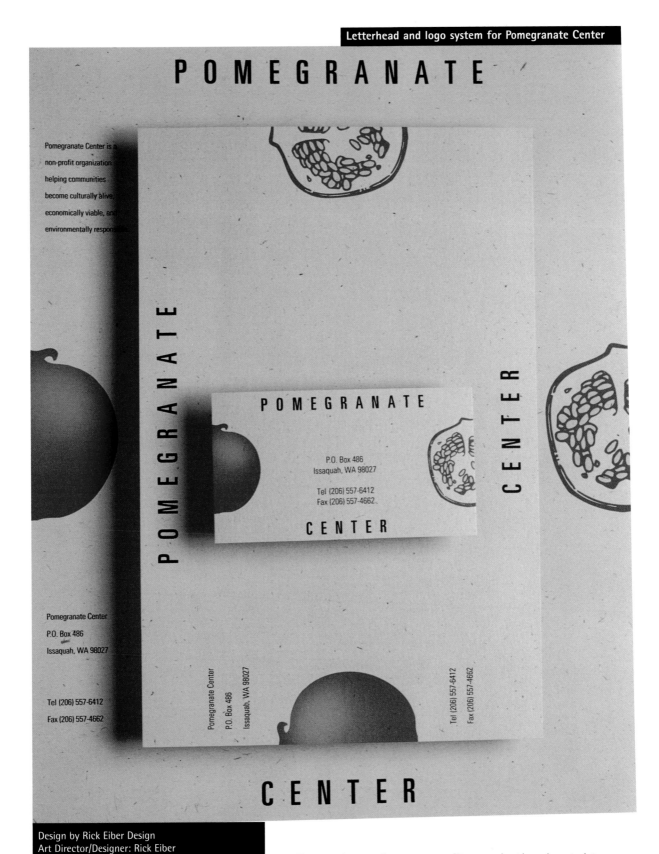

POMEGRANATE

Pomegranate Center is a
non-profit organization
helping communities
become culturally alive,
economically viable, and
environmentally responsible.

POMEGRANATE

CENTER

POMEGRANATE

P.O. Box 486
Issaquah, WA 98027

Tel (206) 557-6412
Fax (206) 557-4662

CENTER

Pomegranate Center
P.O. Box 486
Issaquah, WA 98027

Tel (206) 557-6412

Fax (206) 557-4662

Pomegranate Center
P.O. Box 486
Issaquah, WA 98027

Tel (206) 557-6412
Fax (206) 557-4662

CENTER

Design by Rick Eiber Design
Art Director/Designer: Rick Eiber
Illustrator: David Verwolf

The stationery for a nonprofit organization devoted to
environmental causes reflects the group's green philosophy,
and its namesake fruit, with its speckled recycled paper
and deep-red images of the pomegranate fruit.

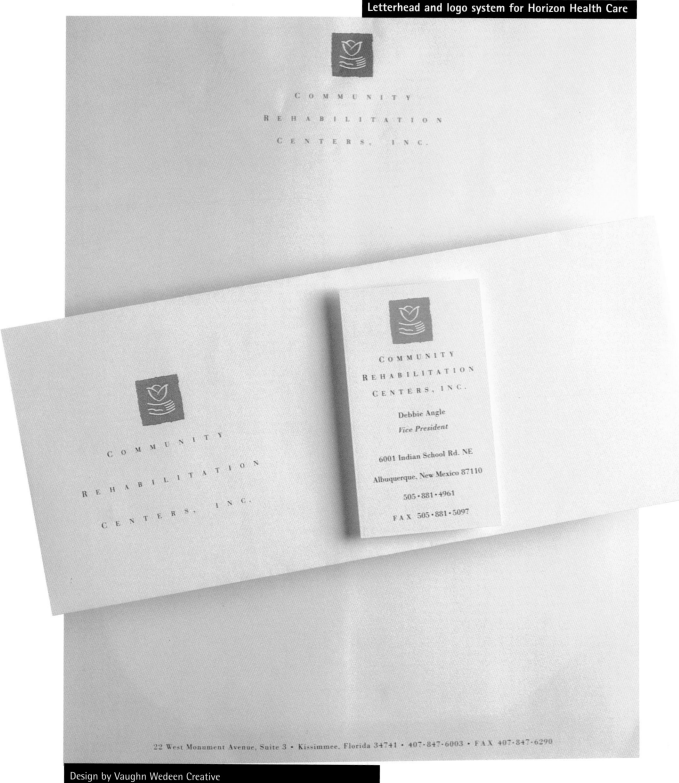

Design by Vaughn Wedeen Creative
Art Directors: Steve Wedeen, Dan Flynn
Designer/Illustrator: Dan Flynn

A soft, gentle image was created for this rehabilitation center through an identity program featuring a logo of a hand cradling a flower, printed in earthy shades of forest green, rust, and mocha brown on cream paper.

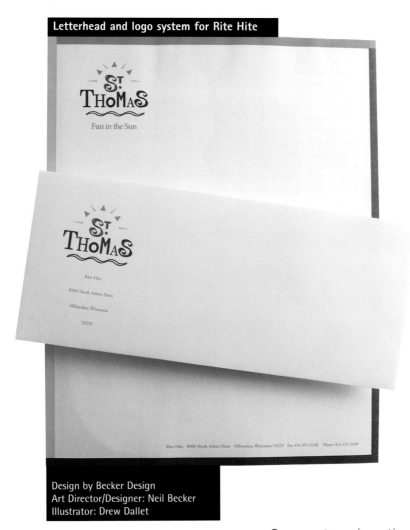

Letterhead and logo system for Rite Hite

Design by Becker Design
Art Director/Designer: Neil Becker
Illustrator: Drew Dallet

To promote an incentive program offering a trip to St. Thomas, special stationery was created that reflects the festive mood of the island, with a lively logo in a variety of typefaces and colors and borders in bands of orange, yellow, green, and blue.

DAVID GIERSDORF

CHRISTIANSEN FRITSCH GIERSDORF GRANT AND SPERRY INC.

 is the essence of graphic
communication. When a typeface is carefully selected and skillfully used, it can
enhance the meaning of the written word and communicate a message instantly and
effectively to the intended audience. Conversely, when a typeface is mismatched to a
project, the results can have a opposite effect, ranging from the banal to the
downright illegible.

The last ten years have seen an explosion in the creation and distribution of digital
typefaces. Once the province of a handful of large type foundries, the type
industry has grown to include hundreds of
small type design studios creating and
marketing their own niche products. The
demand for typefaces has also grown
tremendously, with the explosion of desktop
publishing technology and the growth of
home office businesses. While most graphic

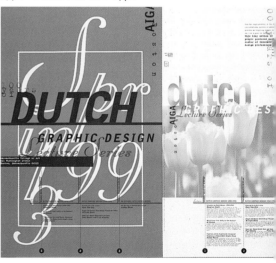

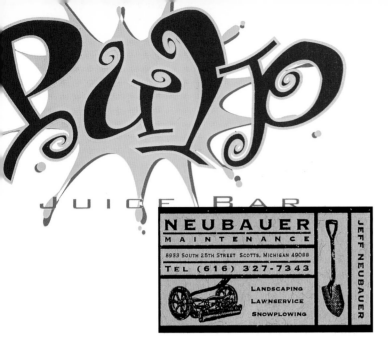

designers were once happy to rely on a core group of favorite classic typefaces and a handful of display designs, they now have tens of thousands to choose from for their projects. The range of choices can be daunting, but it is also inspiring. One need not look far to find an edgy display face for a snowboard product aimed at Gen X-ers, or an elegant version of Bodoni for a limited edition book.

This book features ninety examples of creative, innovative, and appropriate uses of type in projects ranging from business cards to brochures to self-promotional mailers. Some projects may use a beautiful script letter as a central element in the design, while others take a more subtle, understated approach, using a carefully selected, classic sans serif style. Whatever the choice, these projects reveal a love of letters-and a sensitivity to the message at hand.

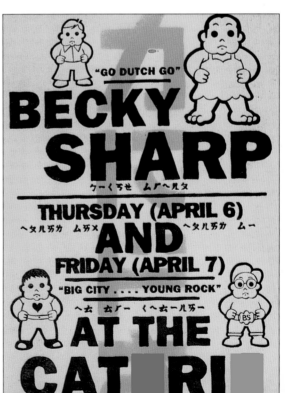

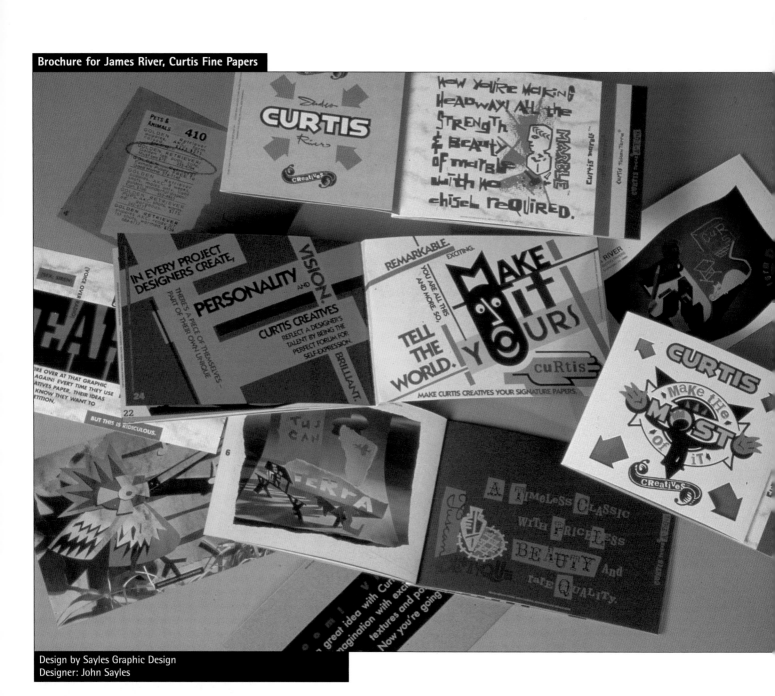

Brochure for James River, Curtis Fine Papers

Design by Sayles Graphic Design
Designer: John Sayles

To promote Curtis Fine Papers as being the ultimate vehicle of self-expression, John Sayles incorporated a variety of provocative display faces in this promotional piece for James River.

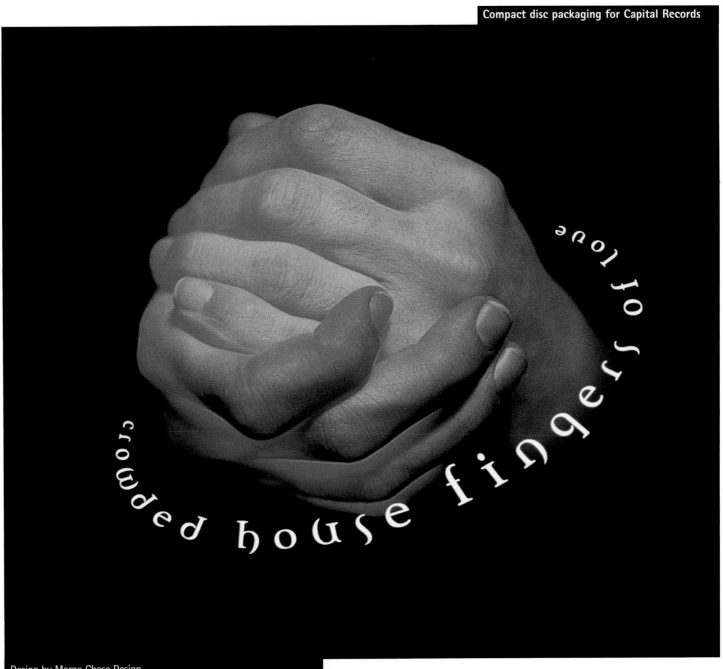

crowded house fingers of love

Design by Margo Chase Design
Art Director/Designer: Margo Chase
Photographer: Sidney Cooper

Los Angeles designer Margo Chase
selected Envision, her own curvy font,
to wrap text around the global sphere
created by clasped hands for this CD
design for pop group Crowded House.

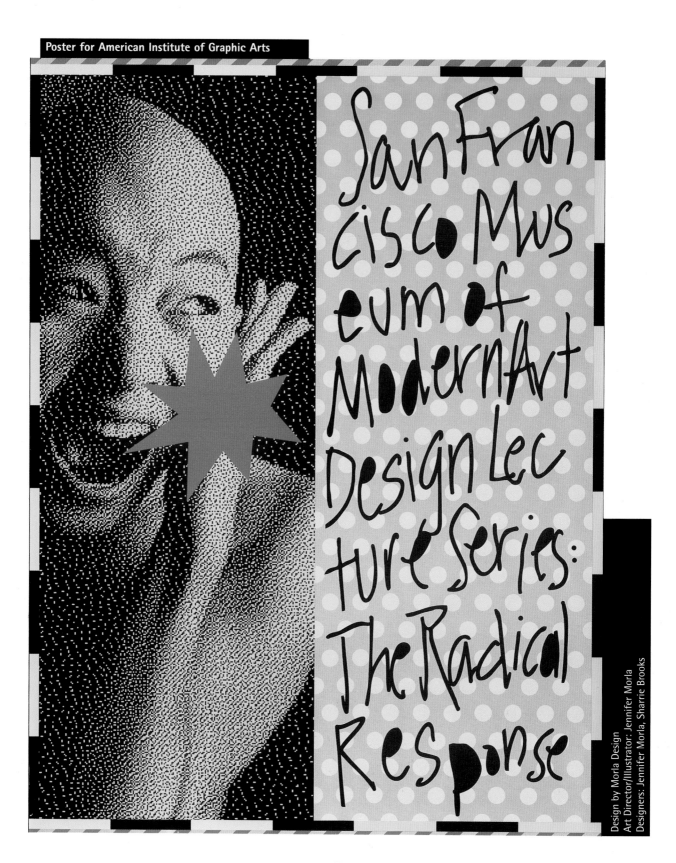

Poster for American Institute of Graphic Arts

San Fran cisco Mus eum of Modern Art Design Lec ture Series: The Radical Response

Design by Morla Design
Art Director/Illustrator: Jennifer Morla
Designers: Jennifer Morla, Sharrie Brooks

The use of a scrawl-like handwritten font emphasizes the radical aspect of this museum lecture series on design issues and lends an immediacy and urgency to the message.

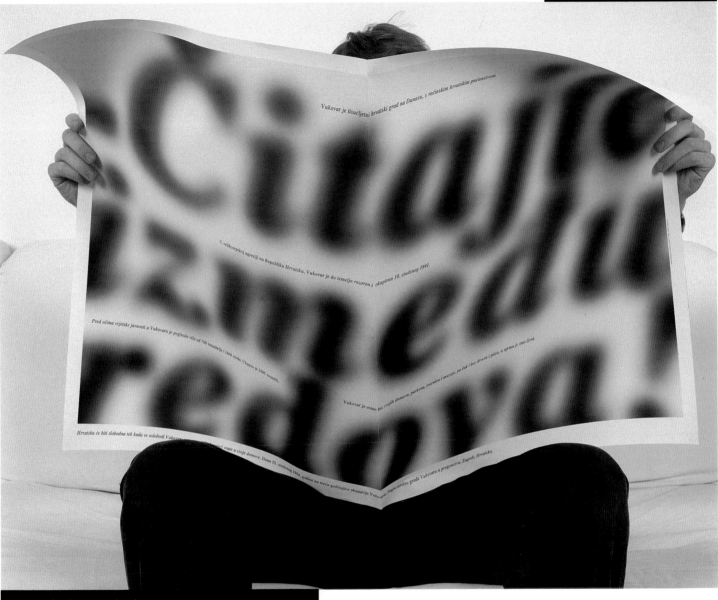

Design by Studio International
Designer: Boris Ljubicic
Photographer: Damir Fabijanic

This political poster from Studio International takes a literal spin on a well-known metaphor. Each side uses blurry, greatly enlarged type to command readers in English and Croatian to "read between the lines"; when they do, they learn of the forced occupation of the Croatian town of Vukovar in 1991.

Design by COY
Art Director: John Coy
Designers: John Coy, Rokha Srey

With wit and style, COY Design turns the tables on its custom furniture client by spelling out the retailer's name using furniture and a computer font in this identity package.

Letterhead and logo system for Laughing Dog Creative, Inc.

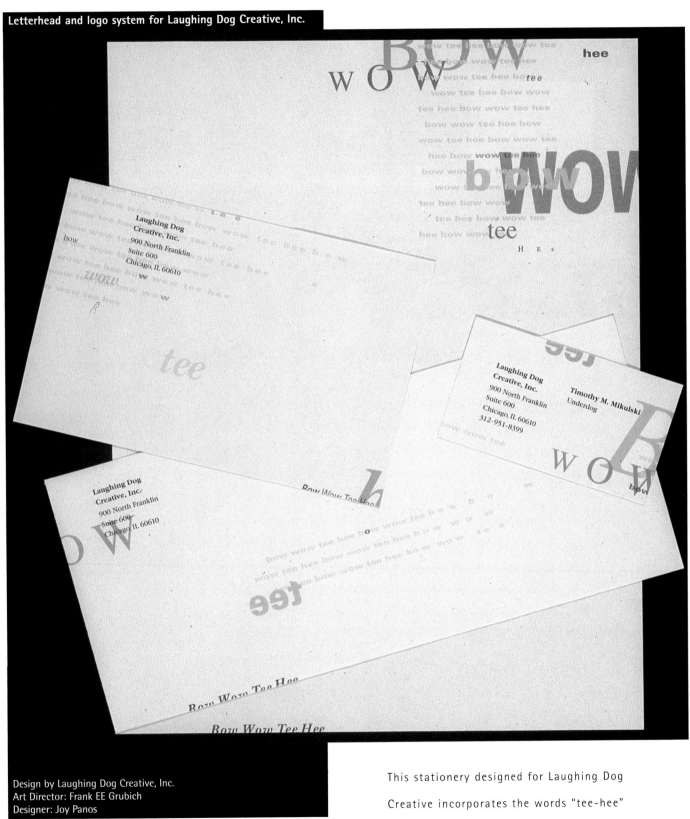

Design by Laughing Dog Creative, Inc.
Art Director: Frank EE Grubich
Designer: Joy Panos

This stationery designed for Laughing Dog Creative incorporates the words "tee-hee" and "bow-wow," set in varying sizes of overlapping serif and sans serif type, for a playful effect.

Journal for Pennsylvania State University School of Visual Arts

robert reczka

m a r y
j e a n
kenton's
freedom

(with limits)

The interpretation of art often implicitly relies on illusions of closure which conceal the complexity, ambiguity, and exercises of power in any era,

encouraging audiences to project the generalized motives of an approach or movement onto any artist whose work resembles that style. This issue is

relevant to Mary Jean Kenton's art which has a variety of sources rather than one distinct allegiance and does not fall into a single category. Kenton

is an artist and writer whose artwork of the last twenty years consists of painted systemic abstractions and related installations. She has long

58 59

Design by Penn State Design Practicom
Art Director: Lanny Sommese
Designers: Scott Patt, Brett M. Critchlow

The cover design and layout treatment for the Penn State *Journal of Contemporary Criticism* eschews the usual staid academic journal format by taking a more graphic approach, with layouts using contemporary sans serif typefaces and abstract black-and-white type treatments to emphasize content.

Identity system for Elixir Design Co.

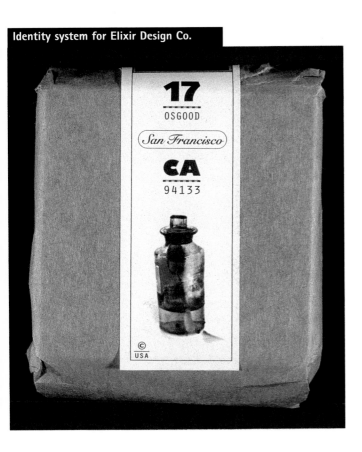

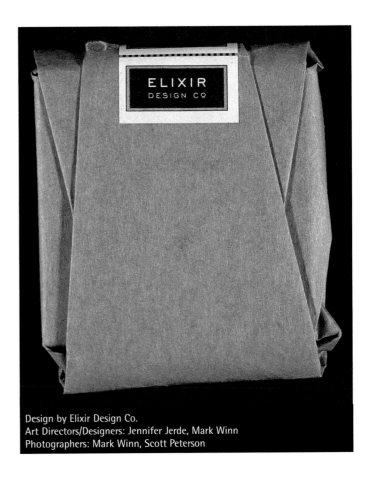

Design by Elixir Design Co.
Art Directors/Designers: Jennifer Jerde, Mark Winn
Photographers: Mark Winn, Scott Peterson

Elixir Design in San Francisco has an affinity for metal typefaces, letterpress printing, and tactile paper. This self-promotion piece plays off the company name with a mailing label showing an image of pharmaceutical bottle complemented with text set in a range of metal typefaces.

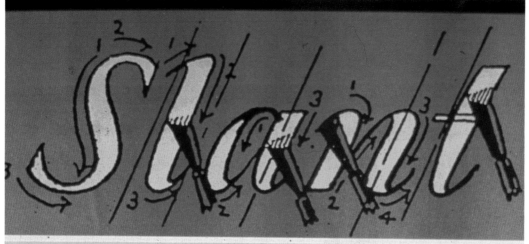

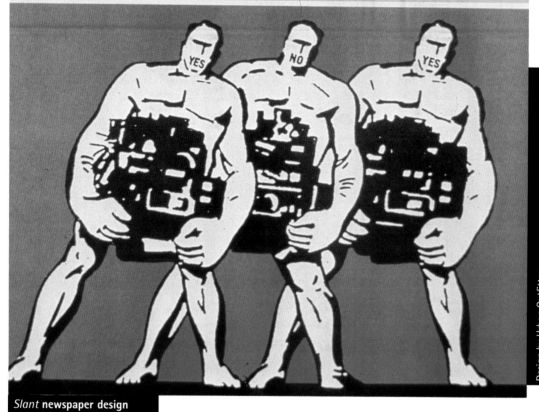

Slant **newspaper design**

Design by Urban Outfitters
Creative Director/Editorial Director/Typography: Howard Brown
Art Directors: Howard Brown, Art Chantry
Designer: Art Chantry

An old-fashioned lettering instruction book
provided the inspiration for Howard Brown's logo
design for *Slant*, a tabloid newspaper published
quarterly by retailer Urban Outfitters for their
young, trend-conscious customers.

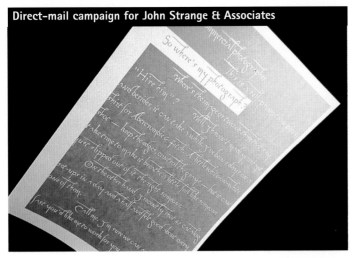

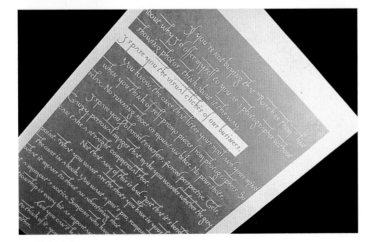

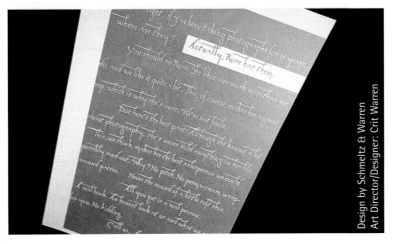

To help a new photography studio launch its business, design firm Schmeltz & Warren avoided showing photographs altogether, instead opting for a more elegant solution for these letters sent to prospective clients. Although the text of the letters was frank in its appeal for business, the use of a graceful, calligraphic script helped lend an ironic twist.

Design by Schmeltz & Warren
Art Director/Designer: Crit Warren

Direct-mail campaign for The Nelson-Atkins Museum of Art

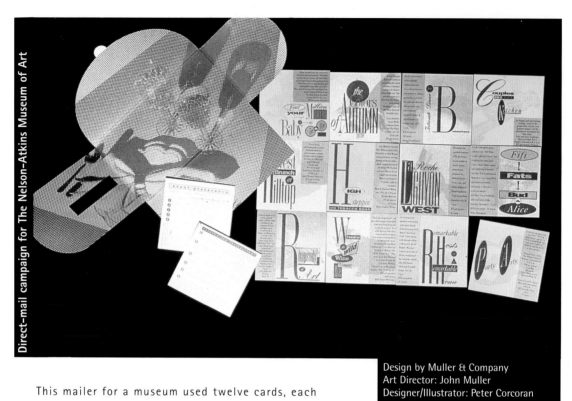

Design by Muller & Company
Art Director: John Muller
Designer/Illustrator: Peter Corcoran

This mailer for a museum used twelve cards, each describing a fund-raising event. To make each one stand out, drop caps were selected for key words to emphasize unique aspects of each occasion, while text was poured in ragged columns to the right or left.

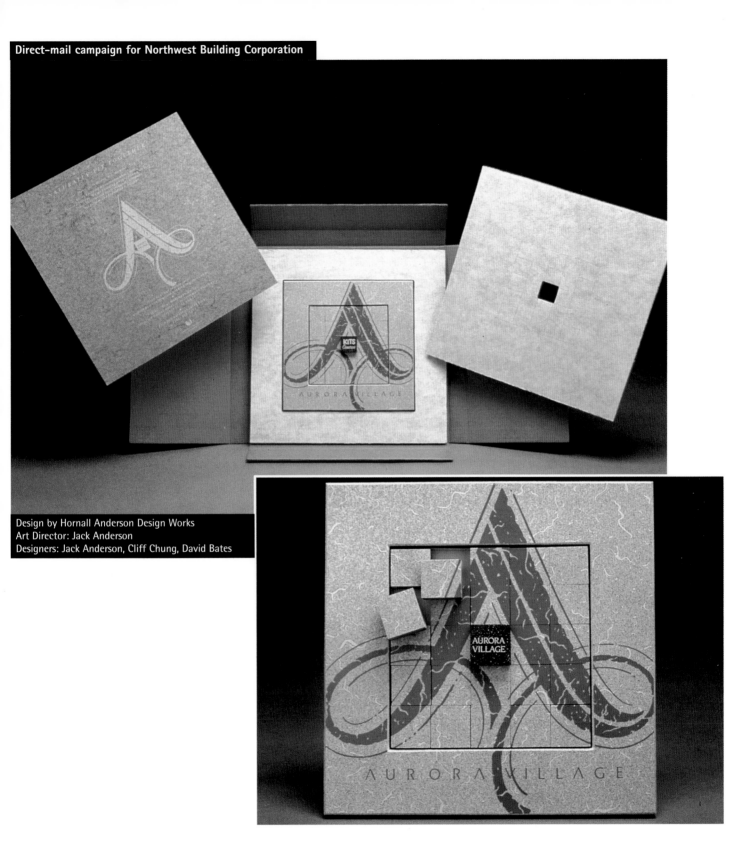

Design by Hornall Anderson Design Works
Art Director: Jack Anderson
Designers: Jack Anderson, Cliff Chung, David Bates

A new identity for a shopping center was mailed to prospective tenants in the form of a puzzle that incorporated the Aurora Village logo. The stylized *A*, which when viewed upside down, can be seen as an equally distinctive letter *V*.

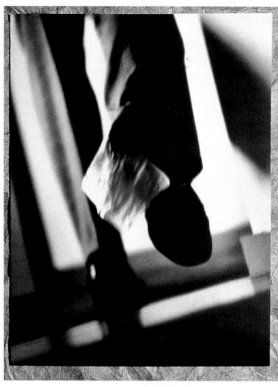
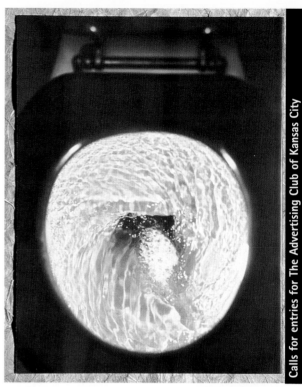

For this series of calls for entry to the Kansas City Advertising Club's 1994 Omni Awards, the typeface of choice was Courier, a typewriter-like font that adds an edgy immediacy to the copy, which humorously portrays the bathroom as being the center of all creative activity. Type was set in reverse, and plumbing-related words such as "flow" and "flushed" were called out in larger point sizes.

Design by Muller & Company
Art Director/Designer: John Muller
Photographer: Dan White, Mike Regnier, Hollis Officer, Nick Vedros, Dave Ludwigs, Darryl Bernstein, Steve Curtis

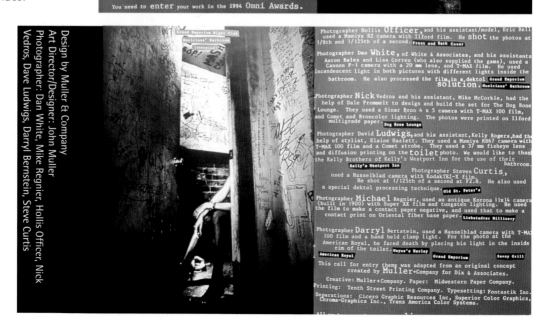

The German
words for
thirst *(durst)*
and silence
(stille) are
graphically
connected
with a
diagonal line
of copy that
shows the
progression
of spiritual
advancement
offered by a
session of
meditation.

Invitation to spiritual exercises poster for Bistum Munster

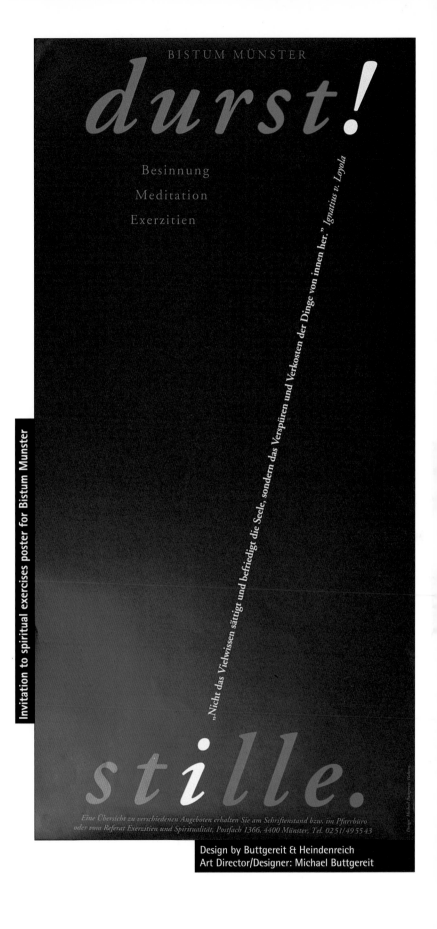

Design by Buttgereit & Heindenreich
Art Director/Designer: Michael Buttgereit

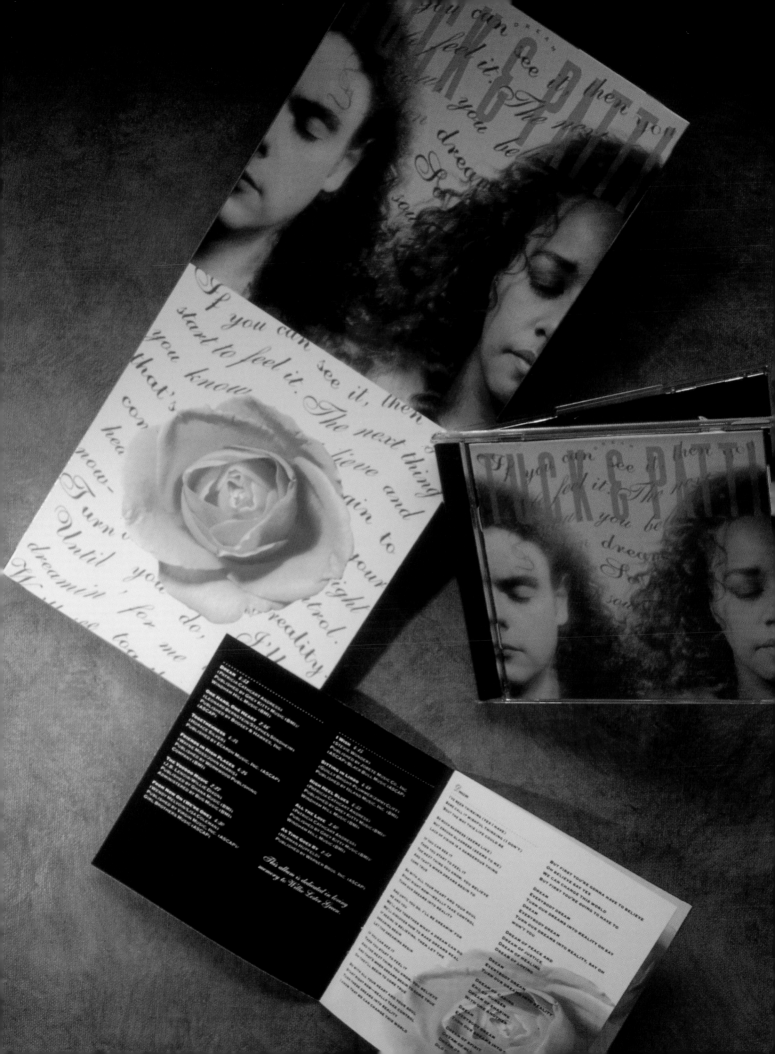

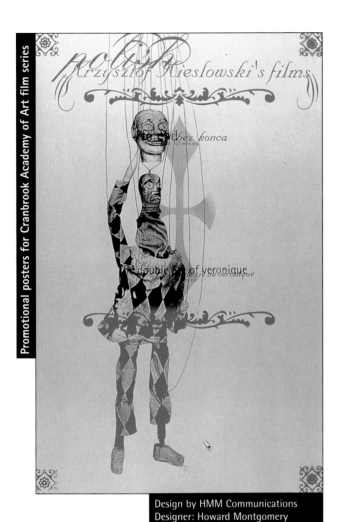

Promotional posters for Cranbrook Academy of Art film series

Design by HMM Communications
Designer: Howard Montgomery

A poster for a film series featuring the works of Polish director Krzysztof Kieslowski creates intrigue with a central image of a two-headed marionette enhanced with a title presented in layers of flourished script type and early twentieth-century corner ornaments.

Packaging for Tuck & Patti compact disc

Design by Morla Design
Designers: Jeanette Aramburu, Jennifer Morla

Morla Design's compact disc packaging for a Tuck & Patti release entitled *Dream*, creates a surreal mood with sepia-toned images of the somnolent duo with lyrics of the title song set in curved lines of romantic script.

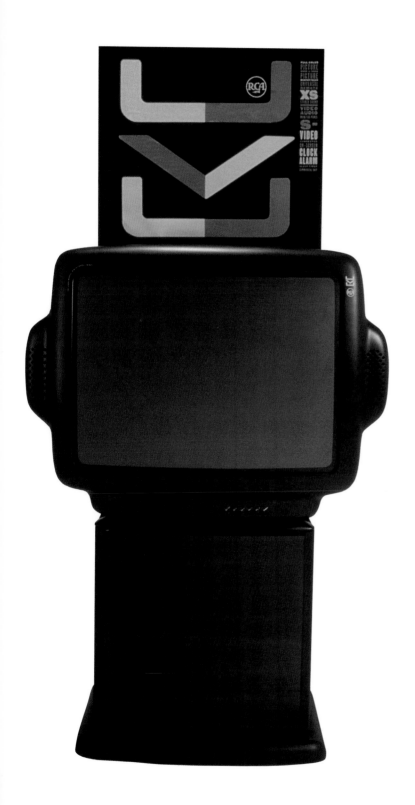

Packages, T-shirts, and other printed pieces for RCA's UVU television were designed by Paula Scher and Ron Louie of Pentagram Design with bold, abstract initial letters and a black-and-orange color scheme for a high-impact and high-contrast effect.

UVU television boxes

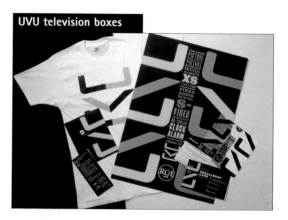

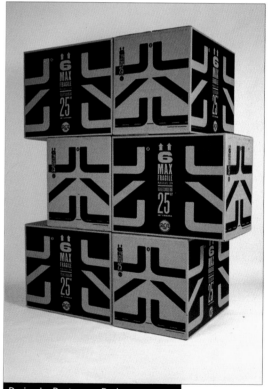

Design by Pentagram Design
Designers: Paula Scher, Ron Louie

Design by Pentagram Design
Art Director/Designer: Paula Scher

Paula Scher's signature style is a bold, expressive use of letterforms. For this poster promoting the International Design Renaissance Congress, she superimposed uppercase Helvetica letters with lowercase Bodoni, suggesting the commingling of two eras of design.

To promote the Independent Project Press' library of typefaces and ornaments, Bruce and Karen Licher printed this catalog on their own Vandercook letterpress with typefaces that reflect their affinity for wood and metal typeface revivals.

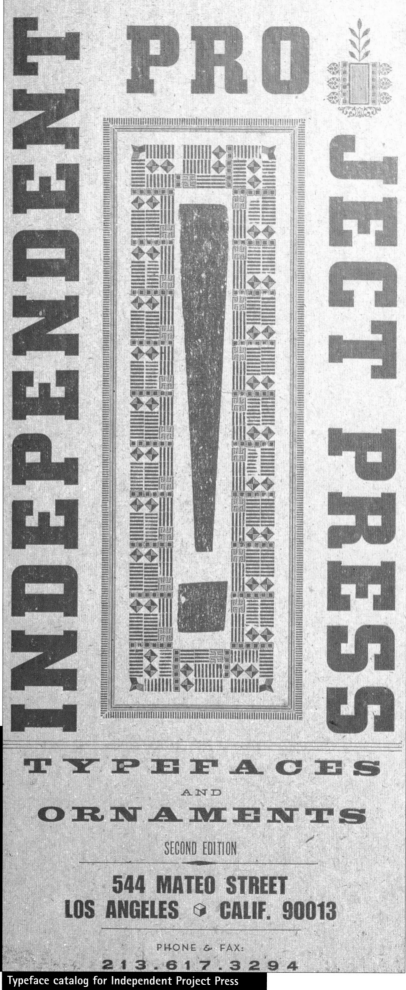

Design by Independent Project Press
Art Directors/Designers: Bruce Licher, Karen Licher

Typeface catalog for Independent Project Press

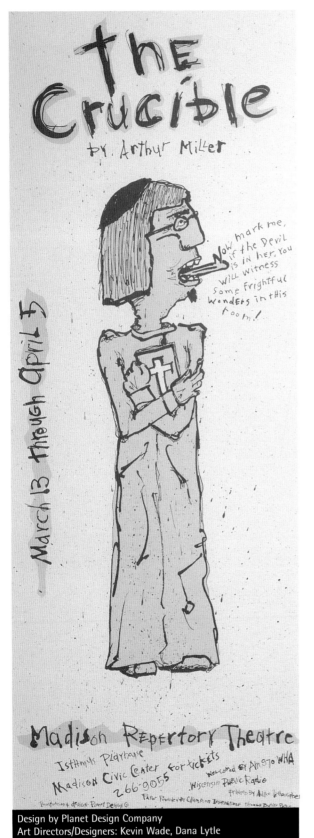

Design by Planet Design Company
Art Directors/Designers: Kevin Wade, Dana Lytle

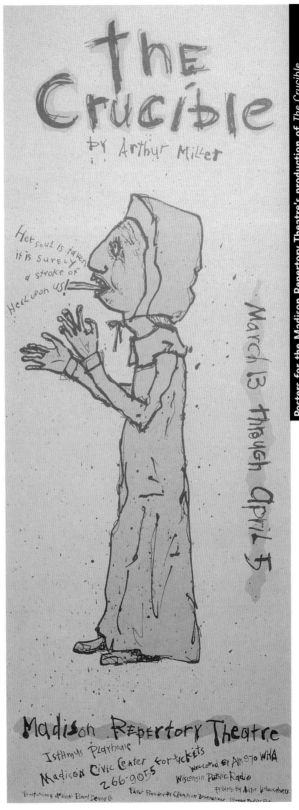

This poster for Arthur Miller's dramatic statement about the 1950s McCarthy hearings shows a deliberately crude illustration by Kevin Wade accompanied by hand-rendered letterforms that emphasize the play's emotionally charged atmosphere.

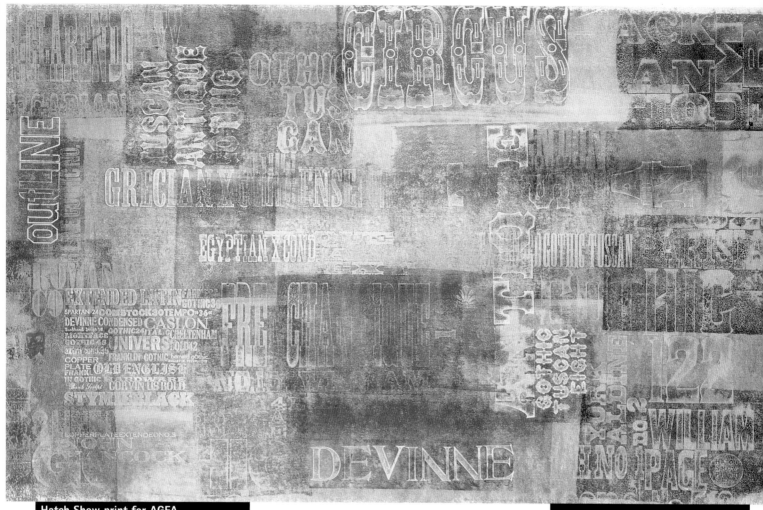

Hatch Show print for AGFA

Design by Segura, Inc.,
Printing: Hatch Show Print

Plates carved from wooden blocks printed this richly layered typographic collage. The font design intricately blends point sizes and kerning in a geometric tapestry of type; the degenerated look of the type adds authenticity.

Layouts in this issue of the Agfatype Idea Catalog use Agfa

typefaces favored by Chicago-area graphic designers and art

directors. The front and back cover of the issue, designed by

Carlos Segura and illustrator Stephen Farrel takes a ransom-note

approach, with letters photocopied and pasted down, emphasizing

the intuitive nature of the design process.

Design by Segura, Inc.
Art Director/Designer: Carlos Segura
Illustrator: Stephen Farrell

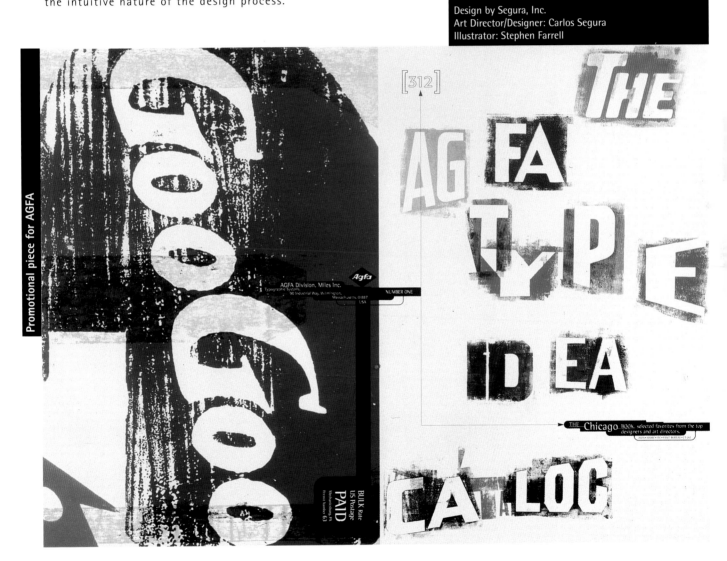

Promotional piece for AGFA

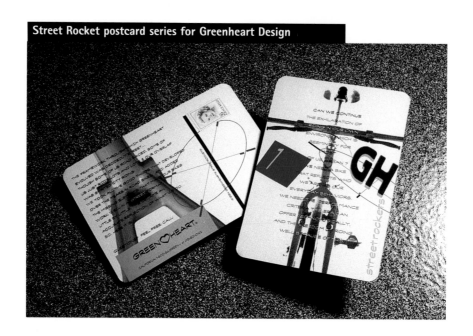

Street Rocket postcard series for Greenheart Design

These postcards for Greenheart Design promote the company's Street Rocket bicycles with photographs of bicycle details layered with text set in a friendly, open display font. A floating company logo in italic, dimensional letterforms, suggests muscle and movement.

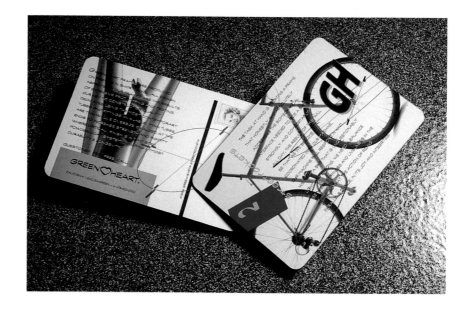

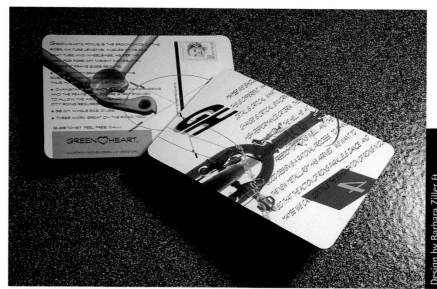

Design by Barbara Ziller &
Associates Design
Art Directors/Designers: Barbara
Ziller, Andrew Graef
Photographer: Kevin Sanchez

bitch, moan, groan, whine, curse, complain, grumble, gripe, reject, refuse, grouch, vote, neglect, protest, procrastinate, postpone, defend, ignore, depl...

It's time to stop talking and do something. Like participate. And vote.

The annual election of the communicating arts group board of directors will be held

thursday november 19 at tomato's (3131 sports arena blvd). Talk starts at 6. Food

(good italian stuff) at 7. Guest speaker bob kwait (award-winning zoo guy) at 7:45. Election at 8:15. Members

pay $12. Non-members $15. (People who make a reservation and don't show will be billed.) If you can't make

it then (at least) send in the proxy ballot. Mark 3 choices or write in some different ones:

o frank cleaver (vp fine arts store) o rebecca debreau (graphic design, m.c.w.e.)

o diane ditucci (sales, arts and crafts press) o elyce ellington (graphics manager, m.c.w.e.)

o laura koonce-jose (computer production quorum) o linda lampman (art director,

lambesis communications) o tom okerlund (copywriter/art director, kpbs-tv) o someone (anyone)

else: _____ . Sign your name here _____ and mail

to cag (3108 5th ave suite f san diego 92103) by november 17 or fax (295-3822) by november 19.

Design by Mires Design, Inc.
Art Director/Designer: John Ball
Illustrator: David Quattrociocchi

A twist on the caveat, "read between the lines," the message on this piece for

the Communicating Arts Group shouts out over the lines. Body text urges club

members to cast their ballot in an annual board-member election, while headline

tells them to put their money where their mouth is. It is a classic example of a

disarming typographic solution with simplicity at its core.

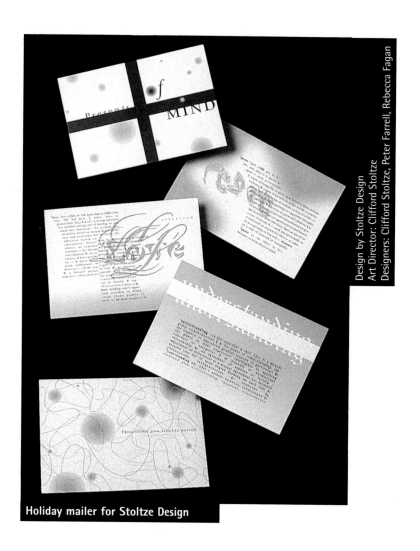

Design by Stoltze Design
Art Director: Clifford Stoltze
Designers: Clifford Stoltze, Peter Farrell, Rebecca Fagan

Holiday mailer for Stoltze Design

A holiday self-promotion by Stoltze Design in Boston featured postcards with the words *peace*, *love*, and *understanding*. Each postcard wove together text with the key word as a central, expressive calligraphic visual.

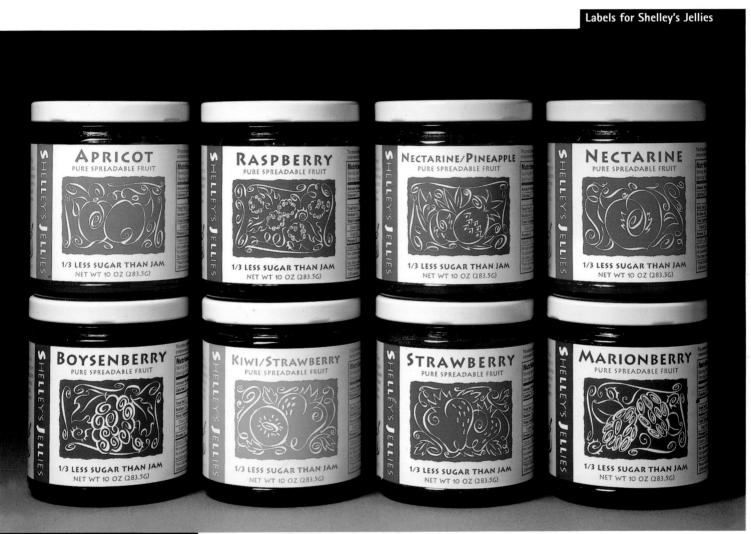

Design by Charney Design
Art Director/Designer: Carol Inez Charney
Illustrator: Kim Farrell

A clean, open and contemporary sans serif font was chosen for label copy for Shelly's Jellies. The typeface selection complements Kim Ferrell's whimsical illustration style and conveys the purity of the all-natural spreadable fruit.

Working with the theme "Expand Your Horizons" for the Western Regional Greek Conference held in San Francisco, John Sayles used a bridge metaphor to reflect the topic and location of the event in this promotional brochure. The piece takes a horizontal format with letterforms spelling out the conference title in a bridge-like configuration.

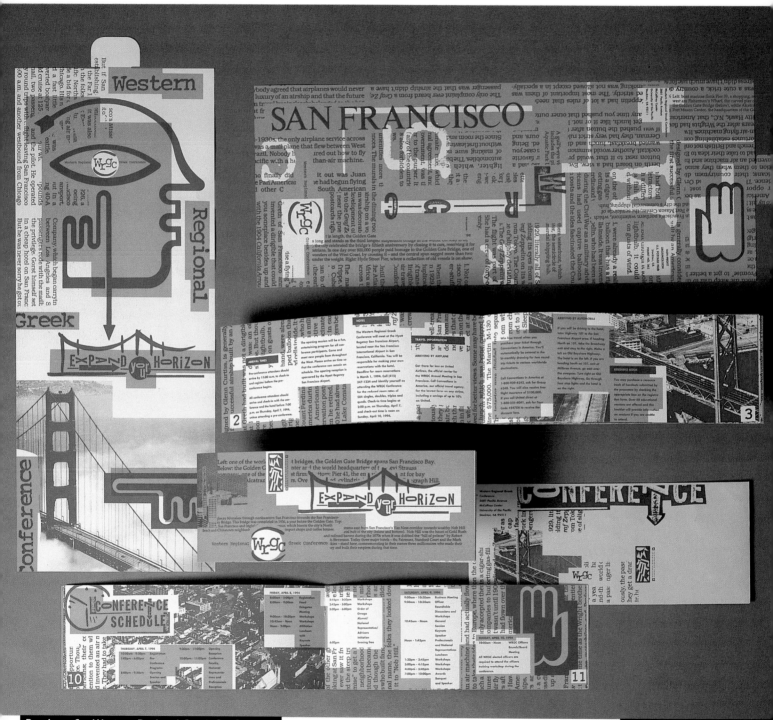

Brochure for Western Regional Greek Conference

Design by Sayles Graphic Design
Designer: John Sayles

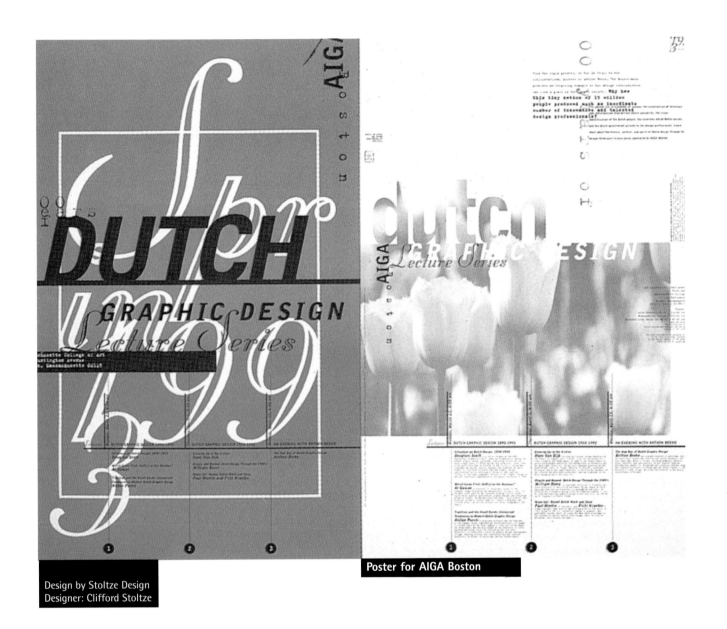

Design by Stoltze Design
Designer: Clifford Stoltze

Poster for AIGA Boston

This poster was created by Stoltze
Design in Boston to promote an AIGA
lecture series on Dutch graphic design.
Its elliptical use of a range of
contemporary typefaces layered with
photographic images reflects Holland's
rich heritage for clean, yet
experimental design.

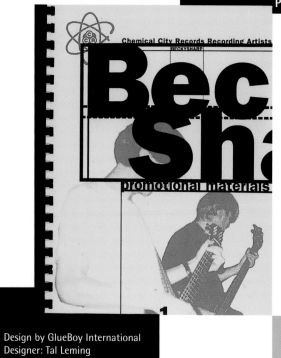

Design by GlueBoy International
Designer: Tal Leming

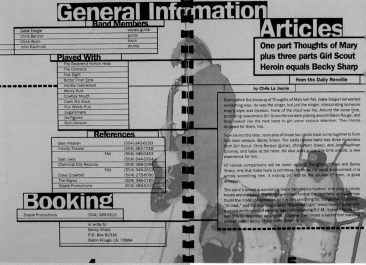

Layouts for this promotional booklet for Becky Sharp, a Chemical City Records recording artist, incorporate a rectangular grid with boldface headline type dropped out of black bars and text and callouts poured into boxes.

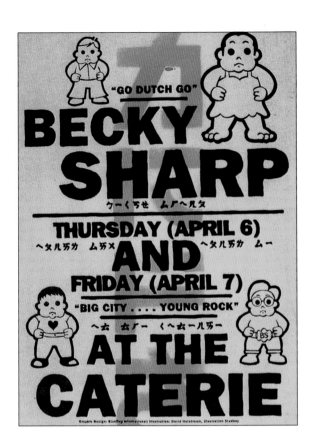

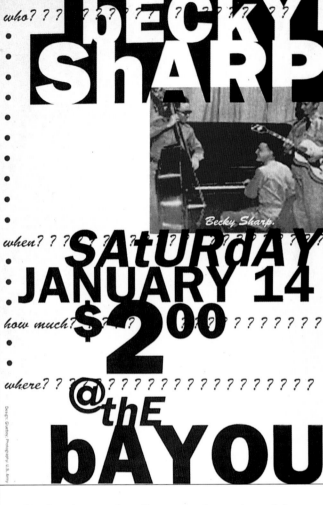

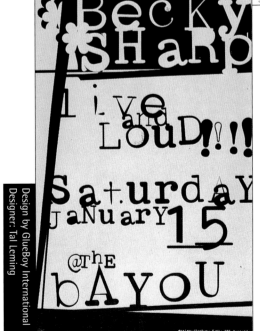

Design by GlueBoy International
Designer: Tal Leming

GlueBoy International's posters for rock musician Becky Sharp playfully mock contemporary Japanese graphics by displaying Kanji letterforms as a background and foreground element combined with garbled translations of English phrases. GlueBoy International designed these two posters to be reproduced on a copier. Text was set in various point sizes and layered for a deliberately unslick look appropriate for a rock performance.

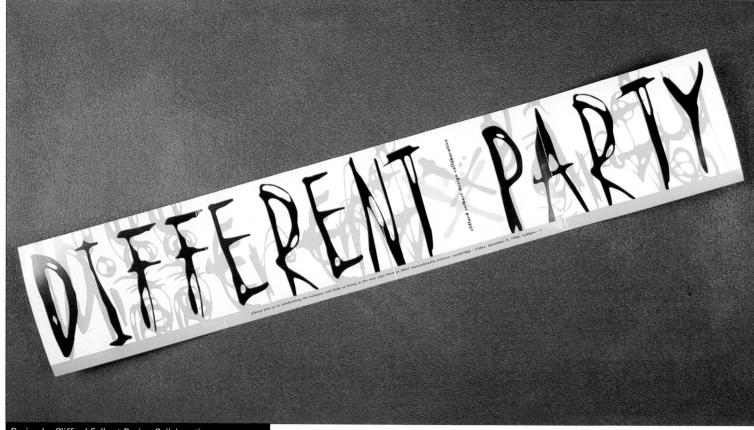

Design by Clifford Selbert Design Collaborative
Art Director: Clifford Selbert
Designers: Clifford Selbert, Jodi Singer, Nancy Brown

This invitation to a holiday party by the Clifford Selbert Design Collaborative takes full advantage of the drama that can be achieved by using two highly contrasting typestyles. The words, "same office" on the outside flaps are set in a neutral sans serif; when the "doors" are opened, the words "different party," pops out in a rough-hewn, funky display face, promising that this will be no ordinary fete.

This annual report for Anheuser-Busch Employee's Credit Union emphasizes financial strength and a sense of community with key phrases such as "working together" and "financial health" shown elliptically with portions of the letters or words missing, creating a mood matching the accompanying photographs.

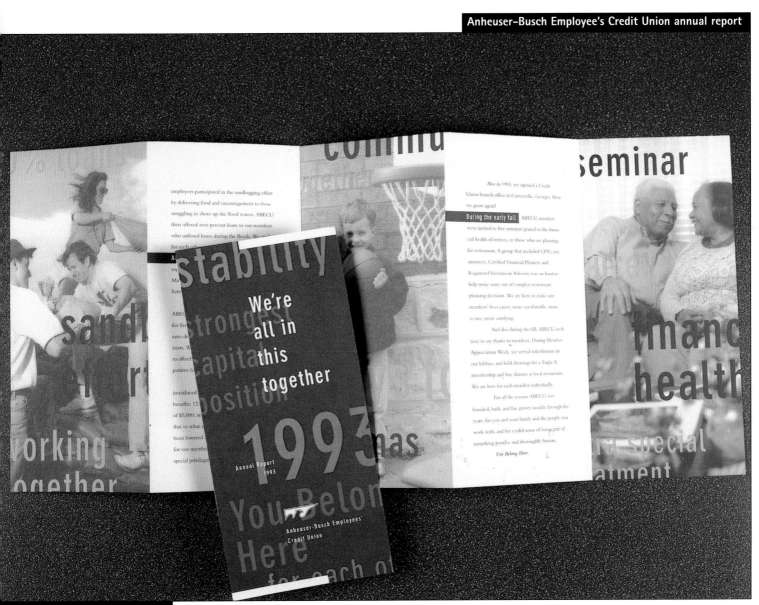

Design by Kiku Obata & Company
Art Director/Designer: Pam Bliss
Photographer: Stephen Kennedy

This promotional poster by Carlos Segura for the band Counting Crows pairs an image of lead singer Adam Duritz distorted in Photoshop with type distressed on a copier.

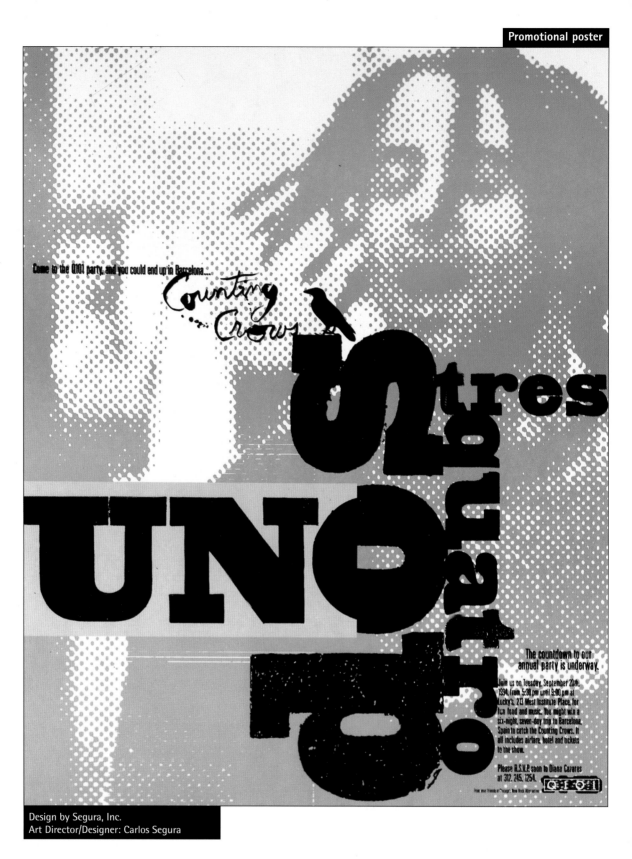

Design by Segura, Inc.
Art Director/Designer: Carlos Segura

Selected Notes 2 ZeitGuys is an interactive font project created by Aufuldish & Warinner and distributed by Emigre. Created as an "exquisite corpse," where each author picks up where the last ended, the project promotes the 126 collected illustrations that comprise the *ZeitGuys* font. The piece uses a navigational device that allows users to pass the cursor over out-of-focus images and type to make the characters pop into view.

click on a page to see it again

Selected Notes 2 ZeitGuys CD-ROM for Zed

click on exit to leave

EX IT

text by Mark Bartlett
design by Bob Aufuldish
images by Eric Donelan

Eric Donelan
statement about *the images*

Mark Bartlett
statement about *the text*

Bob Aufuldish
statement about *the design*

Selected Notes to ZeitGuys

Eric Donelan

ZeitGuys is a collection of 126 images in font format which form a new poetical language to buttress the burned-out shell which is alphabetic communication.

ZeitGuys is an endless "Exquisite Corpse" with each author redefining the image-language, infusing it with particular meaning where before there was none.

Moreover, because of the prevalence of font piracy worldwide, these images will become global, and have the potential to become symbols with different meanings in different cultures. Thus ZeitGuys could be thought of as the first symbol virus to spread worldwide.

Design by Aufuldish & Warinner
Designer: Bob Aufuldish

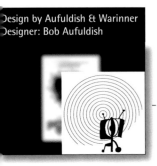 → 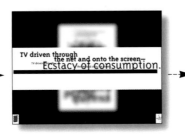 → →

TV driven through the net and onto the screen—
Ecstacy of consumption.

porno queens!

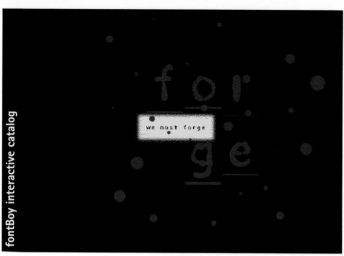

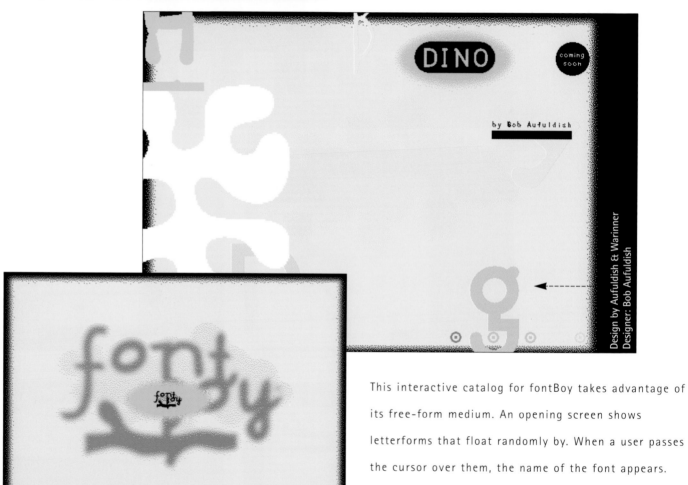

This interactive catalog for fontBoy takes advantage of
its free-form medium. An opening screen shows
letterforms that float randomly by. When a user passes
the cursor over them, the name of the font appears.
Double-clicking sends the viewer to a screen that shows
the full font family.

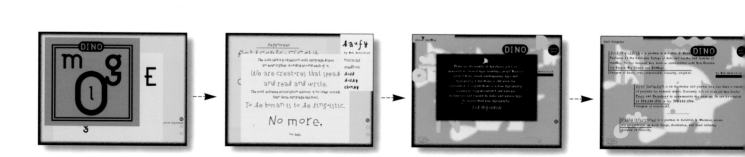

ZeitMovie

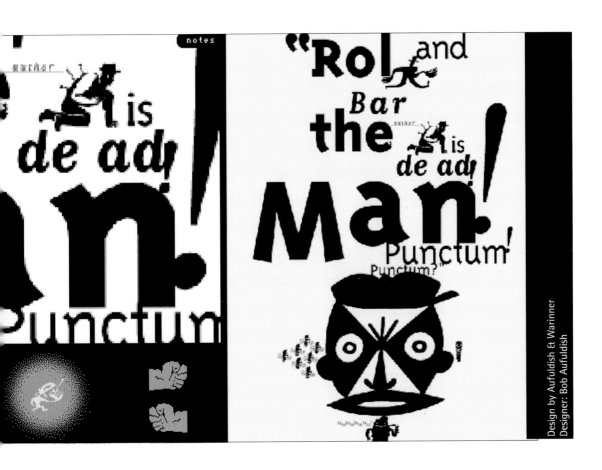

notes

"Rol and Bar the is de adj Man! Punctum! Punctum?

To promote the quirky ZeitGuys font over their bulletin-board service, Emigre created *ZeitMovie*, a piece using sound and animation that makes the illustration font come to life. A shifting sequence of images from the font appears on the screen, enhanced by a sound file that constantly loops.

Design by Aufuldish & Warinner
Designer: Bob Aufuldish

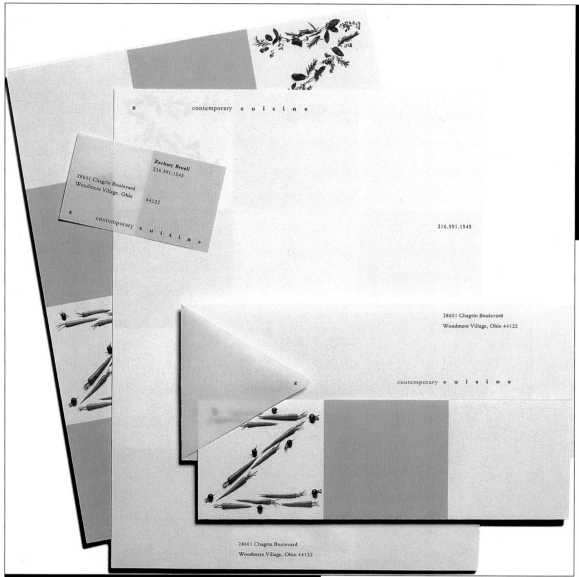

Design by Nesnadny & Schwartz
Art Directors: Joyce Nesnadny, Mark Schwartz
Designer: Joyce Nesnadny

Letterhead and logo system for Z Contemporary Graphics

The 24-piece identity program and interior graphics for Z Contemporary Cuisine by Nesnadny &
Schwartz expressively plays off the angular initial letter *Z* of owner Zachary Bruell's first name. In
printed materials, the letter *Z* is fashioned from a variety of organic materials such as leaves and
vegetables. In the restaurant's entrance, a large, decorative *Z* is created out of grapevines.

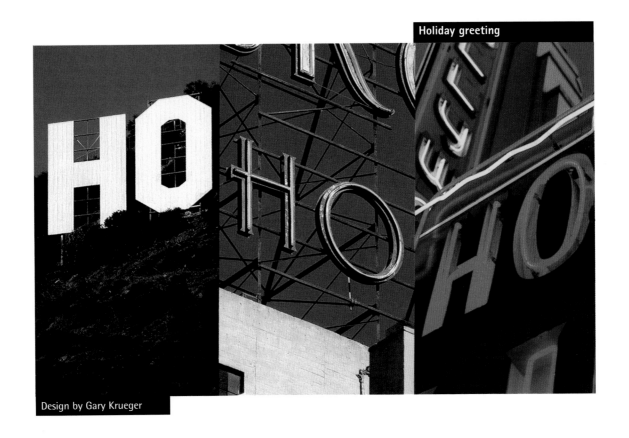

Design by Gary Krueger

Sometimes letterforms found in commercial signage can inspire a designer. Here, Gary Krueger arranged photographs of letterforms found in the landscape—most likely from hotels and the Hollywood hillside—to spell out a holiday greeting.

For these self-promotional postcards created by Stoltze Design, words related to the creative process such as "passion" and "spark" were brought to life in illustrative arrangements that enhance their emotional impact.

pas•sion \'pash-en\ *n* [ME fr. OF, fr. LL *passion-, passio* suffering, being acted upon, fr. L *passus*, pp. of *pati* to suffer — more at PATIENT] (12c) 1 *often cap* **a** : the sufferings of Christ between the night of the Last Supper and his death **b** : an ontario based on a gospel narrative of the Passion **2** *obs* : SUFFERING **3** : the state or capacity of being acted on by external agents or forces **4 a** (1) : EMOTION <his ruling ~ is greed> (2)*pl* : the emotions as distinguished from reason **b** : intense, driving or over-mastering feeling or conviction <driven to paint by a ~ beyond her control> **c** : an outbreak of anger **5 a** : ardent affection : LOVE **b** : a strong liking or desire for or devotion to some activity, object or concept **c** : sexual desire **d** : an object of desire or deep interest — pas•sion•less \-les\ *adj*

passion

Holiday greeting cards for Stoltze Design

' GK *spearca;* akin tooMD *sparke spargan* to swell] (bef. 12c)

spark

1 a : a small particle of a burning substance thrown out by a body in combustion or remaining when combustion is nearly completed
b : a hot glowing particle struck from a larger mass; esp: one heated by friction<produce a ~ by striking flint with steel> **2 a** : a luminous disruptive electrical discharge of very short duration between two conductors separated by a gas (as air) **b** : mechanism controlling the discharge in a soark plug
3 : SPARKLE, FLASH **4** : something that sets off a sudden force <provided the ~ that helped the team to rally> **5** : a latent particle capable of growth or developing : GERM <still retains a ~ of decency>
6 : *pl but sing in constr* :a radio operator on a ship

Design by Stoltze Design
Art Director: Clifford Stoltze
Designers: Clifford Stoltze, Peter Farrell

Johnson & Johnson

& Johnson

Susan & Wayne are proud to introduce the newest
member in the Johnson family. Maegan Tayler, born on January 11, 1996,
net.wt. 8lbs. 8oz. and length 20.5 inches.

Design by Susan Johnson
Designer/Illustrator: Wayne Johnson

To announce the birth of their child, designers Wayne and Susan Johnson couldn't resist co-opting a generations-old corporate mark and creating their own, lowercase version, to make their joyful statement.

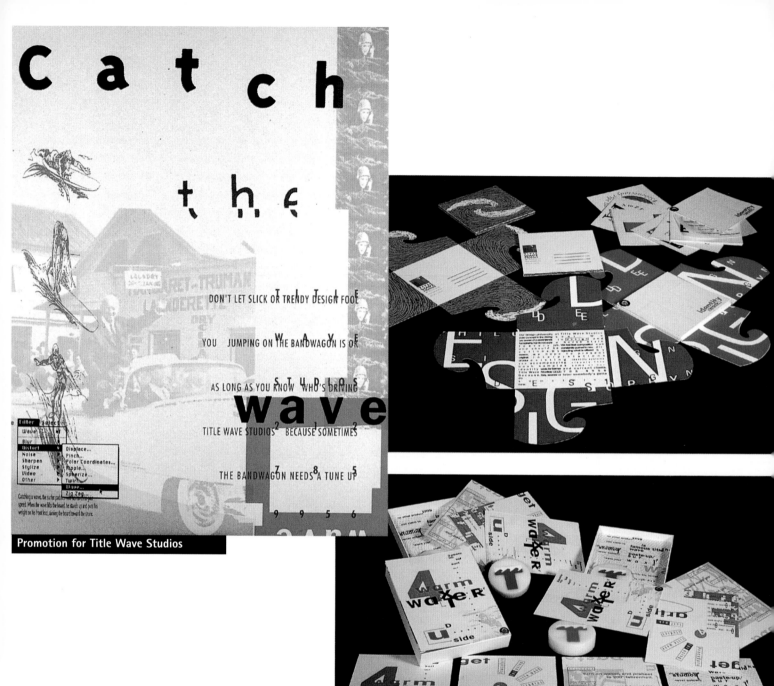

Promotion for Title Wave Studios

Design by Doug Bartow

To promote Title Wave Studios, designer Doug Bartow created a mailer that seized a breaking-waves theme. The piece opens with flaps shaped like curling waves with letters spelling "design" appearing large and somewhat elliptically. Type on packages containing surfboard wax continues the curling-wave motif with text arranged on curves.

A holiday card from Hornall Anderson Design Works uses die-cut letters with airbrushed edges to emulate the look of stencil letters. The flip side features a pastiche of the firm's work.

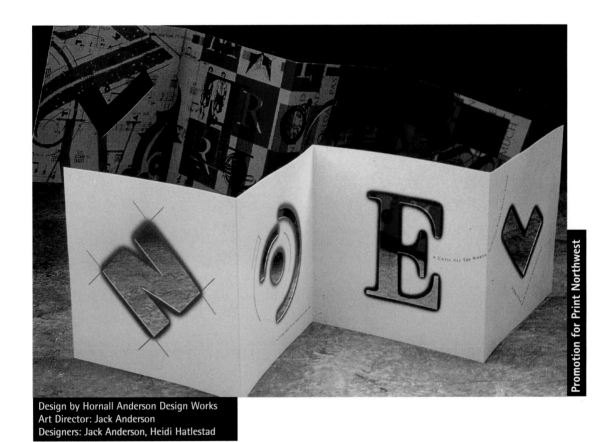

Design by Hornall Anderson Design Works
Art Director: Jack Anderson
Designers: Jack Anderson, Heidi Hatlestad

Promotion for Print Northwest

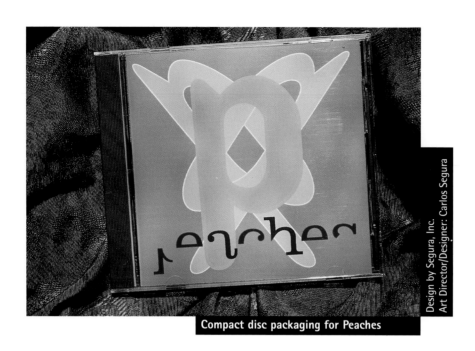

Compact disc packaging for Peaches

Design by Segura, Inc.
Art Director/Designer: Carlos Segura

The CD packaging for a Peaches release was designed by Carlos Segura. The band's name appears in an elliptical typeface that is an exercise in how far letterforms may be reduced to their most elemental form and still be recognized and readable.

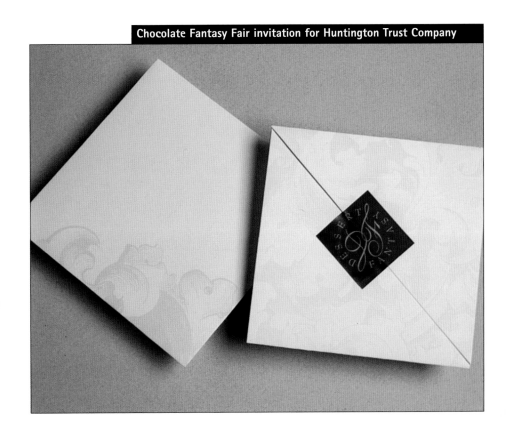

Using baroque motifs and a romantic script typeface, Rickabaugh Graphics created a luxurious mood for this invitation to the Huntington Trust Company's Chocolate Fantasy Fair.

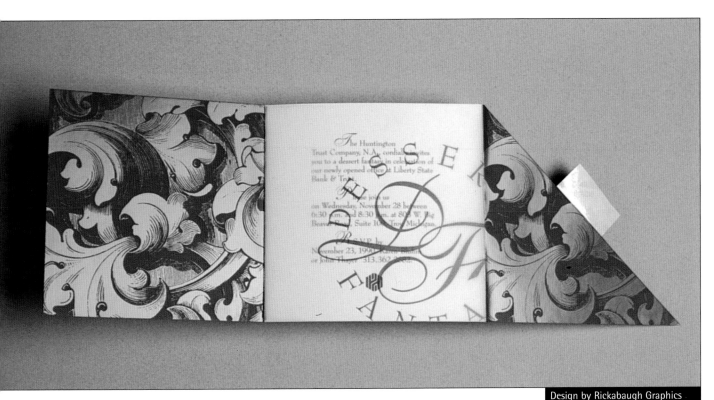

Design by Rickabaugh Graphics
Art Director: Eric Rickabaugh
Designer: Tina Zientarski

What better way to promote a children's bookstore named Scribbles than to create shopping bags featuring stick figures and the store logo written in an exuberant, childlike scrawl?

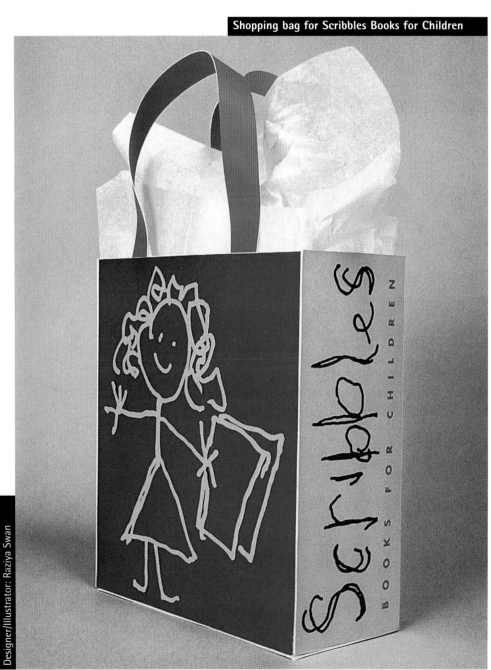

Shopping bag for Scribbles Books for Children

Design by Raziya Swan
Art Director: Alice Dreuding
Designer/Illustrator: Raziya Swan

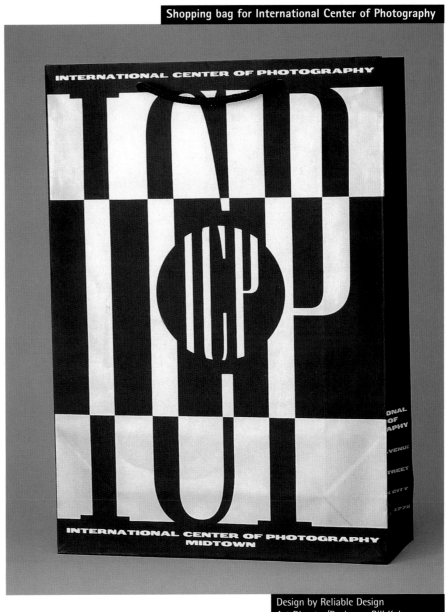

Design by Reliable Design
Art Director/Designer: Bill Kobasz

When creating an identity program for New York's
International Center of Photography, Reliable Design
embraced key elements of photography in a logo design.
This shopping bag design, for example, shows tall,
narrow initial caps that are a dramatic play of
contrasting black and white, while a central logo is
superimposed in a circle, suggesting a camera lens.

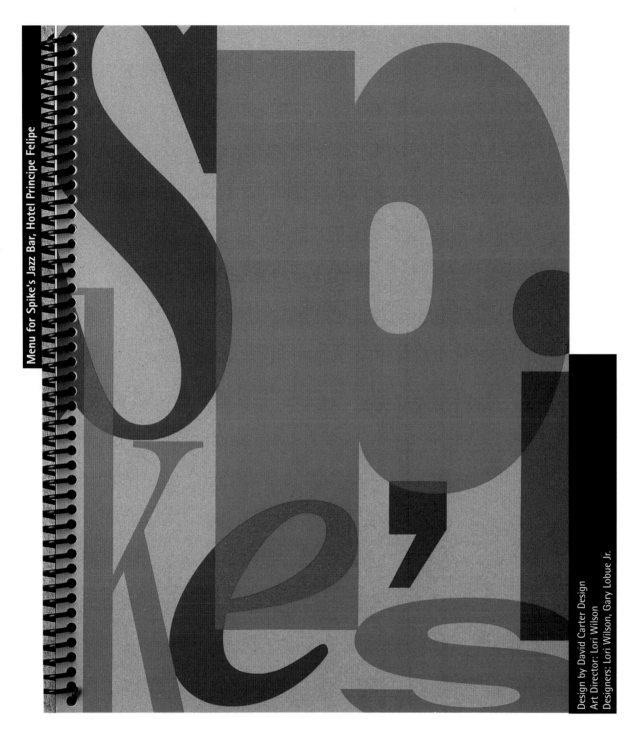

Menu for Spike's Jazz Bar, Hotel Principe Felipe

Design by David Carter Design
Art Director: Lori Wilson
Designers: Lori Wilson, Gary Lobue Jr.

Bold, aggressive type set in various sizes and colors and placed in a free-form, overlapping design highlight the upbeat, improvisational nature of this venue, a jazz bar and restaurant.

Design by Shelley Danysh Studio
Designer: Shelley Danysh

Exploding graphics and lively letterforms enhanced in
Adobe Photoshop give this logo a vibrancy fitting a
juice bar promoting health and energy.

Design by Associates Design
Art Director: Chuck Polonsky
Designer: Beth Finn

The restaurant Banners was given an elegant, understated look with menu designs by Associates Design that feature a black script letter *B* printed on black linen with the establishment name dropped out in white roman letterforms for a striking contrast.

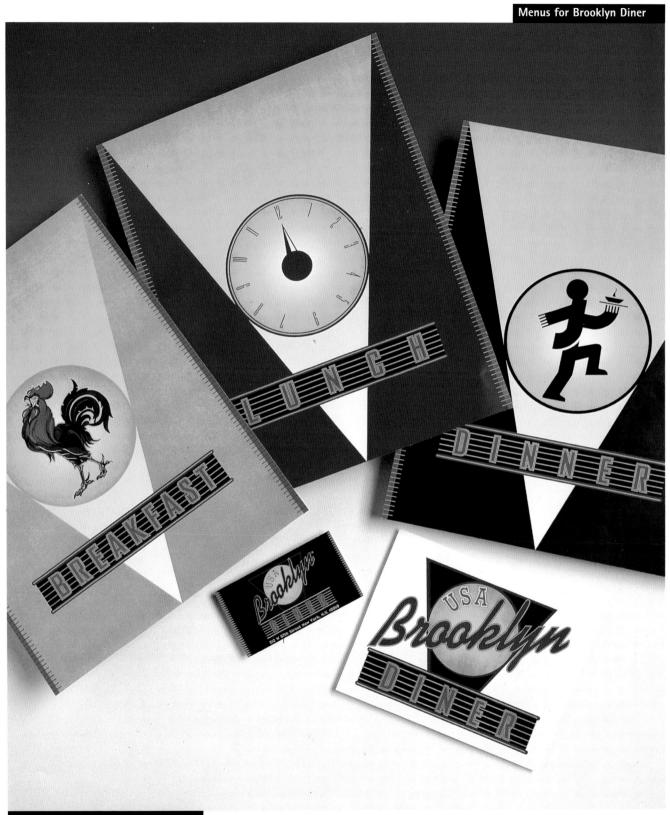

Design by Russek Advertising
Art Director/Designer: Hal Jannen
Illustrator: Martha Lewis

Menu designs for the Brooklyn Diner use a dimensional typeface reminiscent of 1950s neon diner signs, while the restaurant's script logo clearly pays a tribute to the much-beloved Brooklyn Dodgers.

Menus for Jonnick's

Design by Sean Murphy Associates, Ltd.
Art Director/Designer: Sean Murphy
Photographer: David Bell

The flair of a handwritten signature was given to menu designs for Jonnick's Restaurant by Sean Murphy Associates. On menu covers, the restaurant name appears in a widely spaced sans serif face, with the two *N*s dashed off in ink. Menu interiors echo the logo with titles set with capital letters appearing within words, while the rules dividing subjects are accented with the signature *N*s.

Business card for Splendido Biscotti Bakery

SPLENDIDO

Biscotti

Celeste de Tessan

P.O. Box 1347 Glen Ellen, CA 95442
707-939-8656

Design by Holden & Company
Designer: Cathe Holden

A logo design for Splendido Biscotti by Holden &

Company incorporates Italian élan with its chiseled

Roman letterforms complemented by a flourished script.

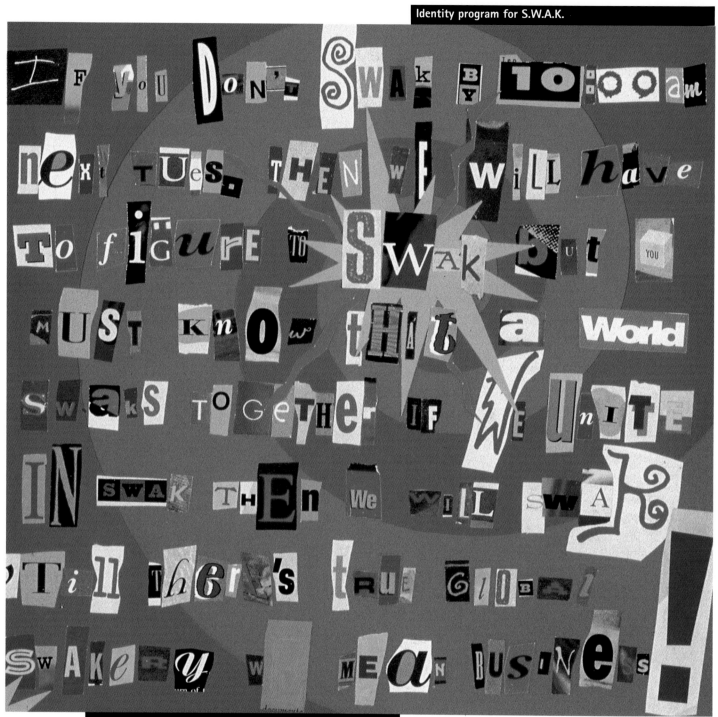

Design by Sackett Design Associates
Art Director: Mark Sackett
Designers/Illustrators: Mark Sackett, Wayne Sakamoto, James Sakamoto

When creating an identity program for S.W.A.K. (Some Wild American Kids), a product line aimed at girls 8 to 15 years old, Sackett Design Associates created graphics that incorporate a ransom-note approach, with a great variety of letterforms pasted together to form a riot of colors and styles that conveys an accessible hipness.

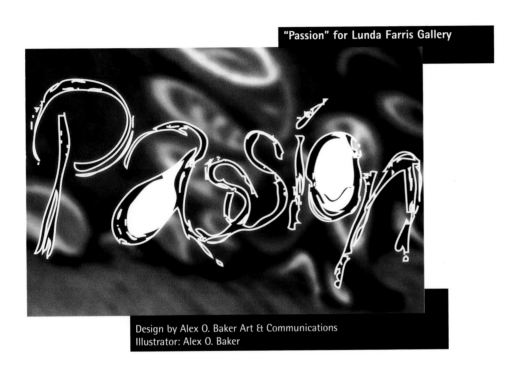

"Passion" for Lunda Farris Gallery

Design by Alex O. Baker Art & Communications
Illustrator: Alex O. Baker

To convey the heat of "passion", designer Alex O. Baker created these letterforms by hand with pen and ink, then scanned them into Adobe Photoshop. The lettering was placed into Macromedia FreeHand, autotraced, filled, and stroked. The letters appear over a image of an old medical illustration of a cross-sectioned human heart.

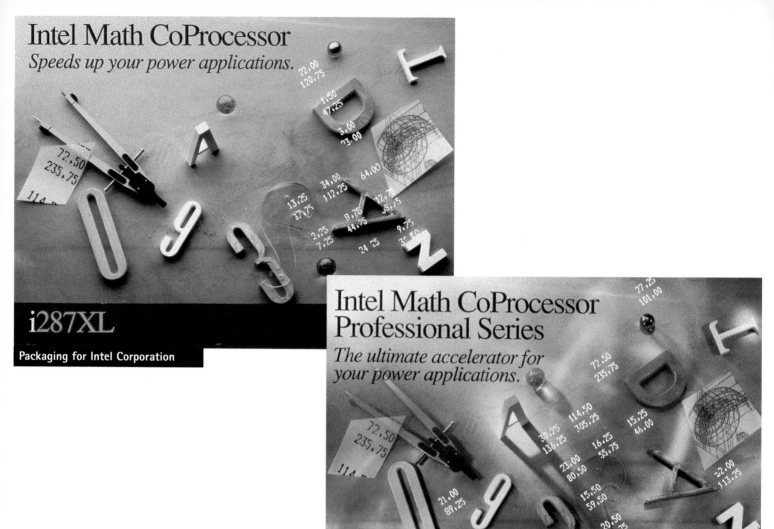

Packaging for Intel Corporation

Design by Hornall Anderson Design Works
Art Directors: Jack Anderson, Julia LaPine
Designers: Jack Anderson, Julia LaPine, Denise Weir, David Bates

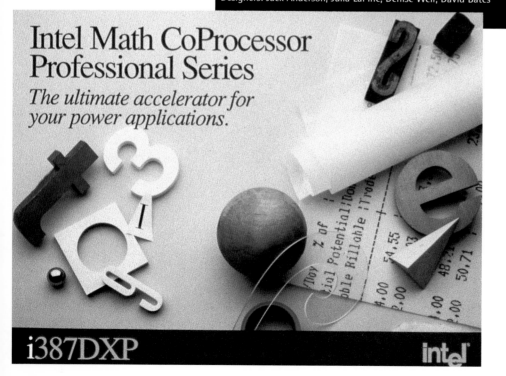

Unlike most computer-product boxes, which typically use flatly-lit product shots or airbrushed illustrations, this product packaging for a coprocessor by Intel features stylishly lit and photographed elements of computation, from a French curve to marbles and metal letterforms. Product information is set in Garamond, an industry standard.

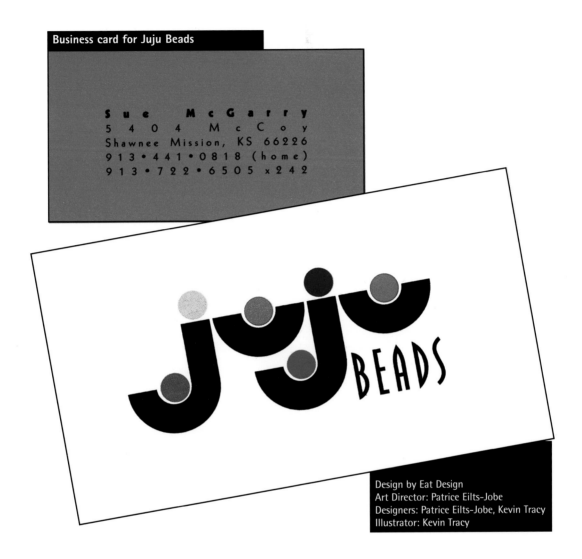

Business card for Juju Beads

Sue McGarry
5 4 0 4 M c C o y
Shawnee Mission, KS 66226
9 1 3 • 4 4 1 • 0 8 1 8 (h o m e)
9 1 3 • 7 2 2 • 6 5 0 5 x 2 4 2

Design by Eat Design
Art Director: Patrice Eilts-Jobe
Designers: Patrice Eilts-Jobe, Kevin Tracy
Illustrator: Kevin Tracy

JuJu Beads, a craft store with a name reminiscent of Juju-bees candies, commissioned a logo by illustrator Kevin Tracy, filled the cups and bowls of letterforms with bead-like circles. The result is a logo that is as colorful and playful as the movie-house candies.

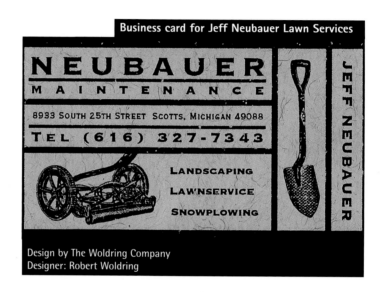

Business card for Jeff Neubauer Lawn Services

NEUBAUER

M A I N T E N A N C E

8933 SOUTH 25TH STREET SCOTTS, MICHIGAN 49088

TEL (616) 327-7343

LANDSCAPING
LAWNSERVICE
SNOWPLOWING

JEFF NEUBAUER

Design by The Woldring Company
Designer: Robert Woldring

For Neubauer Lawn Services, the Woldring Company created an identity that evokes early twentieth-century Sears catalogs, with old engravings of lawn tools and text set in a stolid serif typeface.

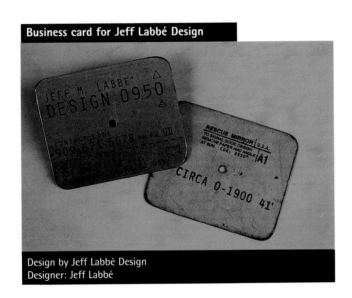

Business card for Jeff Labbé Design

Design by Jeff Labbé Design
Designer: Jeff Labbé

An army-issue rescue mirror serves as the business card for this design studio. Text appears in a no-nonsense, crudely spaced typeface to mimic the institutional type on the flip slide.

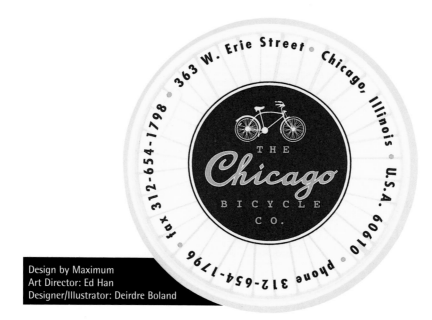

Design by Maximum
Art Director: Ed Han
Designer/Illustrator: Deirdre Boland

This business card design for the Chicago Bicycle Co. cleverly echoes a bicycle wheel with text wrapping around a circular logo design. The logo's retro script and image of a vintage bike suggest old-fashioned quality and service.

How do you have graphic fun with a company name that is inherently unexciting? Business cards created by Hornall Anderson Design Works for CF2GS, a marketing communications firm, playfully spills the company's moniker in colored type on a black background. Designers personalized the cards by rearranging the letters to emphasize the person's initial in the center of the card.

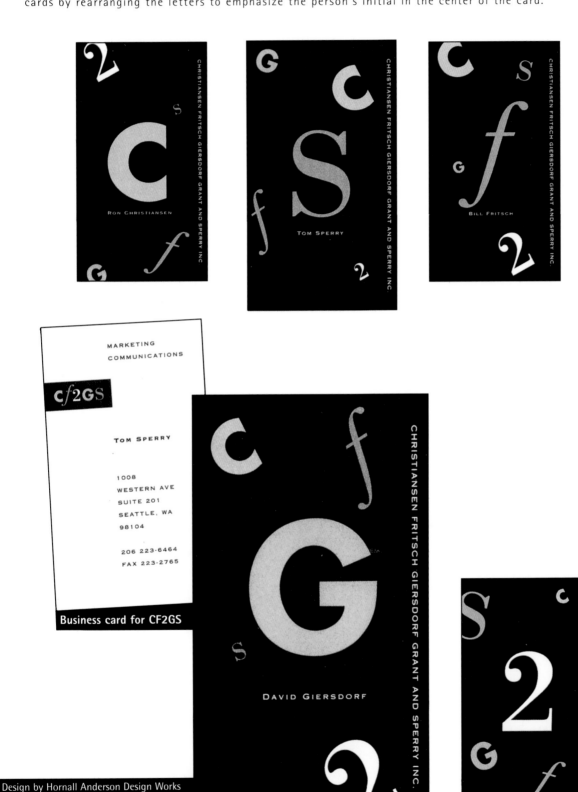

Business card for CF2GS

Design by Hornall Anderson Design Works
Art Director: Jack Anderson
Designers: Jack Anderson, David Bates

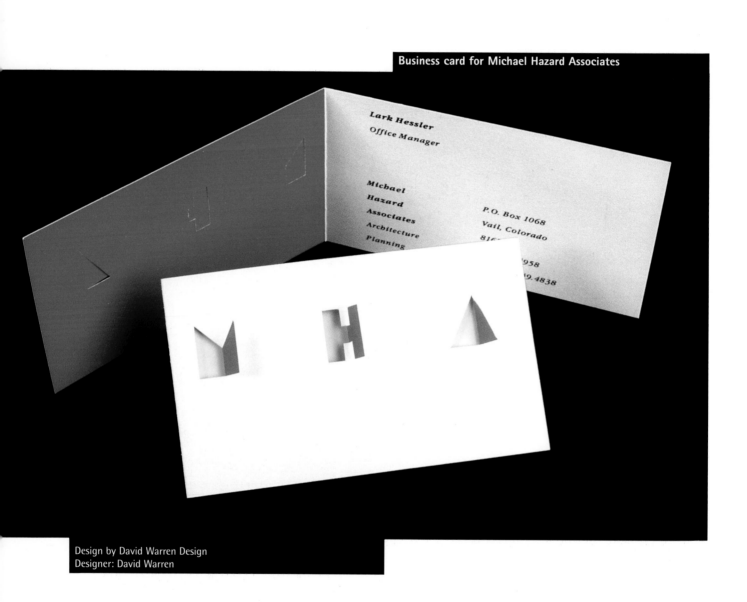

Business card for Michael Hazard Associates

Lark Hessler
Office Manager

Michael
Hazard
Associates

P.O. Box 1068
Vail, Colorado

Architecture
Planning

958

9.4838

Design by David Warren Design
Designer: David Warren

This business card for Colorado architect Michael Hazard effectively uses a die-cut process to create three-dimensional initial letters to instantly and humorously communicate the essence of his profession.

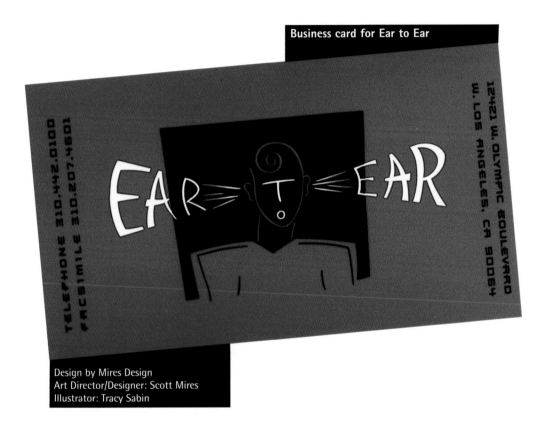

Business card for Ear to Ear

TELEPHONE 310.442.0100
FACSIMILE 310.207.4601

12421 W. OLYMPIC BOULEVARD
W. LOS ANGELES, CA 90064

Design by Mires Design
Art Director/Designer: Scott Mires
Illustrator: Tracy Sabin

The type in this business card is practically audible: The illustrative treatment conveys the whole music listening experience, from words as sound waves to the expression on a listener's face.

Business card for Vitamin DJ

Layers of futuristic atomic
models create a frenetic
energy on business cards
for Vitamin DJ. Design firm
Paper Shrine unified copy
with imagery by setting
type on curved lines and
weaving them in and out
of spheres.

Design by Paper Shrine
Designer: Paul Dean

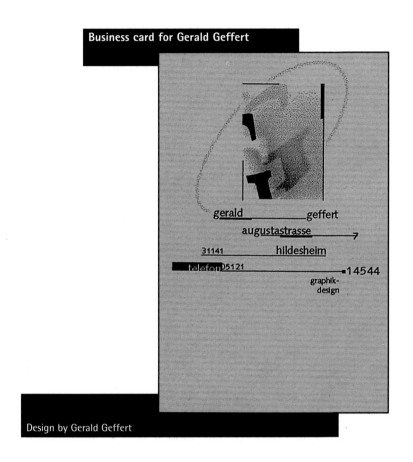

Business card for Gerald Geffert

gerald geffert

augustastrasse 7

31141 hildesheim

telefon 05121 14544

graphik-
design

Design by Gerald Geffert

For his own business card, Gerald Geffert created an logo based on an abstract design of his double initials: One *G*, while seen almost in its entirety, is screened back, while another is printed clearly but far more abstractly, perhaps suggesting both the linear and intuitive aspects of graphic design.

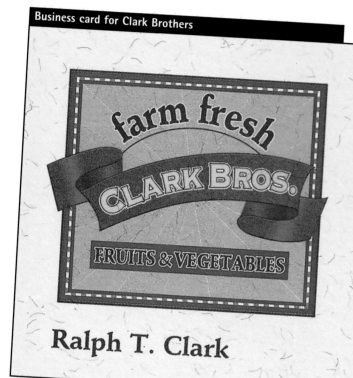

Business card for Clark Brothers

☞ **Office**
5 Concourse Parkway
Suite 3100
Atlanta, Georgia 30328
☎ (404) 804-5830

🌿 **Farm**
Route 6
Moultrie, Georgia 31768
☎ (912) 985-1444

Design by Coker Golley, Ltd.
Art Directors: Jane Coker, Frank Golley
Designer: Julie Mahood

This business card for Clark Brothers Family Farms features a design reminiscent of fruit and vegetable crate labels of the 1920s. The company logo, designed in an outline font and placed on a furled ribbon, promises freshness based on generations of farming experience.

The B[pin]rthPlace
AT SOUTHWEST GENERAL HOSPITAL

Bonnie Jimenez
Perinatal Education Coordinator

7400 Barlite • San Antonio, TX 78224 • (210) 921-8682 • Fax (210) 921-8629

Business card for The Birth Place at Southwest General Hospital

Design by The Bradford Lawton Design Group
Art Directors: Brad Lawton, Jennifer Griffith-Garcia
Designer: Brad Lawton
Illustrator: Jody Laney

Sometimes one tweak of a letter can make all the difference. Replacing the letter I with a diaper pin in this business card for San Antonio's Birth Place at Southwest General Hospital creates a warm and accessible feeling that is distinctly un-institutional.

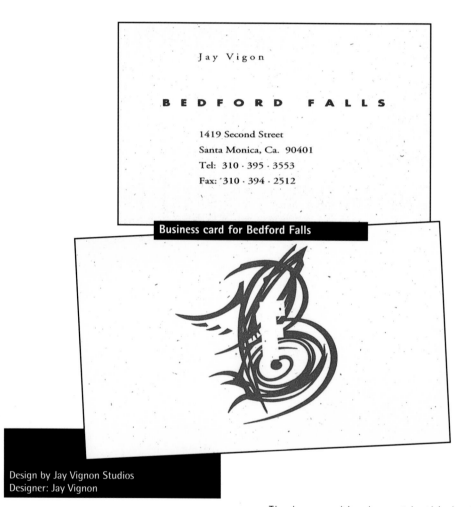

Jay Vigon

B E D F O R D F A L L S

1419 Second Street
Santa Monica, Ca. 90401
Tel: 310 · 395 · 3553
Fax: 310 · 394 · 2512

Business card for Bedford Falls

Design by Jay Vignon Studios
Designer: Jay Vignon

The key graphic element in this business card for West Coast production company Bedford Falls is a primitive, hand-drawn initial *B* with a drop-out cap *F* in Franklin Gothic. The drama of this logo is contrasted on the reverse side with a relatively calm type treatment of company information.

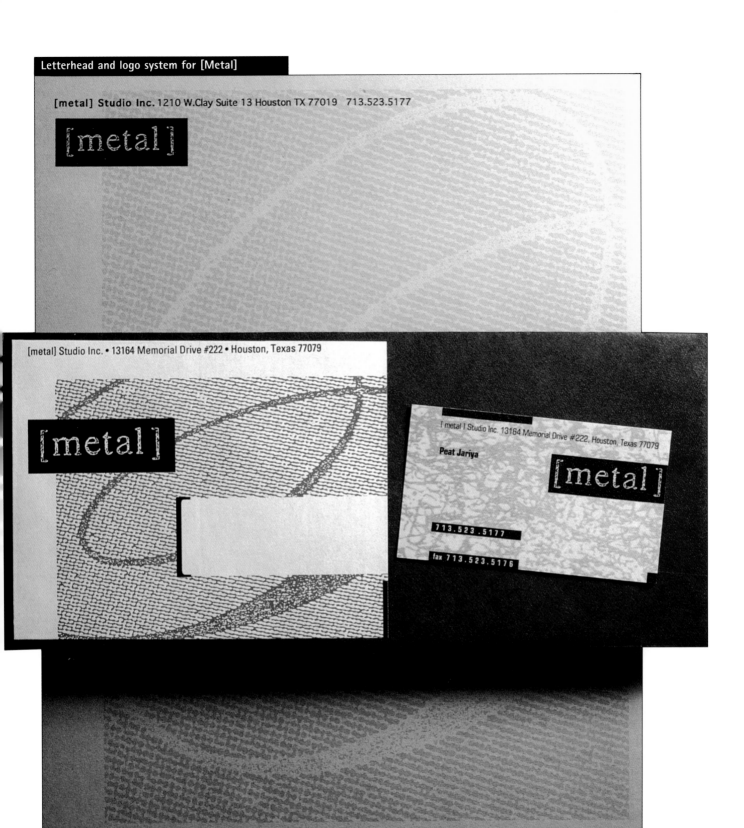

Letterhead and logo system for [Metal]

[metal] Studio Inc. 1210 W.Clay Suite 13 Houston TX 77019 713.523.5177

[metal]

[metal] Studio Inc. • 13164 Memorial Drive #222 • Houston, Texas 77079

[metal]

[metal] Studio Inc. 13164 Memorial Drive #222, Houston, Texas 77079

Peat Jariya

[metal]

713.523.5177

fax 713.523.5176

Design by [Metal]
Art Director: Peat Jariya

Art director Peat Jariya created an identity program with an industrial
look for Metal studio with distressed letters in the logo and screened
calligraphic letters printed in metallic ink.

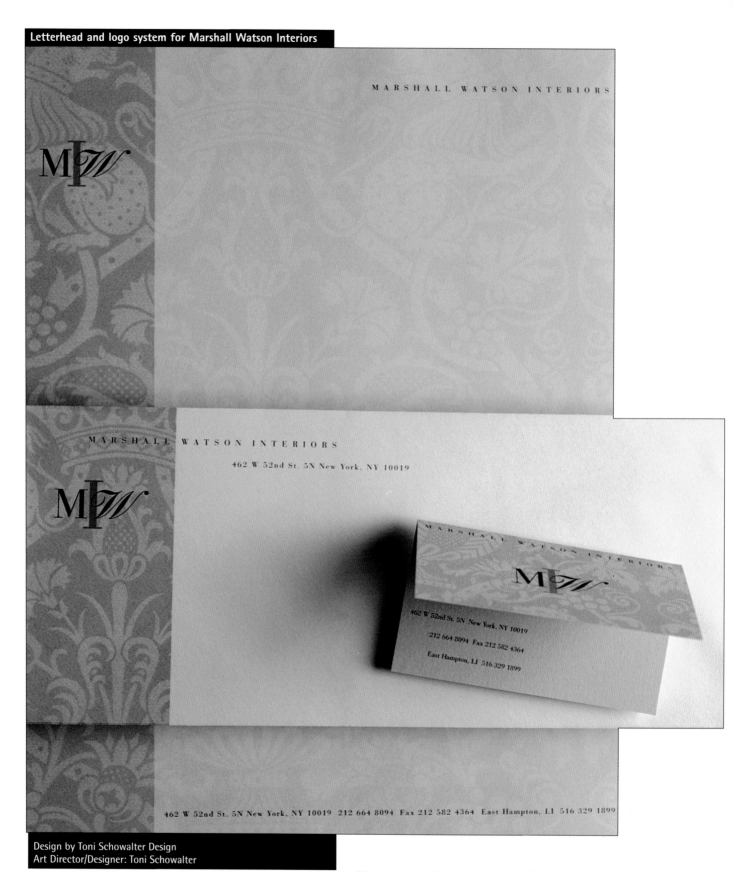

Letterhead and logo system for Marshall Watson Interiors

Design by Toni Schowalter Design
Art Director/Designer: Toni Schowalter

The variety of interior styles offered by Marshall Watson Interiors is reflected in its identity program, which combines initial capitals set in serif typefaces with an italic script font.

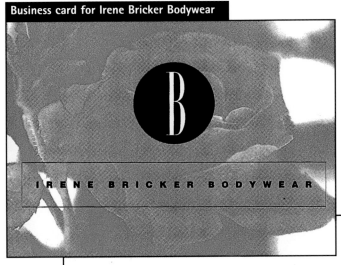

Business card for Irene Bricker Bodywear

IRENE BRICKER BODYWEAR

Irene Bricker

550 Union Avenue

Campbell, CA 95008

408-371-5605

Design by Melissa Passehl Design
Designer: Melissa Passehl

Elegance and simplicity are the hallmarks of this logo treatment for Irene Bricker Bodywear. The tall, lean initial *B* superimposed on the screened photograph of an open rose are a far cry from the brawny esthetic most often seen in athletic-wear graphics.

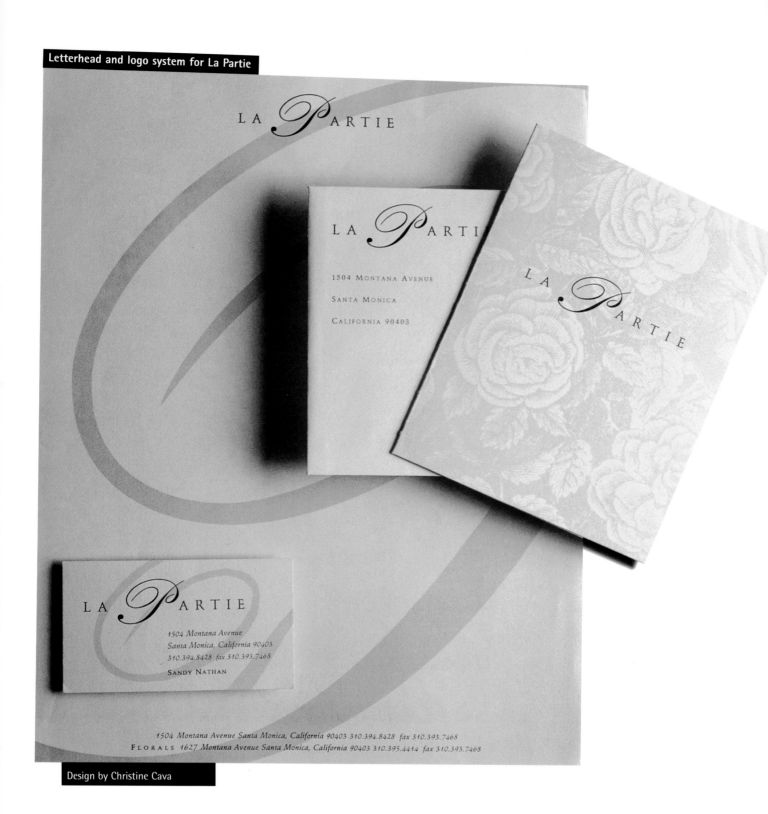

Design by Christine Cava

With a Victorian rose background and an elegant script accenting the letter *P*, the stationery system for event planner La Partie creates a fanciful mood. The flourish in the letter *P* was modified in Macromedia FreeHand.

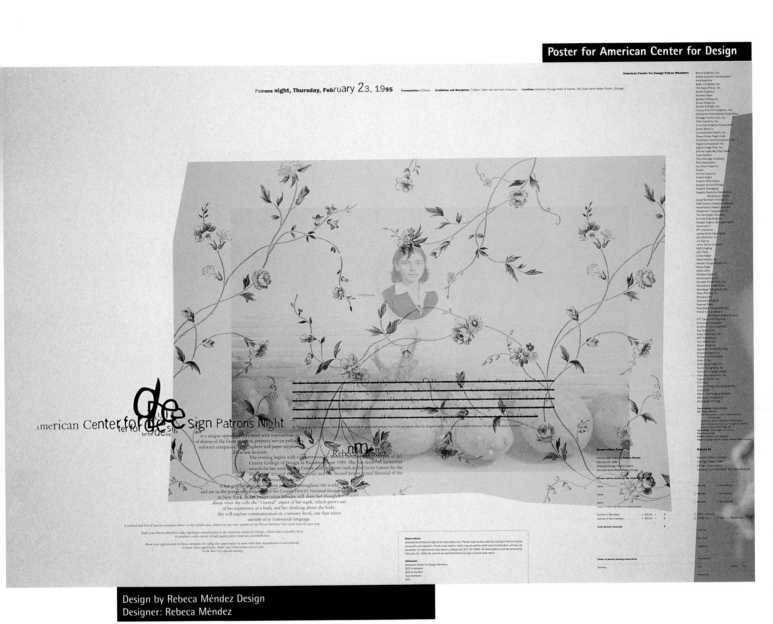

Design by Rebeca Méndez Design
Designer: Rebeca Méndez

Through the seamless interweaving of images from
installations, video, and letterpress work, this poster for
an event at the American Center for Design reveals the
ways Rebeca Méndez explores communication on a
sensory level.

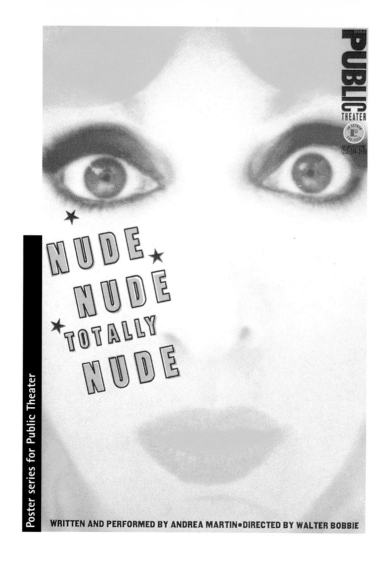

Poster series for Public Theater

NUDE NUDE TOTALLY NUDE

WRITTEN AND PERFORMED BY ANDREA MARTIN • DIRECTED BY WALTER BOBBIE

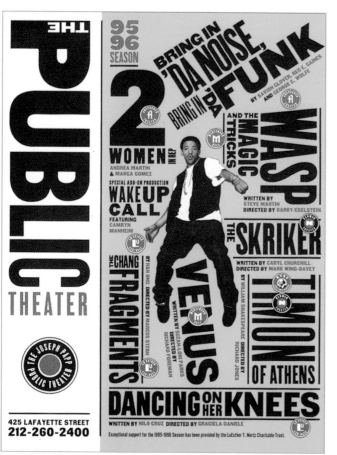

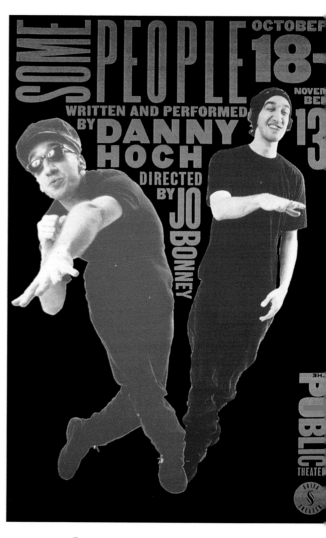

To promote the edgy productions of the Public Theater, Pentagram designers Ron Louie, Lisa Mazur, and Paula Scher created posters with bold, crammed, energetic type that virtually shouts.

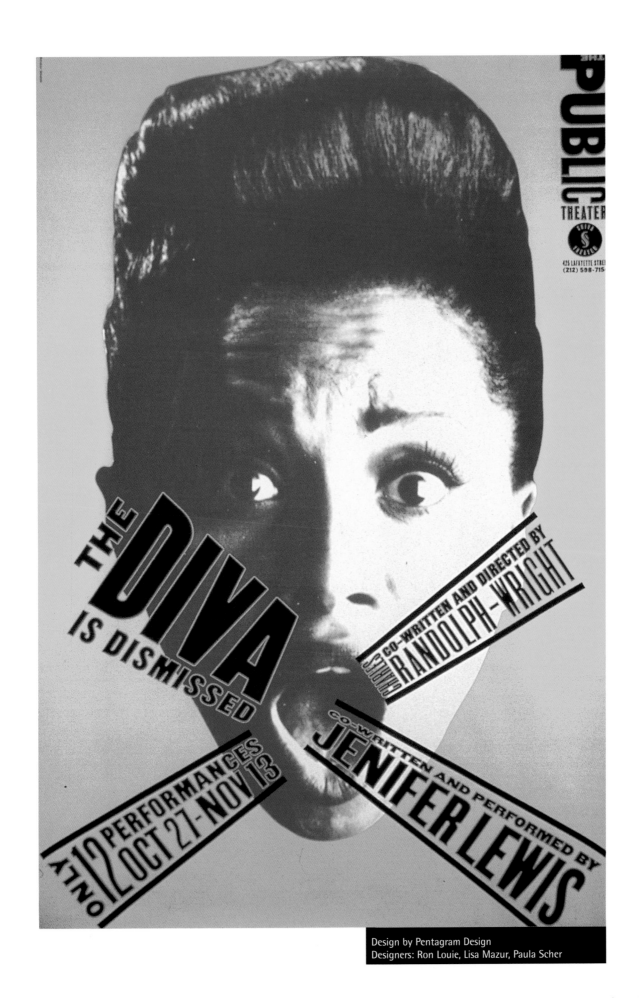

Design by Pentagram Design
Designers: Ron Louie, Lisa Mazur, Paula Scher

Promotional posters for The Apollo Program's type design

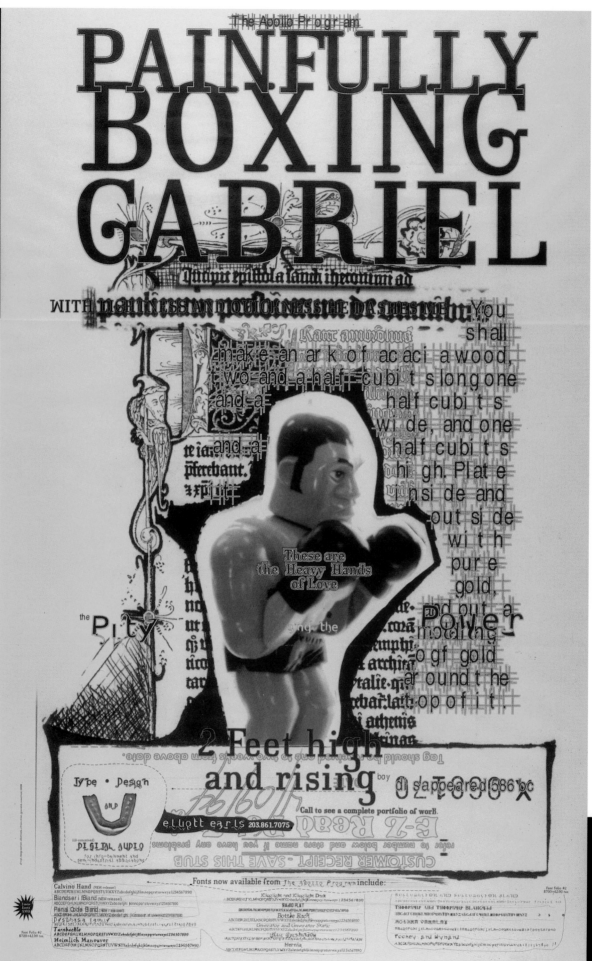

This poster promoting the typeface designs of Elliott Earls' Apollo Program creates a surreal mood by joining layer upon layer of varying font styles with images of toys and decorative elements from medieval manuscripts.

Design by The Apollo Program
Designer: Elliot Peter Earls

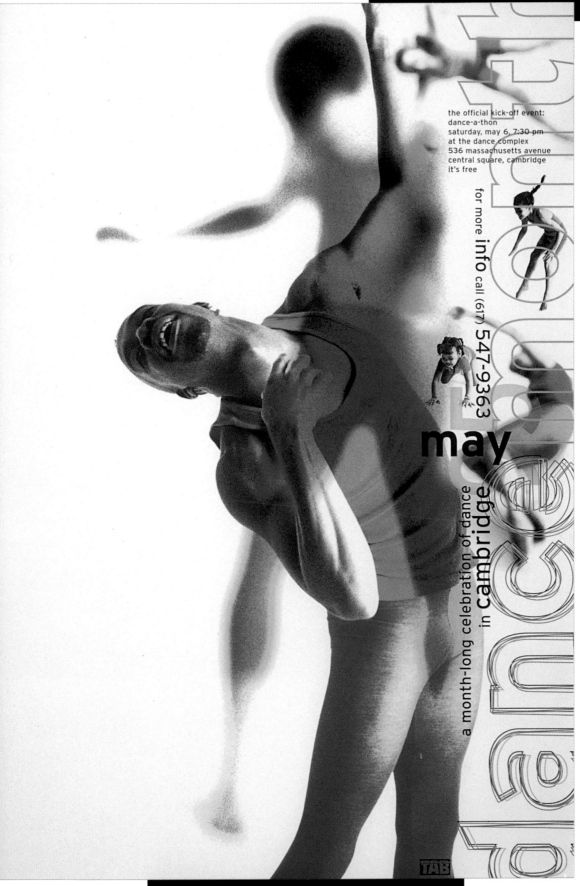

the official kick-off event:
dance-a-thon
saturday, may 6, 7:30 pm
at the dance complex
536 massachusetts avenue
central square, cambridge
it's free

for more info call (617) 547-9363

may

a month-long celebration of dance in cambridge

The colored, layered letterforms suggest movement in the headline for this poster promoting Dance Month, a spring event held in Cambridge, Massachusetts. Type lines shifting directions on the vertical grid add to the playful spirit.

Design by Visual Dialogue
Designer: Fritz Klaetke

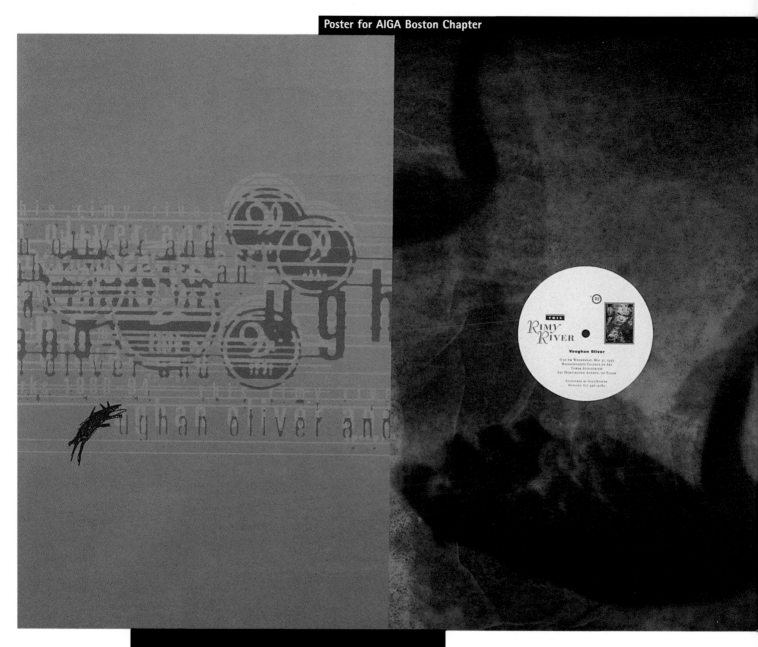

Design by Stoltze Design
Designers: Clifford Stoltze, Peter Farrell

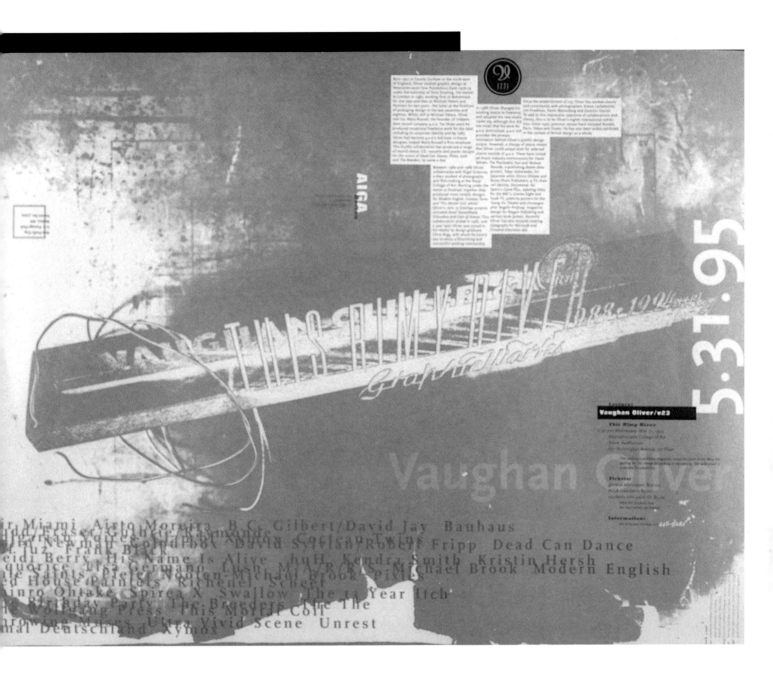

A poster promoting a talk by Vaughan Oliver uses artwork provided by the British designer to reveal and his characteristic blending of photography and disparate type styles in CD cover designs.

Poster for Dance on the Page, CalArts Dance School

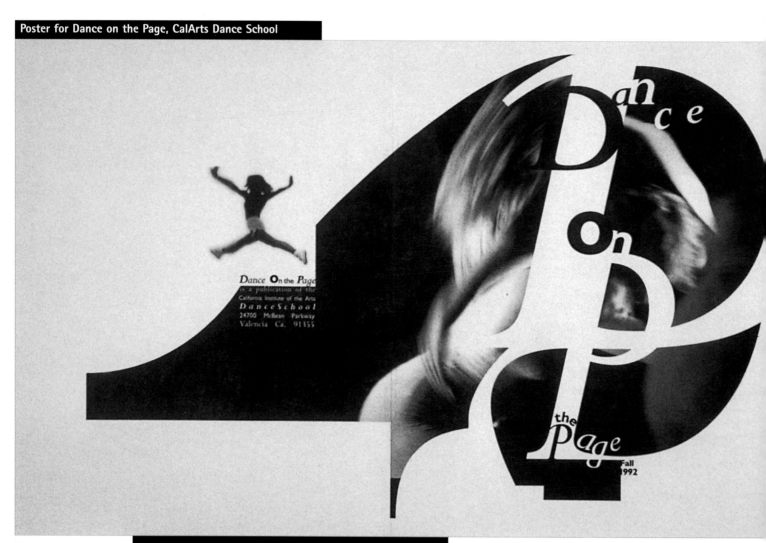

Design by Todd Childers Graphic Design
Designer: Blaine Todd Childers

Blaine Todd Childers focuses on the sensuous shapes of letterforms on a cover for Dance on the Page, a publication for the CalArts Dance School.

The soft-focus Garamond letters spelling out the eyewear manufacturer's name on this packaging at once suggest reverberation and playfully hint at myopia.

Echo Eyewear packaging for Silhouette Optical

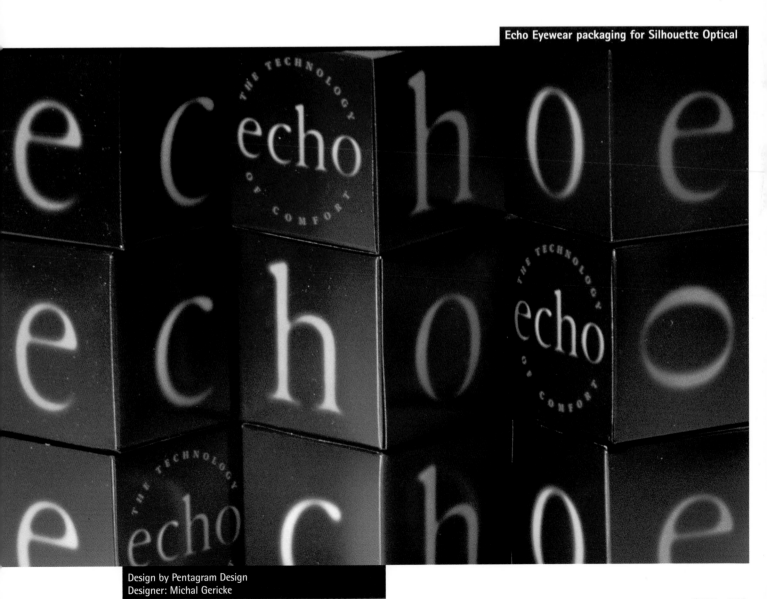

Design by Pentagram Design
Designer: Michal Gericke

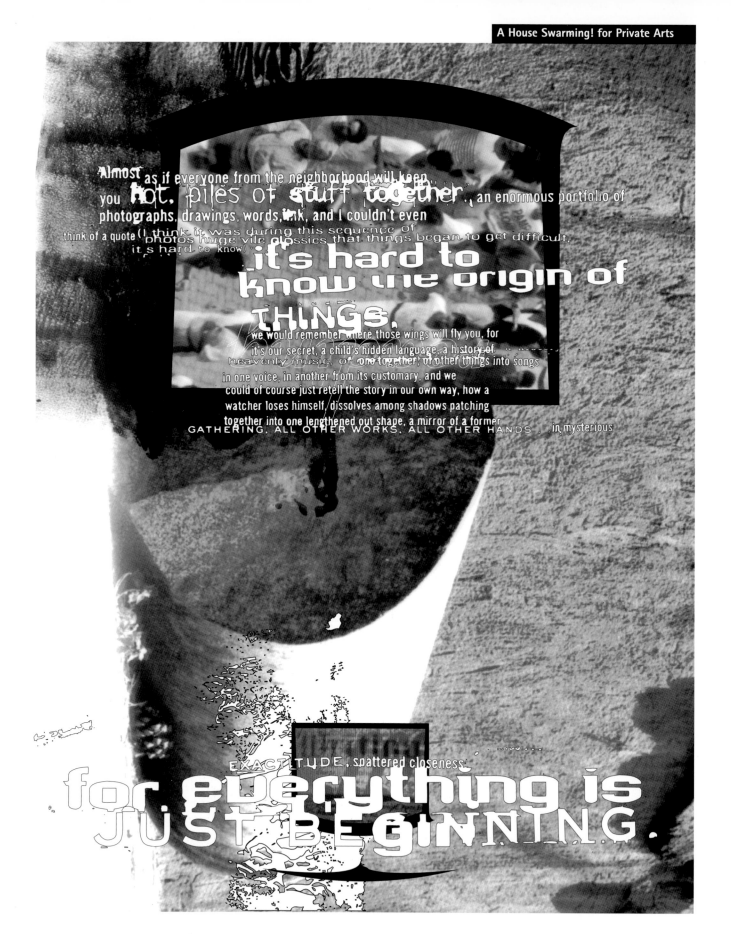

Almost as if everyone from the neighborhood will keep you hot, piles of stuff together, an enormous portfolio of photographs, drawings, words, ink, and I couldn't even think of a quote (I think it was during this sequence of photos huge vile classics that things began to get difficult, it's hard to know) .it's hard to know the origin of things. we would remember where those wings will fly you, for it's our secret, a child's hidden language, a history of heavenly music, of one together; of other things into songs in one voice, in another from its customary, and we could of course just retell the story in our own way, how a watcher loses himself, dissolves among shadows patching together into one lengthened out shape, a mirror of a former GATHERING. ALL OTHER WORKS. ALL OTHER HANDS. in mysterious EXACTITUDE, spattered closeness. for everything is JUST BEGINNING.

For *Private Arts*, a literary journal, Stephen Farrell created a poem/foreword composed of bits of text taken from the journal and assembled into a montage of text and image where letterforms appear to be almost burned onto the page.

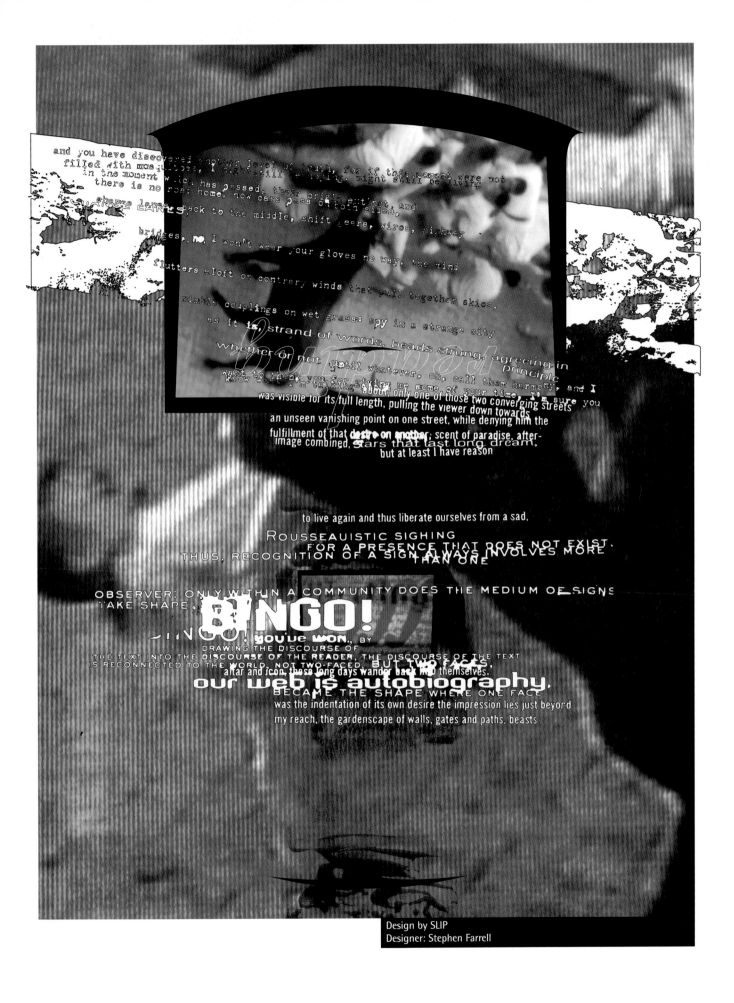

and you have discovered another level of truth, for if this moment were not
filled with mosquitoes, I might still be riding, might still be living
in the moment which has passed, their origin extinct and
there is no road home, now cars pass on both sides,
change LANES back to the middle, shift gears, wires, highway
bridges, no, I won't wear your gloves no way, the wind
flutters aloft on contrary winds that pull together skies,
nimble couplings on wet grass; spy in a strange city
as it is, strand of words, beads strung, agreeing in
whether or not until whatever, oh, call them harmony, and I principle
want to thank you for giving me some of your time, I'm sure you
know what I'm talking about, only one of those two converging streets
was visible for its full length, pulling the viewer down towards
an unseen vanishing point on one street, while denying him the
fulfillment of that desire on another; scent of paradise, after-
image combined, stars that last long dream,
but at least I have reason

to live again and thus liberate ourselves from a sad,
ROUSSEAUISTIC SIGHING
FOR A PRESENCE THAT DOES NOT EXIST.
THUS, RECOGNITION OF A SIGN ALWAYS INVOLVES MORE
THAN ONE

OBSERVER: ONLY WITHIN A COMMUNITY DOES THE MEDIUM OF SIGNS
TAKE SHAPE, BINGO!
BINGO! YOU'VE WON., BY
DRAWING THE DISCOURSE OF
THE TEXT INTO THE DISCOURSE OF THE READER, THE DISCOURSE OF THE TEXT
IS RECONNECTED TO THE WORLD, NOT TWO-FACED, BUT TWO FACES,
altar and icon, these long days wander back into themselves,
our web is autobiography.
BECAME THE SHAPE WHERE ONE FACE
was the indentation of its own desire the impression lies just beyond
my reach, the gardenscape of walls, gates and paths, beasts

Design by SLIP
Designer: Stephen Farrell

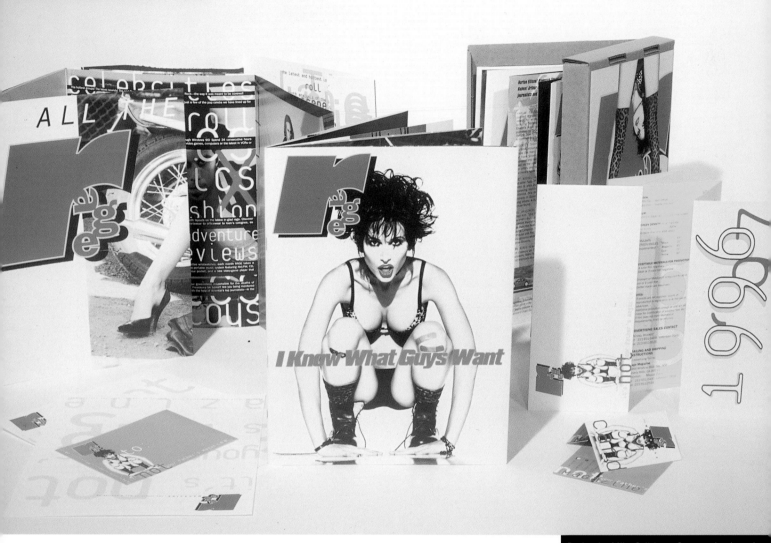

Design by Mike Salisbury Communications, Inc.
Designers: Mary Evelyn McGough and Mike Sal.

The bright, colorful type on the
press kit for this men's magazine
appeals to a young, hip audience.
Type was overlapped, stretched,
and shadowed to give a dense,
busy look.

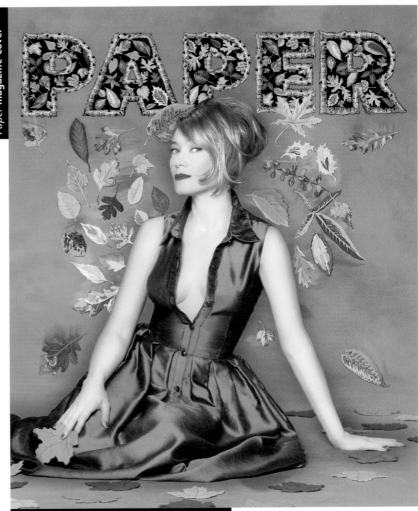

Paper **magazine cover**

Paper magazine, the definitive magazine of New York's downtown culture, is known for the monthly permutations of its logo. For a November issue, the logo was gussied up with falling leaves and outlined in a rustic bark texture.

Design by Malcolm Turk Studios
Designers: Malcolm Turk and Bridget De Socio

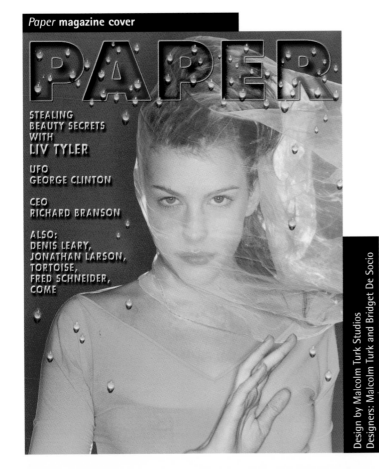

Paper **magazine cover**

PAPER

STEALING
BEAUTY SECRETS
WITH
LIV TYLER

UFO
GEORGE CLINTON

CEO
RICHARD BRANSON

ALSO:
DENIS LEARY,
JONATHAN LARSON,
TORTOISE,
FRED SCHNEIDER,
COME

Design by Malcolm Turk Studios
Designers: Malcolm Turk and Bridget De Socio

Water droplets were created to fall from the logo of this issue of *Paper* magazine featuring a cover image of actress Liv Tyler. The logo's three-dimensional effect was created in Adobe Illustrator.

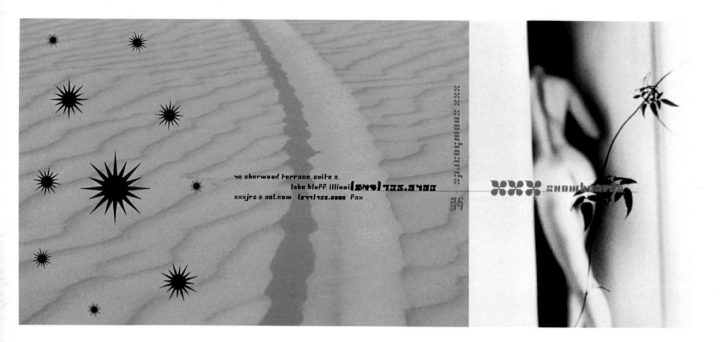

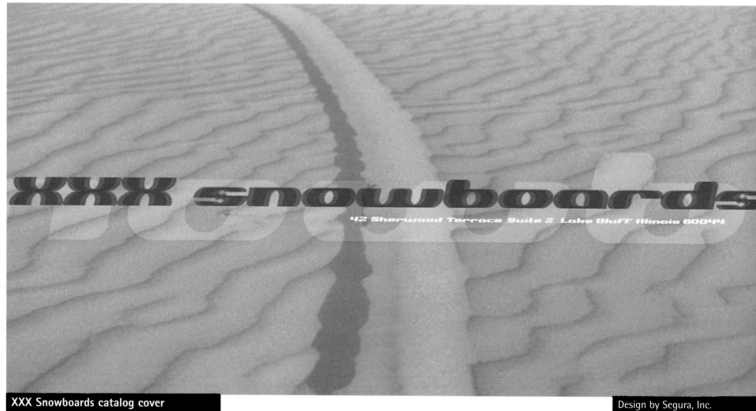

XXX Snowboards catalog cover

Design by Segura, Inc.
Designer: Carlos Segura

A wide swath is cut through powder in this
brochure for XXX Snowboards by Carlos Segura.
The image is matched thick, wide, blurry lettering
that tracks horizontally across the spread.

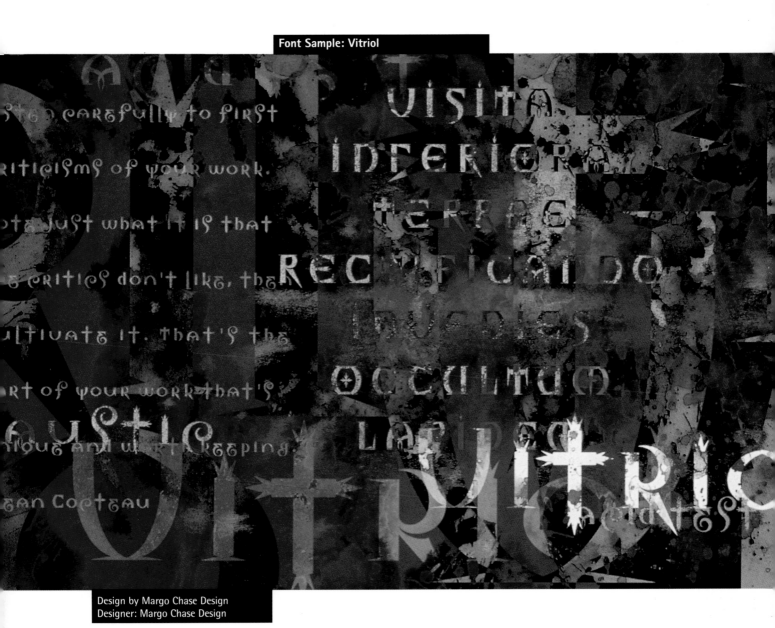

Font Sample: Vitriol

Design by Margo Chase Design
Designer: Margo Chase Design

Margo Chase's Vitriol, a stylized typeface inspired by medieval
manuscripts, is displayed here in layers of distressed backgrounds
that add texture to the ornamented letterforms.

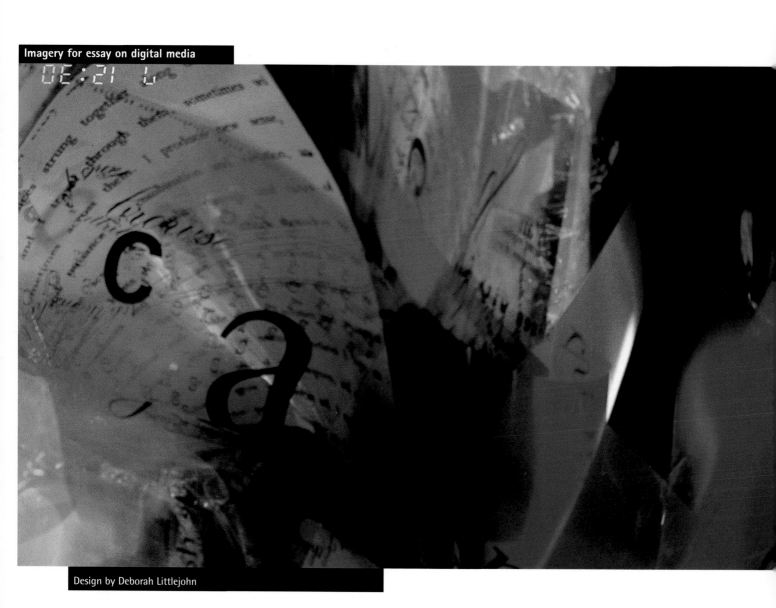

Imagery for essay on digital media

Design by Deborah Littlejohn

An essay on digital typography, designed to be read entirely on the computer screen, is manipulated in Adobe Photoshop to enhance the fluid and dimensional aspects of the digital experience.

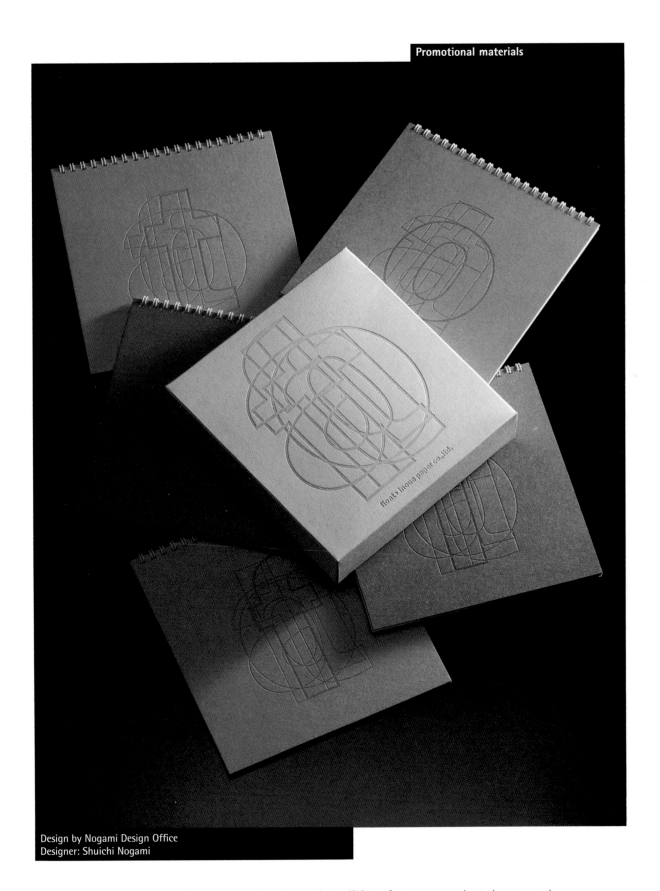

Design by Nogami Design Office
Designer: Shuichi Nogami

To enhance the textural qualities of a paper product, boxes, and

promotional materials were embossed with layers of letters set in

Franklin Gothic Demi; the process rendered inks unnecessary.

13th Floor 157
3309 Pine Avenue
Manhattan Beach, CA 90266

Adele Bass & Company 57
758 East Colorado Boulevard
Suite 209
Pasadena, CA 91101

Alan Chan Design Company 31; 32
2/F Shiu Lam Building
23 Luard Road
Wanchai, Hong Kong

Alex O. Baker Art & Communications 217
2832 Broadway East
Seattle, WA 98102

Alexander Isley Design 36; 56
361 Broadway
Suite 111
New York, NY 10013

Angelo Sganzerla 136
Via Crema 27
21035 Milano
Italy

Associates Design 82; 144; 145; 147; 212
3177 MacArthur Boulevard
Northbrook, IL 60062

Aufuldish & Warinner 51; 197; 198; 199
183 The Alameda
San Anselmo, CA 94960

Barbara Ziller & Associates Design 186
330 Fell Street
San Francisco, CA 94102

Becker Design 161
225 East Saint Paul Avenue
Suite 300
Milwaukee, WI 53202

Bennett Peji Design 91
5145 Rebel Road
San Diego, CA 92117

Blue Sky Design 154
Robert Little
6401 SW 132nd Court Circle
Miami, FL 33183

BRD Design 18; 19
6525 Sunset Boulevard
6th Floor
Hollywood, CA 90028

Brian Cronin 123
682 Broadway
New York, NY 10012

Buttgereit & Heinenreich Kommunikationsdesign 177
Recklinghäuserstrasse 2
D-45721 Haltern am See
Germany

Campbell Fisher Ditko 152
3333 East Camelback
Phoenix, AZ 85018

Carmichael Lynch 12
800 Hennepin Avenue
Minneapolis, MN 55403

Carre Noir 29
Rue des Mimosas 44
B-1030 Brussels
Belgium

Charney Design 78; 189
1120 Whitewater Cove
Santa Cruz, CA 95062

Christina Cava 234
826 5th Street
Santa Monica, CA 90403

Clifford Selbert Design 55; 194
2067 Massachusetts Avenue
Cambridge, MA 02140

Concrete 110; 116
633 S. Plymouth Court
Suite 208
Chicago, IL 60605

CopperLeaf 52
364 West 1st Avenue
Columbus, OH 43201

COY 21; 168
9520 Jefferson Boulevard
Culver City, CA 90232

David Carter Design 149; 210
4112 Swiss Avenue
Dallas, TX 75204

Deborah Littlejohn 250
4130 Blaisdell Avenue South
Minneapolis, MN 55403

Diana Howard Design 13
2025 Stockton #4
San Francisco, CA 94133

Disney Design Group 83
Walt Disney World
P.O. Box 10000
Lake Buena Vista, FL 32830-1000

ECCO Media 49
89 Fifth Avenue
New York, NY 10003

Ed Phelps 139
Two in Design
1163 14th Place NW
Atlanta, GA 30309

Elixir Design Co. 171
17 Osgood Place
San Francisco, CA 94105

eyeOTA in-house design 28; 39
541 Lillian Way
Los Angeles, CA 90004

Free-Range Chicken Ranch 125
330A East Campbell Street
Campbell, CA 95008

Gary Krueger 201
P. O. Box 543
Montrose, CA 91021

George Tscherny, Inc. 140
238 East 72nd Street
New York, NY 10021

GlueBoy International 192; 193
P. O. Box 14857
Baton Rouge, LA 70898

Graffito/Active8 47
601 North Eutaw Street
Suite 704
Baltimore, MD 21201

Greteman Group 102
142 North Mosley
Wichita, KS 67202

Herman Miller in-house design team 14
855 East Main Street
Zeeland, MI 49464-0300

HMM Communications 179
57 Hope Street
2nd Floor
Brooklyn, NY 11211

Hoffman and Angelic Design 25
317-1675 Martin Drive
White Rock V4E 6E2 BC
Canada

Holden & Company 215
804 College Avenue
Santa Rosa, CA 95404

Hornall Anderson Design Works 26; 30; 70; 72; 95; 97; 175; 205; 217; 223
1008 Western Avenue
Suite 600
Seattle, WA 98104

Human Code, Inc. 53
1411 West Avenue
Suite 100
Austin, TX 78701

Ida Cheinman, Rick Salzman 59
P. O. Box 1825
Plattsburgh, NY 12901-0260

Independent Project Press 62; 103; 104; 182
Box 1033
Sedona, AZ 86339

Jay Vignon Studios 230
11853 Brookdale Lane
Studio City, CA 91604

Jeff Labbé Design 221
218 Princeton Avenue
Claremont, CA 91711

Kiku Obata & Company 195
5585 Pershing Avenue
Suite 24D
St. Louis, MO 63112

Kiyoshi Kanai, Inc. 41
115 East 30th Street
New York, NY 10016

Kolar Design, Inc. 66
308 East 8th Street
5th Floor
Cincinnati, OH 45202

Lance Anderson Design 80
22 Margrave Place
Studio 5
San Francisco, CA 94133

Laughlin, Winkler, Inc. 60
4 Clarendon Street
Boston, MA 02116

Laughing Dog Creative 169
900 North Franklin
Suite 620
Chicago, IL 60610

Liska and Associates, Inc. 113
676 N. St. Clair
Suite 1550
Chicago, IL 60611

Louise Fili Ltd. 81
7 West 16th Street
New York, NY 10011

Love Packaging Group 115
410 East 37th Street North
Plant 2
Graphics Department
Wichita, KS 67219

Luis Fitch Company 120
4104 Pinetree Drive
10th Floor, #1031
Miami Beach, FL 33140

Malcom Turk Studios 247
16 Abington Square
2C
New York, NY 10014

Marcolina Design, Inc. 124
1100 East Hector Street
Suite 400
Conshohocken, PA 19428

Margo Chase Design 16; 17; 165; 249
2255 Bancroft Avenue
Los Angeles, CA 90039

Maureen Erbe Design 23
1948 South La Cienega Boulevard
Los Angeles, CA 90034

Maximum 222
430 West Erie Street
Suite 406
Chicago, IL 60610

Melissa Passehl Design 233
1215 Lincoln Avenue
Suite 7
San Jose, CA 95125